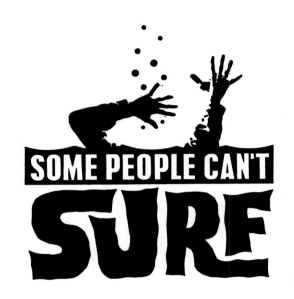

SOME PEOPLE CAN'T
SURF

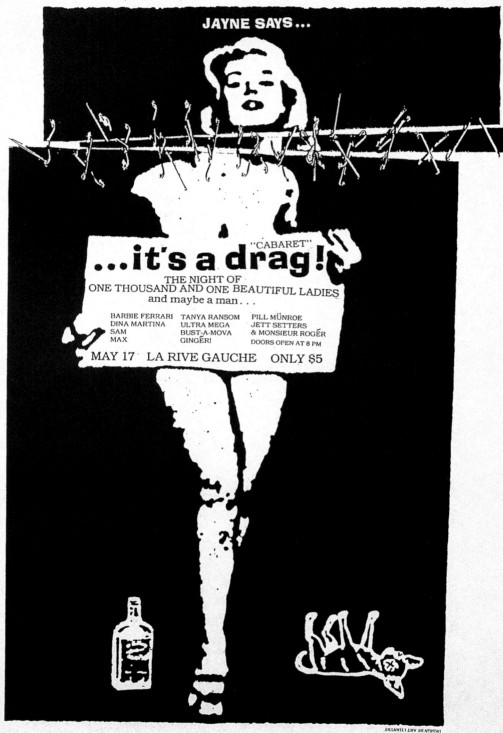

SOME PEOPLE CAN'T SURF
THE GRAPHIC DESIGN OF ART CHANTRY

BY JULIE LASKY

DESIGNED BY ART CHANTRY & JAMIE SHEEHAN

INTRODUCTION BY KARRIE JACOBS

CHRONICLE BOOKS
SAN FRANCISCO

For my parents,
Ruth and Harold Lasky

Library of Congress Cataloging-in-Publication Data available

ISBN 0-8118-2365-2

Printed in Hong Kong

Designed by Art Chantry and Jamie Sheehan
Production photography by Arthur S. Aubry
and Tom Collicott
Typesetting by Jamie Sheehan

Distributed in Canada by Raincoast Books
9050 Shaughnessy Street
Vancouver, BC V6P 6E5

10 9 8 7 6 5 4 3 2 1

Chronicle Books LLC
85 Second Street
San Francisco, California 94105

www.chroniclebooks.com

HALF-TITLE PAGE:
Some People Can't Surf, logo for a T-shirt company, 1986.
FRONTISPIECE:
Drag show poster for The Swedish Housewife, 1994.

CONTENTS

I FIRST ENCOUNTERED ART CHANTRY when I was a design editor at Van Nostrand Reinhold Publishers in New York. He was featured in Steven Heller's book *Designing with Illustration,* a collection of interviews with graphic artists. The project landed on my desk in the late eighties (my job was to help shepherd it through to production) and I was captivated not just by the rugged beauty of Chantry's designs, but also by his feisty explanations of how he accomplished them. Much later, when we began to collaborate on this monograph, I decided I could serve it best simply by following him around with a tape recorder and quoting freely from the transcript. Our conversations, which took place over the phone as well as in person, began in the spring of 1998 and continued for roughly two years. In fact, they're still going on.

I stand by my method, but this book has several behind-the-scenes muses. Steven Heller not only introduced me to Art Chantry's posters but hooked me permanently on graphic design and remains my principal adviser on the subject. Martin Fox offered me a wide, comfortable berth on his staff at *Print* magazine, where I was managing editor through most of the nineties. Scott Menchin has tutored me in the visual arts from the first day of our long acquaintance. And I trust Camilo José Vergara in matters of visual perception more than all the galleries in west Chelsea. I am deeply indebted to the talented staff at *Interiors* magazine for helping to keep after-hours anxiety to a minimum, and to Amy Clyde, Yvetta Fedorova, Eve M. Kahn, Peter Kerr, and Bradley Kulman for their personal and professional support. And I would be a pitiful sort of writer indeed without my great friend and devoted reader Gary Saul Morson.

A chunk of research for this project was done over a late-summer month in 1998 at the Blue Mountain Center in Blue Mountain Lake, New York. My thanks to director Harriet Barlow and to the sponsors of the 1997 Richard J. Margolis Award. Thanks also to the Writers Room, on Astor Place in Manhattan, for its serenity and uncluttered desk space, to Collin Shutz for turning over his Belltown apartment to me during a Seattle research excursion, and to Hank Shutz for leading me to parts of the city I never would have seen on my own.

Alan Rapp, my editor at Chronicle Books, granted me more indulgences than a corrupt medieval priest, though he is honorable and very much of this world. For this, and for his excellent sense of literary refinement, I am grateful.

Little could have been accomplished without the ideas and design talents of Chantry's companion and creative partner, Jamie Sheehan, who has been indispensable at every phase of this project. And I owe much to those I interviewed about Art Chantry and Seattle: Grant Alden, Corey Chantry, Charles Cross, Dave Crider, Edwin Fotheringham, Nathan Gluck, Steven Heller, Karrie Jacobs, Scott McDougall, Courtney Miller, Chuck Pennington, Charles Peterson, Jesse Reyes, Andi Rusu, Mike Stein, and Hank Trotter.

Last and foremost, my thanks to Art, for trusting me with his life.

JULIE LASKY, BROOKLYN, NY

I am for an art . . . that does something
other than sit on its ass in the museum.
I am for an art that grows up
not knowing it is art at all,
an art given the chance of having
a starting point of zero.
I am for an art that embroils itself with
everyday crap and still comes out on top.

CLAES OLDENBURG

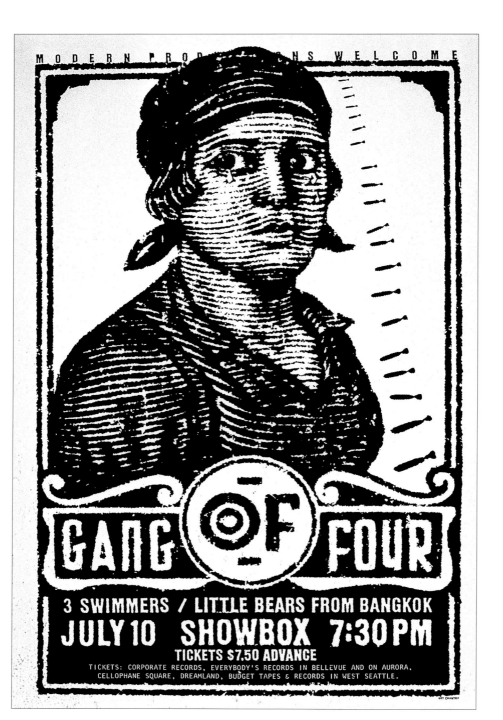

MODERN PRODUCTIONS WELCOME

GANG OF FOUR

3 SWIMMERS / LITTLE BEARS FROM BANGKOK
JULY 10 SHOWBOX 7:30 PM
TICKETS $7.50 ADVANCE
TICKETS: CORPORATE RECORDS, EVERYBODY'S RECORDS IN BELLEVUE AND ON AURORA,
CELLOPHANE SQUARE, DREAMLAND, BUDGET TAPES & RECORDS IN WEST SEATTLE.

THE ART CHANTRY POSTER that I liked best twenty years ago was the one he designed for a 1981 Gang of Four concert at the Showbox, a shabby theater on a block of wino bars and peep shows in downtown Seattle that was once the city's premier new wave venue. The poster featured a woman, an archetypal worker who was lifted, I think, from a Soviet postage stamp, printed to look like a woodcut. Tears rolled down her grainy cheeks as bombs dropped from the sky beside her head. The poster meant a lot to me, because my friends' bands—3 Swimmers and Little Bears from Bangkok—had been chosen to open for Gang of Four, a major label act from England. They were listed right there on the poster, just below the headliner. The record deals, we all believed, would inevitably follow. It was also one of the most sophisticated music posters of its day, subtle and controlled in a culture that placed a high value on barely articulated rage.

Twenty years ago in Seattle, the counterculture heroes were the musicians who played in local bands and the designers (I use the term loosely) who made the posters that represented the single best way of promoting indigenous music and other fringe culture events. There was no Internet, no www-dot-nothing. The local radio stations seemed entirely indifferent to the emerging scene. There were just these amazing posters, constructed out of plastic label-maker type, pictures distressed by repeated photocopying or crummy Letraset—just about anything—that appeared, as if by magic, in the dead of night, wheat pasted to walls and telephone poles all over town.

Seattle, circa 1980, was still a backwater. The term *grunge* had not yet been coined. And there was no Microsoft. There was just this little pressure-cooker orbit of clubs where you pretty much had to have your knees up against the stage in order to see, and theaters that were always on the verge of being closed by creditors or the fire department. It was a scene made up of band members who worked in record stores and espresso bars by day, who dreamed of record contracts that almost never materialized, and whose only route to fame—at least around town—was posters: crude, beautiful, and inventive.

In Seattle, during the long economic nap time that followed the Boeing bust of the 1970s, the posters were our websites. Each new poster was a discovery, a small event. At the university-district record store where I worked, we would talk about the posters almost as much as we'd talk about the music. "Hey," someone would say, "did you see the poster that Frankie from the Beakers made for the Showbox concert with Delta 5? She did something with the type. . . . It's like a ransom note, but much cooler."

Toward the end of 1979, I began working on a new magazine, *The Rocket*. It was a monthly music magazine, intended to cover national acts and to promote the local scene. The design of *The Rocket,* from the outset, was directly related to poster culture. *The Rocket's* original art director, Steve Bialer, once collaborated with senior editor Robert Newman on a newsprint handout for a band called The Enemy. The poster, with its disarming photo of the customarily leather-clad rockers naked and bashful in a swimming pool, was so cheap to reproduce that they were nearly able to do a Christo, gift-wrapping entire city blocks with it. This guerrilla style is what we aspired to. It was what we loved.

The Rocket was a shoestring operation. Our first "office" was a single desk at the headquarters of the *Seattle Sun,* a bankrupt counterculture weekly, in which each of us had a drawer. Eventually, we found deluxe digs in a part of Seattle known as Belltown, which was just making the transition from sleazy to hip. Our neighbor across the hall ran a business called Al Croft C*A*S*H. He advanced his clients money against their income tax returns and charged 30 percent interest, which he claimed as his fee for tax preparation. His customers, who had a way of drifting into our offices, brought an air of genuine desperation to our workplace.

At the time, Art Chantry was bigger than we were. He had a job designing posters for cultural events at the University of Washington. He might even have been on salary. I regarded him as a grown-up, a cool guy who had succeeded in the real world. My scruffy *Rocket* colleagues and I were immersed in the rock and roll lifestyle that our magazine represented. As hard as we worked on every issue, we affected a kind of antiprofessionalism, a bad attitude to set us apart from the newest arrivals on the cultural scene, the yuppies. But Art, whose posters often featured four colors and heavy paper stock, he was a pro.

My own memory aside, nothing about the design of Art's 1981 Gang of Four poster indicates that it is two decades old. It is so fresh that it could just as easily have been printed last week. Today, when I look at Art's posters, I can't always tell which ones are from back then and which are more recent. And that's the strange thing about his work. Many of his posters are timeless. While most graphic design can be readily matched to an epoch—psychedelic, punk, new wave, decon—Art's speaks of a funny, weird, iconoclastic counterculture that, to an extent, still exists in Seattle. After all, Art continues to be involved with it. And Seattle-based firms like Modern Dog have followed closely in his footsteps. But today, this culture is perhaps most vibrant and alive inside Art Chantry's head.

By the time Art took over as *Rocket* art director in '84, many of the original Rocketeers had left Seattle for bigger and better things. The graphic designer Mark Michaelson went to New York to work for Bea Feitler on a prototype for the new *Vanity Fair*. Editor Robert Ferrigno became a feature writer at the *Orange County Register*. Art director Helene Silverman departed for a job at *Mademoiselle*. And I accepted a job as an editor and feature writer at the *New Times Weekly* in Phoenix, then quit and moved on to New York.

There were identifiable Seattle moments at a couple of New York publications. The *Village Voice* was so full of ex-*Rocket* designers and photographers in the late 1980s that other staffers grumbled about the "Seattle Mafia," and at roughly the same time, Silverman, an art director named Jeff Christensen, and I were putting our imprint on a magazine called *Metropolis*. Eventually we all split up and slipped into the mainstream as individuals. The traces of 1980 Seattle faded from our work.

But I still see that old pre-Nirvana, pre–Microsoft Windows Seattle in Art Chantry's designs. I see the kind of idiosyncratic, emotive work that you can do only in a place no one knows or cares about. Seattle is no longer that place, but Art still functions as if it were. Twenty years ago, he seemed like a grown-up. Today—and I mean this as a compliment—he seems like a kid. By sticking to his guns in Seattle, Art was able to become a singular presence in the larger world of graphic design. He was able to hang on to a spirit that the rest of us left behind.

FIG. 1
Poster for an improvisational comedy performance whose title came from a strip club motto.
Client: Unexpected Productions, 1991.

Art has not yet come to its maturity if it do not pull itself abreast

with the most potent influences of the world,

if it is not practical and moral,

if it do not stand in connection with the conscience,

if it do not make the poor and uncultivated feel that

it addresses them with a voice of lofty cheer.

RALPH WALDO EMERSON

CIGAR BAND COLLECTION

MODERN PLASTICS ENCYCLOPEDIA, VOL. 36, NO. 1A, 1957

PET CLOTHING CATALOG

STACK OF ENAMELED METAL TEENGENERATE BAND POSTERS PIERCED WITH BULLETS FROM A .45 AUTOMATIC AND AN AK-47

BOOKS ON THE OCCULT

MAGAZINE BOXES LABELED "SCIENCE & MECHANICS," "ROD & CUSTOM," "DEATH," AND "LEWD"

EMPTY TIMEX WATCH DISPLAY CABINET

BIOGRAPHY OF THE MAN WHO INVENTED VELVET PAINTING

BLACK-AND-WHITE PHOTO OF A DERELICT WAVING AN AMERICAN FLAG

FIVE 1950s CHA-CHA RECORDS FEATURING AN UNCREDITED MARY TYLER MOORE ON THE COVERS

EARLY 1950s HI-FI CABINET

PARROT

A tiny fraction of the objects in Art Chantry's Seattle studio, May 1998

ART CHANTRY WORKS IN AN INDUSTRIAL SECTION of Seattle, across the street from a Hostess factory blasting the scent of chocolate on Mondays. His studio is a neatly organized room that opens onto a motel-like terrace linking offices belonging to other designers and artists. When clients arrive, they find the street door locked, but they know to shout up for Chantry to let them in. If he's expecting a visitor, he turns down the music—usually something old that he's chosen from his shelves of vinyl, a collection so big and obscure that Jello Biafra, of the now-defunct punk band the Dead Kennedys, sometimes calls looking for an album. Or he interrupts a conversation—he's a liquid, hyperbolic, intensely engaging talker—to cock an ear, waiting for the sound of his name to float up from the parking lot.

The building, a former hat factory, houses the School of Visual Concepts. Since 1985, Chantry has taught poster design here to aspiring graphic designers. His students know him as a legend—a guy who even when he was young (he's forty-six now) was internationally famous and a curmudgeon. Chantry tells the story of waiting for people to come to his very first class. He was sitting in a chair facing the lectern with his portfolio propped up next to him. The first student to arrive, Jesse Reyes, settled into an adjacent seat and, figuring that he was talking to a classmate, began chatting about Chantry's reputation for crankiness. Chantry was impressed.

Reyes became his protégé and good friend. And like many of Chantry's protégés and friends, Reyes ultimately left Seattle for new opportunities, while Chantry remained behind, hugging the city as if it were a rancid security blanket that he both loves and wishes someone would pry out of his hands and burn.

Chantry's world is colored by paradox. This is probably why he has earned his other reputation—as one of the most gifted graphic designers in America—through collage, the art of taking things that don't go together and combining them seamlessly. He uses design to conquer incompatibilities that engage him in life, though one senses that his daily division of the world into neat hemispheres of good and evil, attraction and repulsion, is a kind of artifice in its own right.

This, for instance, is how he describes Dallas, where he gave a lecture several years ago: "That place is God and Devil. That was where it became obvious that all the guys with the suits and ties hate me and all the guys dressed casually like me. It's that simple." Once, after speaking at a design conference in California, he was shown his audience's written responses. The pages formed two piles, he insists, "exactly the same height. One pile said, 'Best I've ever seen. Fucking fantastic. The guy's a genius.' The other said, 'I want my money back. What a fucking waste of time. This guy should be killed.'"

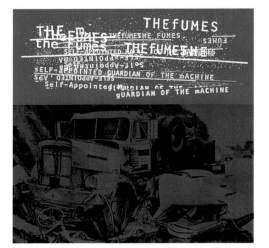

FIG. 2
CD cover for The Fumes
evokes the Northwest with
a photo of a 1957 Chevy
crushed by a logging truck.
Client: Empty Records, 1996.

FIG. 3
The visual language of hot-rod
culture was adopted for this
Mono Men single.
Client: Estrus Records, 1995.

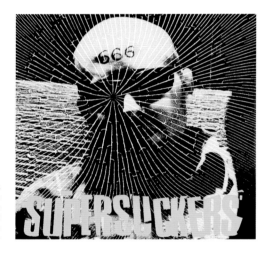

FIG. 4
Chantry used scissors
and a photocopy machine
to ravage the logo of this
Supersuckers record.
Client: Sub Pop, 1991.

FIG. 5
Chantry designed a preworn-
looking LP cover for
The Phantom Surfers,
a band so averse to
high technology that it
refused to issue CDs.
Client: Estrus Records, 1992.

For Chantry, graphic design is a folk art whose best practitioners are often anonymous and whose best examples may be deceptively rough or naive. Packed with meaning that is fully transparent only to a discrete slice of culture, such work nevertheless has an energy and directness that slicker souls find irresistible. Who makes it? Hot-rod pinstripers, layout artists at obscure trade magazines, printers wrestling with technology, and untrained sign painters. It might emanate from cultural niches where surfers bob over waves or punk rockers build and smash instruments. Often its creators are unconscious that their split-fountain rainbows of ink and gaudily painted notices have anything potent to contribute to the world. They're just doing their day jobs, or scratching an itch to be expressive, while their graphic forms mutate across the landscape, from tattoos to vans rusting in vacant lots to video arcades to rows of drugstore greeting cards. Often such forms make their way to the bastions of corporate design culture: magazine ads, book jackets, VH-1. Shedding their origins, they gain greater authenticity for seeming to spring out of nowhere. They are born, Chantry says, of popular culture itself.

And yet they have a provenance. Chantry likes to trace the roots of graphic pop icons, from the peace sign to the happy face, to demonstrate that real people are behind images that seem to well up from such indistinct places as "the fringe" and "the zeitgeist." In the meantime, he charges, a few creative geniuses unfairly get the credit for inventing contemporary design language. He strongly opposes the Great Man Theory of history, an offshoot of Ralph Waldo Emerson's belief that "all history resolves itself very easily into the biography of a few stout and earnest persons." Rather than credit innovations in contemporary design to dwarves standing on the shoulders of graphic giants like Herbert Bayer or Paul Rand, he prefers to think of conventional design heroes as Gullivers propped up by, and taking credit from, hordes of obscure Lilliputians. This is not to say that he dismisses the contributions of revered designers and artists—Marcel Duchamp, Andy Warhol, and Lester Beall are a few who reside in his personal pantheon—but that he is more interested in people whom history has overlooked.

Take Harley Earl, for instance. Though not a folk artist by any measure, Earl did put the tail fin on the Cadillac when he was design director of General Motors in the fifties—in Chantry's view a triumphant conflation of science, industry, and art. It galls Chantry that historians slight Earl, who also introduced "chrome-laden behemoths, two-tone paint schemes, wraparound windshields, [and] the hardtop,"[1] while sanctifying designers at institutions like the Bauhaus, Ulm, and Cranbrook: "They try to credit Wolfgang Weingart with new wave punk graphics," Chantry says,

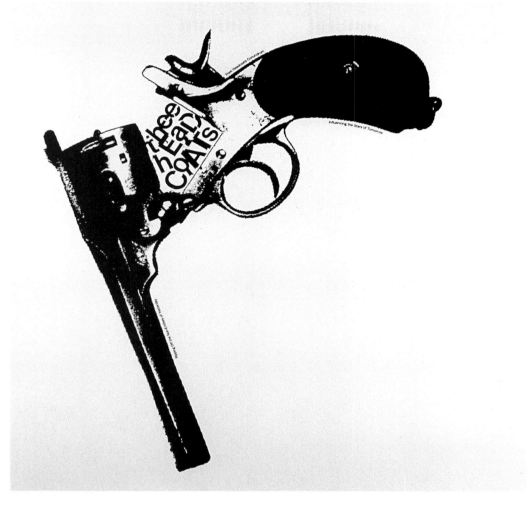

FIG. 6
Broken press type is crammed into a cocked firearm on this LP for the band Thee Headcoats.
The tiny title running along the shaft and muzzle reads,
"Thee Headcoats Conundrum: Influencing the Stars of Tomorrow . . . Ripping off the Nonentities of Yesterday."
Client: Super Electro Sound Recordings, 1994.

"but it's individuals striving against really oppressive odds who make graphics interesting, not guys in universities. They sit around and talk about stuff that other people have done and think they have discovered it." His reverence for the insufficiently acknowledged is not just theoretical but a central feature of his work. It therefore represents the starting point from which his own story must be told.

Chantry has achieved prominence and spawned dozens of imitators by producing riffs on history—in graphics that show a special affection for obscure or outmoded forms. These designs speak on several levels. They contain inside references to Seattle's culture, where for twenty years they have helped to galvanize and document the city's music, theater, and art scenes. ("Chantry isn't just a figure in the development of what is known as the Seattle style, he's the reason there is such a thing," the Seattle art critic Regina Hackett wrote in 1993.)[2] And they pay homage to old, neglected masters of popular culture in a style that would be too hastily labeled retro. Challenged by the low budgets typical of his clients—garage-band record labels, local clubs, nonprofit social groups, small theater companies—he has explored and exploited low technology's creative potential. Because his goal is to self-consciously perpetuate forms from the past, he is an archaeologist as well as an artist, preserving as well as reinventing artifacts of design, especially ephemera that others would not consider worth keeping: comic books, pornography, carnival graphics, ads found in the backs of old trade magazines, pictures of hucksters and long-forgotten politicos.

Chantry's main source of collage materials is subcultures. He uses the word *subculture* to refer to tribal creative groups that share a language, a set of heroes, and a body of historical knowledge considered arcane to outsiders. Skateboarders are an example. So are drag queens and drag racers. Once upon a time letterpress printers and typographers formed subcultures too, he says, before digital technology wiped out most of their businesses. These fraternal orders (they are in fact composed primarily of men) tend, moreover, to be blue collar with little hope of upward mobility, and their members practice tricks of economy that sometimes indirectly produce novel aesthetic effects. Whether their instrument is a car engine, a guitar, or a letterpress, members of subcultures know its mechanics; to take apart and rebuild—to customize—is a form of expression as well as the low-budget key to greater speed and precision.

Although Chantry has made no formal study of subcultures, his characterizations resemble those offered by cultural studies experts. In her introduction to *The Subcultures Reader,* coeditor Sarah Thornton distinguishes subcultural groups in general terms: they are perceived as "oppositional." They are "envisaged as disenfranchised, disaffected

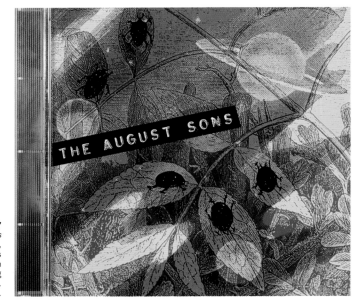

FIG. 7
Plants, Planets, and Insects
is a CD by The August Sons,
Mississippi goat farmers
who built their own
recording studio by selling
Harley-Davidson parts.
Client: El Recordo, 1995.

Record label logo, 1997.

Record company T-shirt, 1993.

Theater company logo, 1992.

Record title typography, Sub Pop, 1993.

and unofficial. Their shadowy, subterranean activities contrast dramatically with the 'enlightened' civil decencies of the 'public.'" They are "generally seen as informal and organic." They are defined by what they are not: "The emphasis is on variance from a larger collectivity who are invariably, but not unproblematically, positioned as normal, average, and dominant. Subcultures, in other words, are condemned to and/or enjoy a consciousness of 'otherness' or difference."[3]

Chantry's observation that the members of subcultures demonstrate a mastery over materials and tools echoes writings by the scholars John Clarke and Dick Hebdige, who perceive a link between subcultures and bricolage, or the practice of building with whatever materials come to hand. (The term derives from the French word *bricoler*, "to putter about," and won its theoretical status in the writings of the French anthropologist Claude Lévi-Strauss, who used it to describe the way in which "primitive man" made sense of the physical world.)[4] One can see why Chantry dwells on this aspect of subcultures. Constructing from mongrel parts or improvising with found objects is effectively a style of collage, but not collage as it is mostly practiced in the computer age. Computers allow designers to manipulate information in countless ways, yet the final results are rarely translated exactly as they are viewed on the monitor. Computers are instruments of hypothetical desire, whereas the subcultures that

Chantry admires often come from a precomputer era of observable moving parts with an obvious relationship to the sounds and images they generate in the physical world. By assimilating the methods as well as the products of old subcultures, he helps to promote them to a younger generation of cultural outlaws—nineties garage bands, say, whose members are infatuated with the campy pop graphics of sixties surfers. His work is more than homage in that he inserts himself into a tradition, which he furthermore mediates, exaggerating and redefining the antiquated styles and images he resurrects.

Chantry doesn't work on computer. His tools are the printing press and the photocopier (a kind of press, after all, in its power to manufacture multiple images), and he knows how to use them.

I learned about printing technology by doing it: just going to press checks, talking to those guys, watching or thinking. It's pretty logical. The press puts down one layer of color at a time. That's all you basically need to know. The rest of it is how you manipulate the way the ink hits the paper, and everything I do is aimed at that process. Nothing really exists until it comes off the press. That's your palette and brush and pigment right there.

His results would be nearly impossible to achieve with more sophisticated technology, for he aims to reproduce the look of erosion and haphazardness. For all

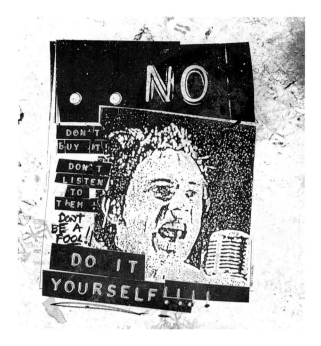

FIG. 8
Roughed-up poster for Urban Outfitters, 1995.

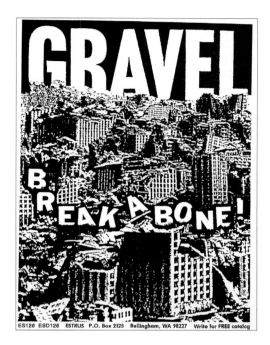

FIG. 9
Promo poster for the band Gravel.
Client: Estrus Records, 1992.

Seattle Kink Information Network logo, 1998.

Internet porn site logo, 1999.

Film-criticism magazine logo, 1979.

its flexibility, the computer allows only the most skillful graphic designers to represent accidents digitally as unpremeditated gestures. Just as the writer who works on-screen never reveals the inked-out lines that indicate the tussle of finding the mot juste, so the designer confined to digital tools can't help covering up a succession of revisions. But printing is full of accidents that one cannot erase, and the degradation achieved by alternately reducing and blowing up type on a photocopier (a standard Chantry technique) produces an otherwise hard-won texture of decay. Chantry, like the Dada artists, prizes the paradox of carefully controlled spontaneity to match the exuberance of the original designs he puts in his collages, and he captures ephemeral states in part to blend old and new material. Spontaneous messes are desirable if they can be harnessed into precise form. Here, for instance, is how he created a promotional poster for the Philadelphia-based clothing chain Urban Outfitters: "We took all the paper and we threw it on the ground in the silk-screen shop. Then we took it out and threw it onto the street and let cars run over it. Then we silk-screened onto it"(Fig. 8).

Chantry developed a mastery of his tools also for budgetary reasons. Because he couldn't afford professional typesetting early in his career, he learned typography by cutting out printed letterforms and pasting them down one by one with a glue stick. He continues to be famous among his peers for his vast collection of old press type—

the stick-down letters amateurs once relied on for professional-looking text. Chantry still uses the stuff, especially when it's dried up and chunks of the letters have broken off. He refined his color sense by creating his own separations, preparing the color plates to be combined on press, a step normally left to experts. He knows design to its bones. Though he rarely illustrates from scratch, he is a skillful draftsman, and his cleverly elaborate music packaging reveals that he is as comfortable working in three dimensions as in two.

Marginality is a large theme for him. Subcultures are defined by words like *alternative* and *underground,* evoking both sideways tributaries from an American mainstream and immersion into unsettling, even dangerous, below-grade activities. One of his clients, a compiler and producer of small local bands, even assumed the name Subterranean Pop, later Sub Pop, to signal its interest in alternative music. His hometown breeds extremism, Chantry believes, the most recent evidence being the protests that disrupted the 1999 World Trade Organization talks in Seattle and the city's decision to cancel its 2000 New Year's festivities out of the fear of terrorism. As in other lovely, low-density western regions, this one has attracted utopians from both ends of the political spectrum, activists and isolationists, communitarians and libertarians. "I have this theory about the continental U.S.," Chantry explains. "The

0015

A collection of rock logos and product marks.

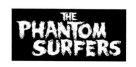

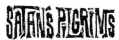

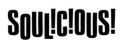
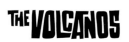
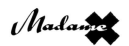

A collection of rock logos and product marks.

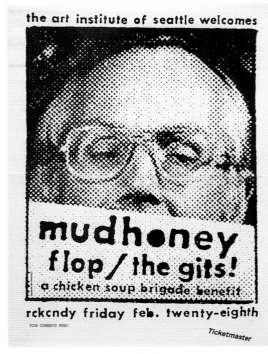

FIG. 10
Benefit show sponsored by the Art Institute of Seattle with
a portrait of conservative Washington senator Slade Gorton.
The gesture was deliberately ironic; Gorton was not supportive
of his gay constituents, and the first event raised money
to help people with AIDS, 1992.

FIG. 11
Poster for a benefit concert at RKCNDY. Chantry designed
this piece shortly before Bill Clinton was elected president.
The clients, he says, "freaked out. They made me cover
the eyes, which only made it obscene."
Client: Art Institute of Seattle, 1992.

Snowboard filmmaker's logo, 1994.

T-shirt company logo, 1985.

Reissue record company logo, 1987.

corners are where people who don't fit in go to find new life, and they keep piling up in the corners because there's no place farther they can go."

Nonetheless, Chantry believes that Seattle's underground culture has been in decline over the past twenty-five years, and he blames the erosion partly on another migration pattern: the exodus of creative spirits in search of better opportunities. "A lot of famous people in the punk and psychedelic scenes came from the Northwest. They couldn't make a living so they migrated south. For talent, south is the only place to go unless you go east to Chicago or New York." In fact many of his circle of culturally minded designers, including a large number who worked with him on the monthly music magazine *The Rocket,* the site of some of his most innovative work, abandoned Seattle for bigger cities. He views himself as a holdout in an alien environment.

Chantry blames another part of the counterculture's demise on Seattle's transformation into a high-tech capital attracting straightlaced entrepreneurs. When, in 1999, software company Adobe's regional headquarters moved into a large complex in the liberal neighborhood of Fremont, the new building signaled yet one more triumph of the corporate drone (however youthful) over the free-spirited artist (however grizzled). Of Fremont's landmark statue of Lenin, Chantry quotes the designer Frank Zepponi as suggesting that someone should "put a cash machine in its butt" to comment on this transmutation of neighborhood values. Not that Seattle, the home of defense giant Boeing, ever lacked for traditionalists. But Chantry judged it an ominous blow to the underground when local conservatives, after years of trying, finally curtailed the display of street posters in 1994, on the unconvincing pretext that they were dangerous to workers climbing utility poles, and thereby cut off an important advertising medium for small theaters and clubs.

Much can be learned about the self-image of Seattle's cultural purists from the titles of a documentary film and book devoted to the city's music scene. The 1996 movie *Hype,* directed by Doug Pray, is about the grunge phenomenon of the late eighties and early nineties, when a few bands found their way to the national stage and attention was suddenly turned not just to every scruffy teenager in the region who strummed an electric guitar but also to the teenager's attire and speech habits.

FIGS. 12–14
Front and back cover and inside spread from *Loser: The Real Seattle Music Story.*
Back cover photo: Alice Wheeler. Publisher: Feral House, 1995.

Eventually flannel shirts and work boots appeared on the pages of *Vanity Fair,* modeled by the likes of Joan Rivers. Meanwhile, the *New York Times* published a lexicon of grunge terms that had been handily invented on the spot by a sales rep at Sub Pop.

Complementing the dismissively titled *Hype,* the 1995 book *Loser,* by Clark Humphrey, chronicles Seattle's music scene back to the fifties, when Northwest bands like the Sonics and the Wailers fueled early rock and roll, and culminates in the decline of grunge. Like *Hype, Loser* is a story of original talents that were misappropriated, canned, puffed up, adulterated with weaker substances, and finally killed off. If Kurt Cobain hadn't existed to inflict a fatal gunshot wound on himself after reaching international celebrity, both *Hype* and *Loser* would have had to invent him, for the ultimate lesson of each history is that authentic talent cannot bloom far beyond its native soil; transplanted, it mutates into a weed or is choked to death.

Given his prominent role in Seattle's underground, it is no coincidence that Art Chantry is featured early and repeatedly in *Hype,* where we first see him shredding punk posters with a paper cutter and joyfully recounting episodes of Northwest luridness, the "dark side" captured most famously by David Lynch in his 1980s television series *Twin Peaks.* And Chantry not only designed *Loser*'s cover and pages, but also suggested the book's title (he borrowed it from Kurt Danielson of the Seattle band TAD, who proclaimed, "The Loser is the existential hero of the 90's"). Still, it would be too much to credit the self-deprecation of both *Hype* and *Loser* to Chantry's influence, just as it would be inaccurate to suggest that Chantry is merely a representative of a city suffering from an inferiority complex: In some ways, he embodies a frontier town that is aware, with a mixture of pride, humility, and disdain, of its place on the edge, but ultimately, like anyone else, he is his own unique product. Genes, pranks, barflies, heroes, gray skies, conifers, countless sitcoms, yellowing newsprint, and the stain of printers' ink are all melded into the collage of Art Chantry. This book represents an effort to disassemble some of its intricate components and to show how they are reconfigured in the work.

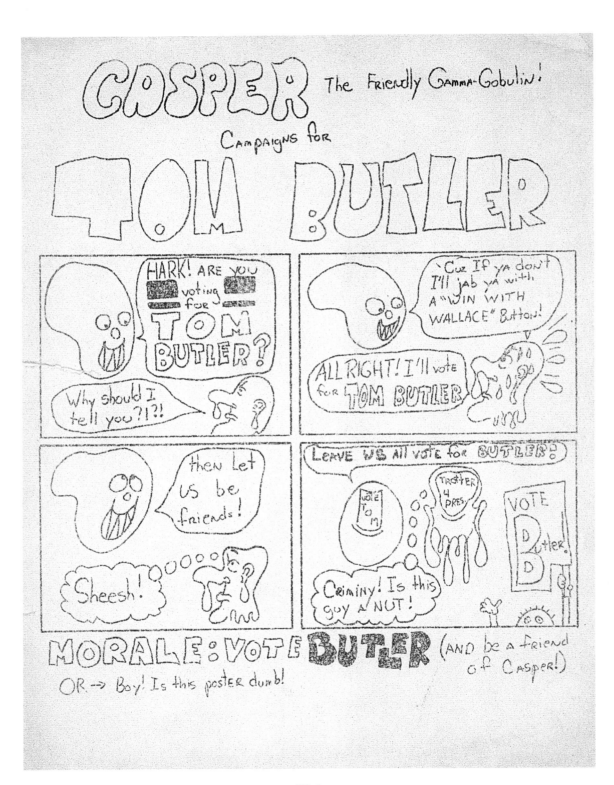

FIG. 1
Art Chantry's first poster, 1968.

David Lynch was right: There is an evil in these woods.
This may be a land of perky backpackers and nerdy engineers,
but it's also a land of environmental destruction,
deliberately released radiation clouds,
racist fraternal lodges, brutal gangs of every race,
serial killers, child-abuse cults, Satanic and occult groups,
white supremacist bombings, neo-Nazi safe houses,
UFO sightings, mysterious cattle mutilations,
ice skaters with thug boyfriends,
and other phenomena you'll never find in a tourist guide.
Even our early heritage is one of brutality, exploitation, and genocide.

CLARK HUMPHREY
LOSER: THE REAL SEATTLE MUSIC STORY

ARTHUR SAMUEL WILBUR CHANTRY II WAS BORN ON APRIL 9, 1954, in Seattle, Washington, the anniversary, he notes, of Robert E. Lee's surrender at Appomattox, which ended the Civil War. Some evidence suggests that Chantry is descended from the British sculptor Sir Francis Chantrey (1781–1841), who was knighted for, among other accomplishments, his statues and busts of King George III, Sir Walter Scott, and the inventor James Watt. According to a 1999 issue of the English magazine *Derbyshire Life and Countryside,* Sir Francis showed extraordinary artistic promise as a child; he would "often be seen carving figures on the end of stout sticks."

He also loved to draw, and would often make sketches on the kitchen floor before his mother cleaned it. It is recorded that one day, when Mrs. Chantrey had a guest to dinner, she produced a home-made pork pie on the top of which the boy had modelled in pastry, while it was still damp, a sow and her litter of pigs. Mrs. Chantrey was embarrassed, but the visitor was markedly impressed.[1]

Art Chantry himself won an art competition in the first grade for a clown drawing that showed an unusual degree of expression. But if a genetic link between the two artists isn't sufficiently established by the name and early signs of talent it is virtually sealed by a portrait of Sir Francis revealing a pointed chin; a broad jawline; full, sculpted lips; and a domed forehead. The face looks very much like Chantry's own (Figs. 2–3).

Chantry's father and namesake was a lawyer from Seattle who became an assistant attorney general of Washington state and was eventually disbarred for embezzling money from a client. A highly decorated World War II veteran, Arthur Sr. was educated at Harvard law school on the G.I. bill, graduating in the top quarter of his class. Chantry's mother, Mary, or Marie, as she called herself, grew up locally with little formal education. Both parents had been married before when they met. Art was raised with Marie's daughter, Cindy, born in 1952, and a younger brother, Corey, born in 1956.

A charming man in public life, Arthur Sr. was prone to alcoholic rages at home; he fought bitterly with Marie and terrified their children. Art's only memory of a boyhood Christmas is of his father attacking his mother and seeing her blood stain a pile of gifts. Years later, he came across a book on sociopathic behavior and was astonished by its precise description of his father's erratic and violent moods.

The couple divorced when Art was ten, and Marie moved with the children to Tacoma, forty miles south of Seattle. Left without adequate financial support, they scraped by on $100 a month earned from rent on property Marie had received as part of the settlement. "I remember as a kid being in the house with the lights off trying to hide from the people trying to repossess my mother's bed," Chantry says. "When I first started my business I refused to have a bank account or a credit card

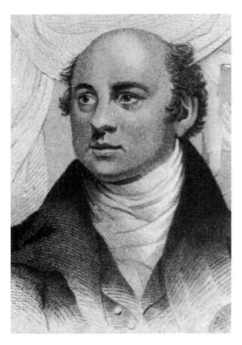

FIG. 2
Sir Francis Chantrey
b. April 7, 1781.

FIG. 3
Arthur S.W. Chantry II
b. April 9, 1954.

because I was scared of them." Marie, whose only prior position had been as an elevator operator, was unqualified for most jobs, yet she found the thought of going on welfare insupportable; only a few years before, she had entertained the governor of Washington in her home. "It's like we were a family that fell from grace with God," Chantry says. He maintained a cool relationship with his father until Arthur Sr.'s death, from liver cancer, in 1997.

Tacoma is perhaps best known to outsiders as the home of crooner Bing Crosby. Chantry recalls it as a brutal place—the embodiment of the Pacific Northwest's "dark side." He was in fifth grade the first time a gun was pulled on him. By the time he moved away, in 1974, he had come to know twenty-three people who would be murdered. Violence, drugs, pollution, poverty, and superstition are the city's most vital characteristics, he charges: "Tacoma's like a little piece of Oakland that broke off and floated up here. It's right down in the armpit of the Northwest. There's this joke about the way it smells: they call it the Tacoma aroma. It's real blue-collar, real poor, with paper pulp and chemical plants. It's like one of the most polluted Superfund sites on the planet."

Yet for Chantry, Tacoma's darkness was also bound up with an outlaw energy that produced some fine early rock and roll and later a spirit that he insists was uncon-

sciously and wonderfully "punk." When he sums up the city's claims to infamy, it is with a giddy, almost loving rant that refers to prototypical fifties rock bands like the Ventures and the Wailers in the same breath as Charles Manson, who used to vacation in Tacoma, and Ted Bundy, with whom Chantry believes he regularly shot games of pool in a bar. (Only later did he connect the handsome stranger with the notorious serial murderer, who was later executed in Florida.)

Everything famous in Seattle took place in Tacoma, but Seattle took credit for it. Loretta Lynn recorded her very first records in Tacoma. Buck Owens lived up here for a while and had a TV show here. Don Gallucci, originally drummer for the Kingsmen, which did "Louie, Louie," became a record producer in L.A., and one of the first projects he produced and recorded was Funhouse *by the Stooges. Tacoma has that kind of culture. The world shifted a little bit on its axis because of that . . .*

Tacoma's like the beginning of all culture in the known universe and nobody seems to realize it. Cattle mutilations, New Age Church . . . the occult has always been big in Tacoma. It's a bizarre place. It is my home.[2]

Chantry links the demonic, creative energy of his childhood home to the evolution of Pacific Northwest culture. The whole region, he believes, "is just one of those places where people stew in their own juices and you develop these enormously

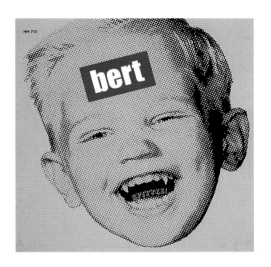
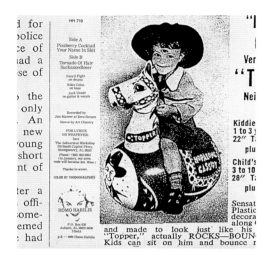

FIGS. 4 & 5
Vintage clip art illustrates the front and back cover of "Spittle," a 45 released by the band Bert.
Client: Homo Habilis Records, 1995.

Halloween CD cover designs (unpublished).
Client: Rhino Records, 1995.

Coffee shop T-shirt design, 1993.

Charity haunted house logo.
Client: Z-Rock Radio, 1992.

twisted talents. And it could be somebody as twistedly brilliant as Kurt Cobain or it could be as brilliantly twisted as Ted Bundy."

His Manichaean view of experience as a continual struggle between extreme forces is not uncommon to Americans of his generation, who saw how moonlike aspects of light and dark culminated in the Great Society, feminism, and the green movement, as well as bombings, political assassinations, and drug overdoses. Bifurcation continues to be part of his worldview. Speaking recently about a city that now hosts the headquarters of Microsoft, Starbucks, and Amazon.com, he noted: "Seattle during the last twenty years has been very bizarre, because you have this dark underground and you have this yuppie lifestyle, and outside Seattle people saw one or the other and they thought somehow it was all the same. But if you really look at it, it was yin and yang battling it out up here. And I think yin won. Or was it yang? I forget."

The creative impulses that emerged from these shadows offered some compensation for his unhappiness as a child. He survived by retreating into a world of American pop culture—comic books, *Mad* magazine, monster trading cards, model car kits (especially custom cars), his sister's fan magazines, radio, and "TV, TV, and more TV," he relates. "This was a proper foundation for a life in American graphic design."[3]

In fact, popular culture from the fifties has been one of Chantry's strongest graphic influences—and he used it long before retro-hungry Americans became besotted with the decade's aquas, avocados, and elliptical forms. He was affected by the period's neon signs and continues to celebrate the untrained artists who produced them. A memoir he wrote for the newsletter of the Seattle Design Association in 1988 evokes the sense of promise conveyed by features of the landscape that others might have viewed as commercial detritus: "When I was a kid, there was a giant Eiffel tower–style Richfield sign on South Tacoma Way that I could see from my bedroom window twenty miles away. It was a scar on the evening sunset, but its blue glow, way out there on the edge of my known world, enticed me: it held the promise of other lands and of a better or at least different future."[4]

Fresh scrubbed faces and crew cuts, staples of fifties and early-sixties advertising, crop up in his work repeatedly, where they are treated with equal measures of respect and irony. For a 45 cover executed in 1995 for the Homo Habilis label (the band is Bert, the title "Spittle"), he grafted fangs onto the open mouth of a laughing child, whose jug ears and blond, slicked-back hair came straight out of clip art from forty years before. Even so, he made the image look mischievous rather than nasty—as if he were reinventing Dennis the Menace for the modern age. The back cover portrait,

FIG. 6
This pop CD/LP by The Holidays features the logo from the long-defunct
Holiday magazine. Client: Chuckie-Boy Records, 1990.

Record label logo.
Illustration: Peter Bagge. Client: Mike Stein, 1989.

Voice talent logo.
Client: Mike Stein, 1998.

Record label logo.
Client: Mike Stein, 1998.

of a boy on an inflatable Hopalong Cassidy horse, reveals a third eye in the child's forehead that may be considered grotesque only to those who don't recognize the reference to Eastern mysticism, especially as it was embraced by the band Nirvana (Figs. 4, 5).

The complexity of Chantry's use of period images and styles evolves partly from his long attachment to them as graphic forms shaping a design sensibility as opposed to reclaimed pieces of an idealized or belittled past. His affection for the golden age of magazine publishing made it easy to conjure up the *Holiday* magazine logo he recalled from boyhood for a record by the Seattle pop band The Holidays (Chuckie-Boy, 1990) (Fig. 6). And he still has a carnival poster that he tore off a wall at fifteen. Enamored of not just the imagery but also the production method—customers continue to order the patterns from a catalog and specify accompanying type—he followed the routine in working with an Arkansas-based printer to design a 1990 Holidays promotional poster series (Figs. 7–10). After sketching out the type he wanted, he selected stock images dating from the forties and fifties from a printer's catalog and instructed the press to use them randomly depending on whichever were available. The graphics were silk-screened, and the text was printed on a letterpress poster printer. "You can feel the texture of the type, slammed in so bad that the type's cracked and chipped," he notes with approval. The unit cost was about fifty cents.

Chantry's taste for popular icons from his youth is broad but not haphazard. "I've always been attracted to darkness, and that's evident in my work, which often has shock value. And it has a lot to do with growing up in a household that was actually dangerous," he says. He recalls spending hours tracing the monsters executed by Steve Ditko, the comics artist who created Spider-Man, and Jack Kirby, originator of the Fantastic Four. Jim Steranko, an artist who introduced psychedelia to comic books with creations such as "Agent of S.H.I.E.L.D." and "Dr. Strange" also inspired him.

As a boy he subscribed to *Famous Monsters of Filmland* magazine and became fascinated with "monster type," a style of lettering found on pulp literature of the era that conveyed a zesty horror through irregular outlines, slashing gestures, and vivid colors. Chantry traced the source of the most proficient of this lettering to the magazine's art director, Harry Chester, who was also the first art director of *Mad*. After decades he managed to track Chester to New York and obtain his phone number, but he hasn't summoned the nerve to call him. "For thirty-five, forty years I've tried to learn to do type like that," he says. "I can fake it almost, but not quite." He approximates the style by cutting apart Chester's own letterforms and reassembling them, as in a series of posters starting in 1995 for Crockshock, an annual festival that showcased bands at the legendary Seattle club the Crocodile Cafe (Fig. 11).

THE HOLIDAYS
NEW RECORD
OUT NOW!

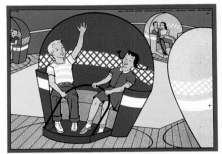

"EVERY DAY IS A HOLIDAY!"
FROM CHUCKIE - BOY RECORDS

THE HOLIDAYS
NEW RECORD
OUT NOW!

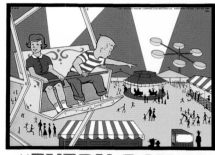

"EVERY DAY IS A HOLIDAY!"
FROM CHUCKIE - BOY RECORDS

THE HOLIDAYS
NEW RECORD
OUT NOW!

"EVERY DAY IS A HOLIDAY!"
FROM CHUCKIE - BOY RECORDS

THE HOLIDAYS
NEW RECORD
OUT NOW!

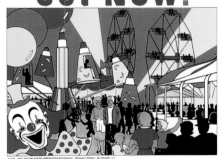

"EVERY DAY IS A HOLIDAY!"
FROM CHUCKIE - BOY RECORDS

FIGS. 7–10
Promo poster series for The Holidays, with artwork specified from an Arkansas printer's catalog.
The series was inspired by carnival posters Chantry recalls from youth.
Client: Chuckie-Boy Records, 1990.

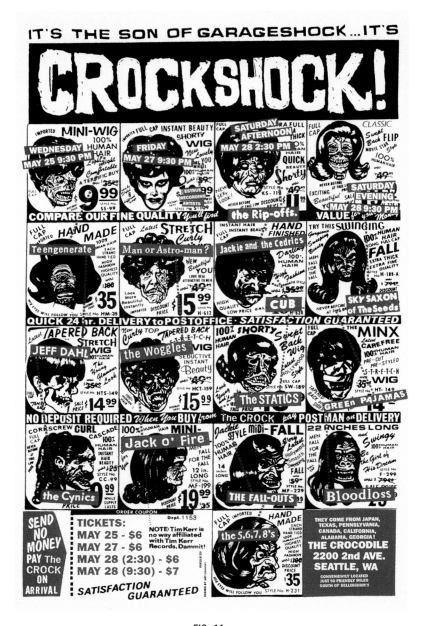

FIG. 11
Monster type animates a poster for an annual music festival at the Crocodile Cafe, Seattle's legendary club, 1995.

Estrus Records catalog logo, 1997.

Product mark, 1988.

Play title, 1986.

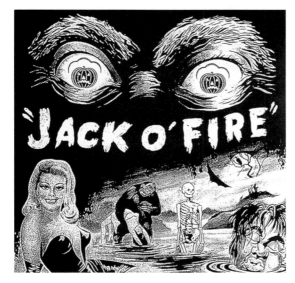

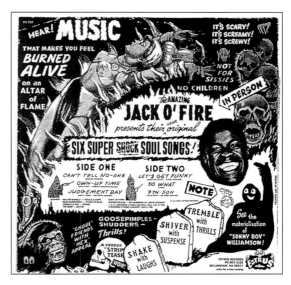

FIGS. 12 & 13
Chantry offered a "spook showcard" approach inspired by
vintage Halloween imagery for the punk/blues band Jack O' Fire.
Client: Estrus Records, 1993.

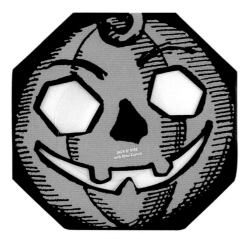

FIG. 14
Die-cut jack-o'-lantern record sleeve with glow-in-
the-dark vinyl. Client: Estrus Records, 1992.

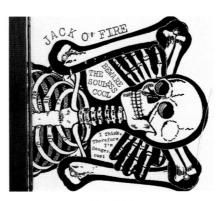

FIGS. 15 & 16
This Jack O'Fire CD package with
extending skeleton was released only in Japan.
Client: Estrus Records, 1993.

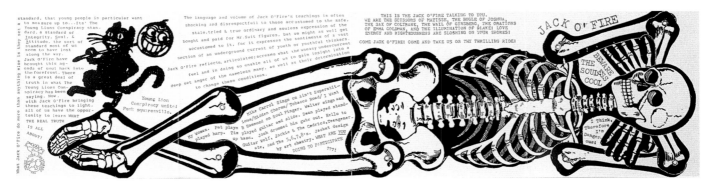

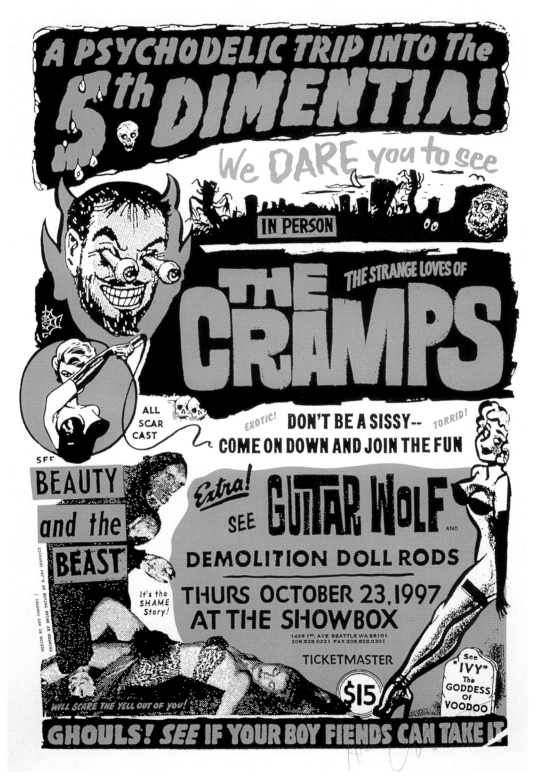

FIG. 17
For this Cramps poster, Chantry put together ads from
old movie and monster magazines and contributed his own lettering.
Client: The Showbox, 1997.

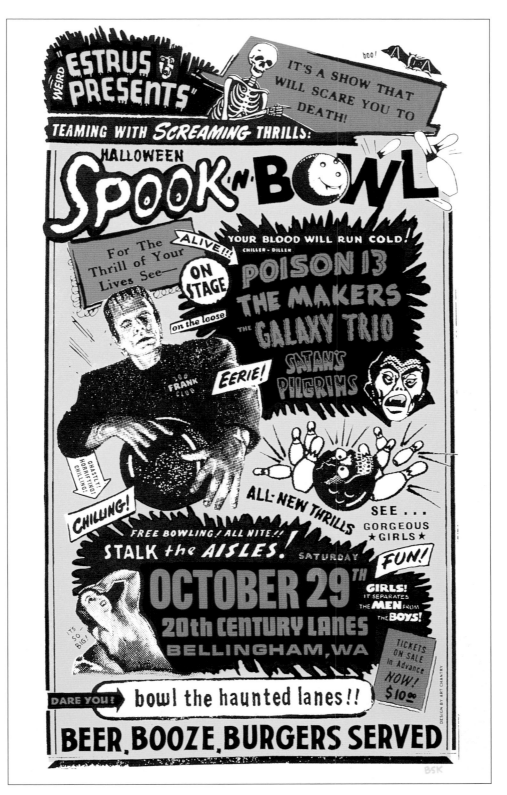

FIG. 18
Poster for a rock concert held in a bowling alley on Halloween.
Client: Estrus Records, 1994.

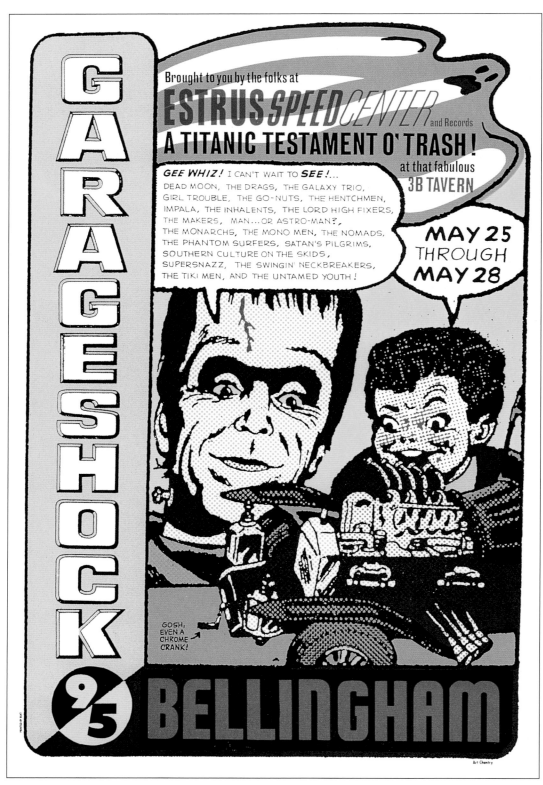

FIG. 19
Garageshock, a music festival that inspired the Crocodile Cafe's Crockshock, is a more or less annual event
in Bellingham, Washington, that showcases Estrus bands. Chantry designed this poster to look like a travel
sticker on the side of an RV and created ticket stubs that were actual water-transfer decals (Figs. 19A–D).
Client: Estrus Records, 1995.

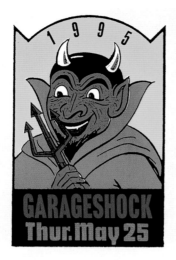

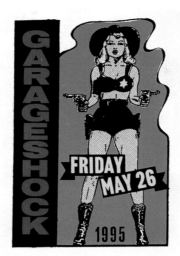

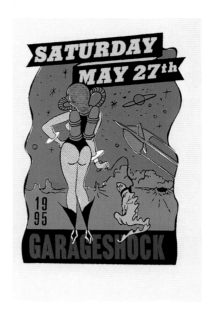

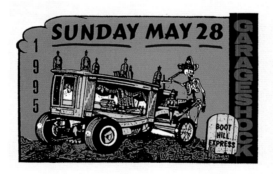

FIGS. 19A–D

Another strong influence was psychedelia, which was impossible to escape in the late sixties. Though inspired by artists who doted on drugs and the organic stylizations of Art Nouveau, psychedelia quickly shed its decadent associations and entered the mainstream, most famously in Heinz Edelmann's animated *Yellow Submarine* movie for the Beatles and in the hot-hued designs of Peter Max. But Chantry's interests were purer than the work of these popular artists. He was studying psychedelic rock posters for the likes of Janis Joplin and the Grateful Dead, designed by Victor Moscoso, Rick Griffin, and the team of Alton Kelley and Stanley Mouse. Indeed, he is in many ways a direct offspring of this group of San Francisco poster artists who wove their graphics into a cultural and historical moment that was identified with a burgeoning American city. The woozy compositional brilliance of this work offered a direct corollary to the fluid music pulled taut by melodic riffs and hooks. And Chantry clearly learned much from its vibrating colors and artful confusion of figure and ground.

Chantry's first poster dates from 1968, when he was editor of the student paper put out by his eighth-grade journalism class (Fig. 1). Printed on a mimeograph, the work presents four panels of a cartoon strip called "Casper the Friendly Gamma-Gobulin [*sic*]," about a blob with a toothy grin—the name accurately reflects a cross between a ghost and a microscopic blood particle—who is trying to elect a student named Tom Butler class president. Addressing a drippy-nosed voter, looking a bit like a Blue Meanie from *Yellow Submarine,* Casper threatens to jab the voter with a "Win with Wallace" button if he doesn't support his candidate. The panicked voter agrees. Chantry's use of big outline lettering for emphasis offers no clue to his future accomplishments in typography. Nor does the drawing hint at his talent for drafting. But the sensibility is recognizable. At the bottom Chantry added the following "morale": "Vote Butler (and be a friend of Casper!), or Boy! Is this poster dumb!" At fourteen, he already was a gentle ironist whose acidity was directed mostly at himself.

Chantry entered high school in Tacoma that fall. It was, he recalls, "a very important year for me," remembered happily as "the year I discovered friends, psychedelic posters, rock and roll, girls, French symbolist poetry, and existentialism." It was also a year of public trauma that deeply impressed him: "The assassination of Robert F. Kennedy was the end of the world. (In retrospect it is more pivotal than JFK's death, because that was the moment everybody gave up and bought a gun.) Then the unbelievable disaster (to this 14 year old) at the Democratic National Convention. It's the first time I realized there truly was no future."[5]

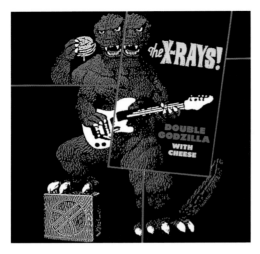

FIG. 20
Client: eMpTy Records, 1996.

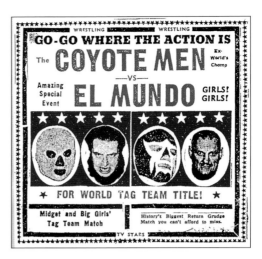

FIG. 21
Client: Estrus Records, 1999.

FIG. 22
Client: In the Red Records, 1995.

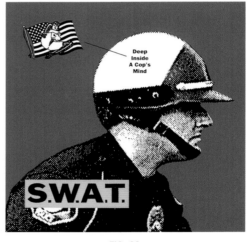

FIG. 23
Client: Amphetamine Reptile Records, 1994.

His extremist attitude was aligned with the zeitgeist. *In Rites of Passage: A Memoir of the Sixties in Seattle,* Walt Crowley, then editor of the city's alternative newspaper, *The Helix,* referred to 1968 as the decade's "defining year": "It embraced the peak of the period's playfulness and the depths of its depravity and violence. If anyone had doubts that a genuine revolution was imminent, the events of early 1968 laid them to rest. If anyone hoped that a revolution could actually succeed, the events of late 1968 crushed their dream beneath the boot of repression."[6]

At this point, Chantry's poverty had harsher implications than physical and emotional discomfort. The Vietnam War was in full throttle, with husbands and college students granted exemption from service and combat soldiers largely pulled from blue-collar neighborhoods like his own. Chantry was familiar with men—friends of his sister's, primarily—who had "come back from 'Nam vegetables." "Because I was poor, I knew that as soon as I graduated I was going to go to the fucking front, and that's all I had to look forward to," he recalls. By April 1, 1969, the U.S. deployment in Southeast Asia had reached its height of 543,400 troops, and American fatalities soon surpassed the 33,629 who had lost their lives in Korea.[7] Only then did President Nixon announce support for a lottery that made all men of draft age eligible for combat. Still, Chantry expected to be shipped out with the rest.

The worldwide student uprisings of 1968 reached Tacoma, where according to Chantry there was noisy unrest, though "the local media seemed to not report it." In nearby Seattle, riots broke out on July 1 in the Central Area over the conviction of three black students who had engaged in a sit-in at Franklin High School protesting the expulsion of another student. As chronicled by Walt Crowley, the Seattle school district rushed to declare Franklin its "first 'magnet school' under a new plan to stimulate voluntary desegregation."[8] Suddenly progressive education became the norm, and Tacoma's Washington High School, the federally funded alternative school Chantry attended, was a product of its times, with liberal teaching approaches clashing with conservative ideas of how students ought to look and behave. Chantry was a member of the school's second graduating class. The first, he says, conducted "a full-blown riot with tear gas" over the school's enforcement of dress codes and refusal to allow students to leave campus at lunchtime: "They would send people home for wearing bell-bottoms. I was sent home for having sideburns below the level of my ear, and for having holes in the knees of my jeans. When I started, people had crew cuts. When I left, they had hair down to their butts. The class valedictorian had only a 3.4 grade average. My last year, my average dropped from 3.6 to 1.4."

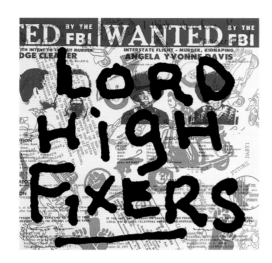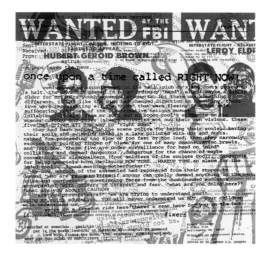

FIGS. 24 & 25
Described by Chantry as a soul/punk/mod band, Lord High Fixers received a design for its first ten-inch
album and CD that combined Black Panther glyphs and wanted posters with faxed communications.
Client: Estrus Records, 1995.

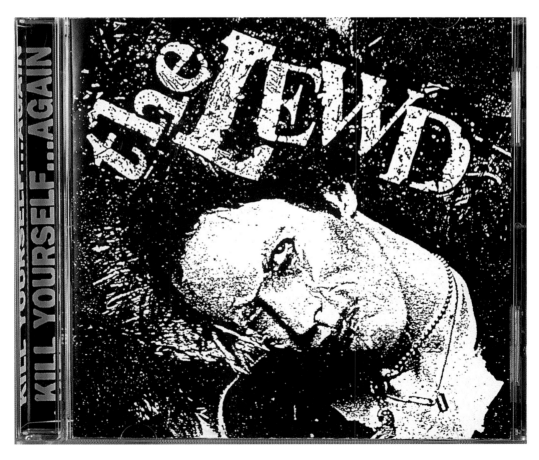

FIG. 26
A monster sensibility was a natural for Chantry's CD reissue design for The Lewd, a late-1970s punk band.
Logo design: Satz. Photographer: Saulias Pempe. Client: Chuckie-Boy Records, 1998.

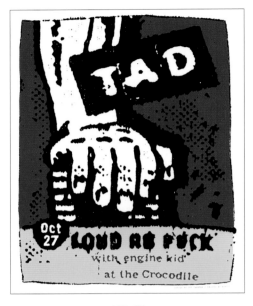

FIG. 27
Comics inspired Chantry's poster for the grunge band TAD.
Client: Crocodile Cafe, 1995.

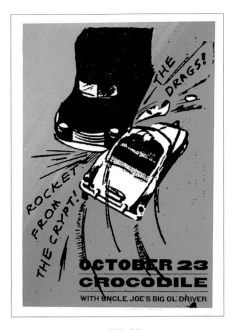

FIG. 28
A psychedelic split fountain of ink highlights
the diagonal composition of this club poster.
Client: Crocodile Cafe, 1995.

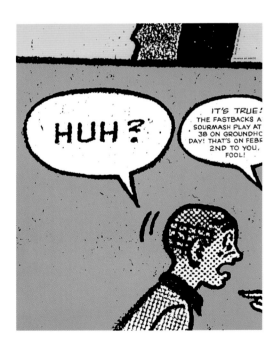

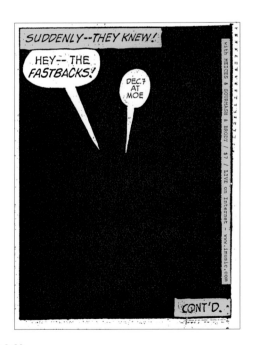

FIGS. 29 & 30
"No, it's not Archie," Chantry says about his comic-book approach to Fastbacks
posters for the clubs 3B Tavern (left) and Moe (right), both 1995.

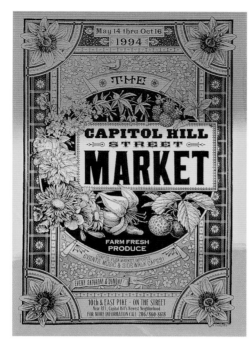

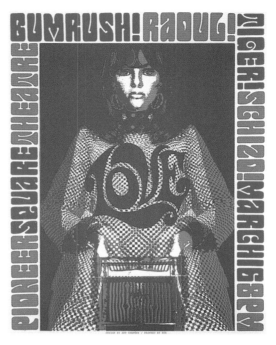

FIG. 31
Psychedelia meets Victoriana in this poster
promoting a street market in Seattle's
fashionable Capitol Hill district, 1995.

FIG. 32
Rock poster design recycled from an unpublished 'zine cover.
Unlike theater and political posters, the best music posters,
Chantry insists, are meaningless.
Client: Tes. Lotta, 1995.

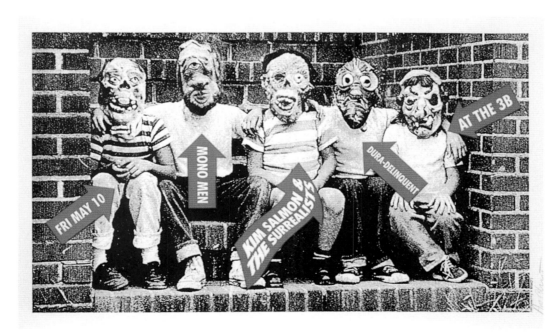

FIG. 33
Chantry chose the gruesome faces on this rock poster to subtly evoke characteristics of each band. He assigned
the "oldest"-looking face, for example, to the Mono Men because of the relatively advanced ages of its members.
Client: 3B Tavern, 1996.

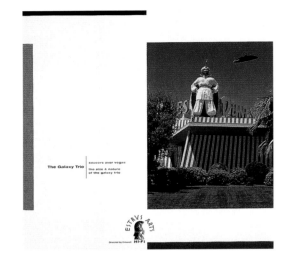

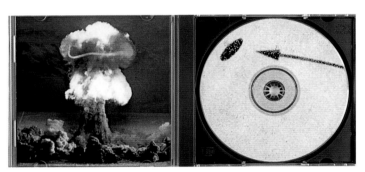

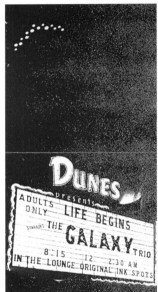

FIGS. 34–37
Ten-inch record (top) and
CD package, including
disk and booklet, for
The Galaxy Trio, a surf band.
Chantry interpreted the
title, *Saucers over Vegas*,
literally. Saucers even surf
in the back cover photo.
Client: Estrus Records, 1994.

Shown right: Galaxy Trio logos.

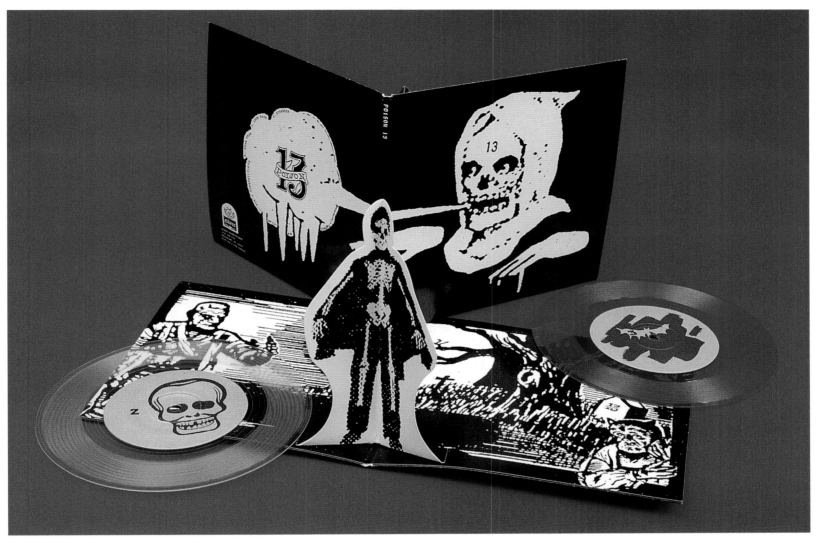

FIG. 38
Double 45 for the band Poison 13 with a pop-up ghoul that glows in the dark.
Client: Estrus Records, 1996.

It was during high school that Chantry received his first professional design commission—to create the logo for a friend's guitar store. The pay was five dollars. "I used psychedelic typography, which was more like the kind of lettering one does on a 'pee chee,' one of those school folders common to the Northwest," he relates.

He also discovered rock music. Tacoma may have contributed to rock's history, but the club scene was dismal, and the local radio stations offered little satisfaction. This was a familiar plight of youth in conservative communities. Years later, Kurt Cobain complained about being starved for exciting sounds in his hometown of Aberdeen, Washington, though Seattle had boasted an indie scene for years. But a dearth of alternatives was especially hard on avant-garde-minded kids in the early seventies, when soft rock dominated the airwaves. Recalls Chantry: "There were a couple of discos in Tacoma, but they were filled with G.I.s, and you didn't want to go in there. Instead my group would cruise around, trying to find something on the radio to listen to. Once in a while a Rolling Stones song would come on and we'd say, 'Thank God,' and then it went back to 'Me and You and a Dog Named Boo.'"

He and his friends fell together because of shared feelings of marginality, he says, hosting parties that, to their discomfort, attracted military personnel, members of the Bandito motorcycle club, and the madam and some of her employees at the local brothel. He recalled a G.I. named Tarzan who was obliging to the point of pathology. "If you ever wanted to rob a bank, you'd just say, 'Go get some money,' and he'd do it," Chantry recalls. "This was my circle. It led to my tolerance for crazy people." Insanity, he adds, forms another basis for subcultures—"people who find commonality with each other because they don't fit in anywhere else."

At eighteen, Chantry pulled eighty-one in the draft lottery, a number low enough to send him to Vietnam. He was scheduled to report for a physical on his nineteenth birthday, April 9, 1973. A month before that date, Nixon called an end to the draft. Having received a small scholarship, Chantry enrolled the next spring in a local religious school, Pacific Lutheran University. He had yet to learn what a graphic designer was.

FIG. 1
Six-foot-tall poster promoting a reissue CD collection of classic punk rock.
It was wheat pasted in major cities all over the world in a single night.
Art director: Coco Shinomiya. Client: Rhino Records, 1994.

The revolution against taste, once begun,

will land us in irreparable chaos.

EDMUND GOSSE

CHANTRY SPENT A MISERABLE YEAR AT Pacific Lutheran University (PLU), which he later described as "a stuffy and lonely place."[1] Like many of his counter-cultural peers, he thought of religion—any religion—as just another overbearing institution that failed to practice the humanistic principles it preached and caused more misery than it assuaged. Across America, distrust of almost any group charged with protecting the public's welfare, from politicians to the police, ran deep in the Vietnam years and soon reached a nadir with the Republican-orchestrated break-in at the Democratic National Committee headquarters at the Watergate Hotel. Chantry, who later described himself as being "so cynical, I'm just about dead,"[2] resented having to attend daily religious services and was disappointed by the theological orientation of even secular studies: "I remember taking a lit class on the short story. They stressed that every story had several levels [of meaning]. On top were the religious connotations, and if you didn't get them, you flunked. I fell in love with the stories of Guy de Maupassant and Sherwood Anderson, and all they could talk about was their religious content."

He accepted a job as a sanitation worker to support himself and was stung by fellow students who ostracized him for picking up garbage. "That's where I really learned oppression, even in a bigger way than being poor. Nobody would talk to me." He makes light of having been a garbage man, claiming still to use some of the things he found for his artwork, but under the humor lurks a complicated relationship with discarded objects. On the one hand, Chantry, like all graphic designers, knows that many of his designs are ephemeral. Flyers die with the end of a concert, ads with the end of a campaign. A gnatlike lifespan can even be a source of pride for him, as when his first punk poster, which he designed in 1978, was deemed so offensive that every copy was ripped off the walls within twenty-four hours (Fig. 2). Suitably, the title for the 1985 book he based on his collection of Seattle punk posters is *Instant Litter* (Figs. 3, 4).

On the other hand, Chantry is a collage artist with a special interest in castoffs. He hunts through junk stores and rummage sales as well as on the street, looking for images to file away for recycling. The goal, he says, is to make his own graphics so compelling that they, too, will be plucked from the rubbish. "I want my stuff to survive so ten years down the line, people pick it up and find it interesting. I don't create art. I create artifacts," he insists. Chantry's garbage cans are therefore hardly mundane, but a purgatory from which detritus is either cast into the flames or elevated to a new purpose, outstripping the old because the objects and images are no longer mere objects or images but charged historical remnants.

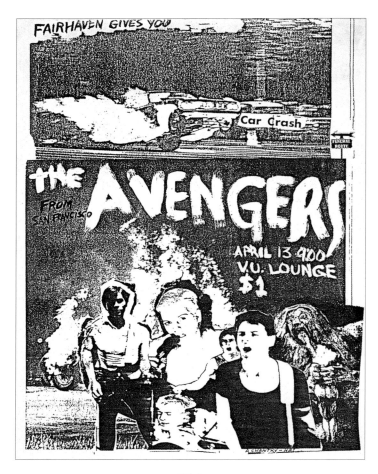

FIG. 2
Chantry was thrilled when his first punk poster, for an Avengers concert, was ripped off the walls of the Western Washington University campus within twenty-four hours of being posted, 1978.

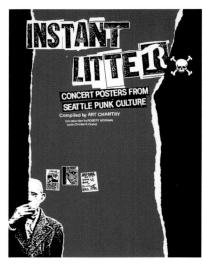

FIGS. 3 & 4
Cover and spread from *Instant Litter,* Chantry's compilation of Seattle punk posters. Designer: Art Chantry. Publisher: The Real Comet Press, Seattle, 1985.

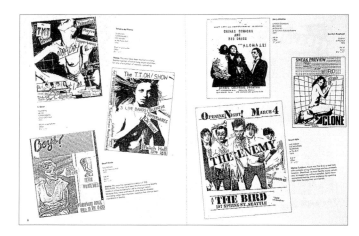

In his year at PLU, Chantry barely encountered the concept of graphic design, much less explored his attraction to seemingly disposable materials. He took his first illustration class with a young instructor, Nancy Ohman, who encouraged his drawing talent. In the school's library, he discovered *Graphis* magazine, the design publication then edited by Walter Herdeg and published in Switzerland. A feature on Polish poster art showed him exactly the kind of work he wanted to do and attached a name to it. "I discovered that I was a graphic designer (at least that's what the magazine called these poster artists)."[3]

In 1974, he transferred to Fort Steilacoom Community College (FSCC), later renamed Pierce Community College, in Tacoma. That year he discovered the British illustrator Ralph Steadman, renderer of maniacally expressive political cartoons radiant with ink blobs hurled from the artist's pen, and he became acquainted with the animation of Terry Gilliam, who earned his first fame as the sole American member of England's Monty Python Flying Circus comedy troupe. Chantry found a more satisfying work-study job interning in the school's graphics department, which was attached to the library. Under the tutelage of the department's director, Rebecca Nolte, he practiced basic layout and typography techniques and learned how to operate a stat camera. This, he says, was his "only real design education."

His first silk-screened poster was for the college's Christmas festival (Fig. 5). Printed one color, its restrained layout fails to hide that he was already taken with degraded imagery (blobby snowflakes), obscure letterforms (with medieval calligraphic flourishes), and cheerleading ad copy ("old-fashioned fun for the entire family"— one can almost can see the ghosts of triple exclamation marks). Chantry still has his preferred version of this poster, in which the text and image spin off their vertical axis, and a few accidental drips of white ink add an "early punk touch" (Fig. 6).

For another silk-screen experiment at FSCC, he designed a self-promotion piece with ink blotches marring his name, like the impressions of thrown rotten tomatoes (Fig. 7). (About the mod lettering style, he recalls, "I thought I was doing Lubalin.") Much later, literal images of rotten tomatoes reappear on a poster he designed for an exhibition of his work. When putting himself in the picture, Chantry sometimes conjures an imagined audience of rowdy hecklers—a more sophisticated version of the coda he wrote on his "Casper the Friendly Gamma-Gobulin" poster. But the gesture is not reducible to adolescent defensiveness. It also relates to his interest in narrative. Telescoping both presentation and critical response, he makes a typically static medium dynamic and multivoiced. Irony and self-criticism are just a couple of his strategies for increasing the depth of the two-dimensional poster. His use of historical references also

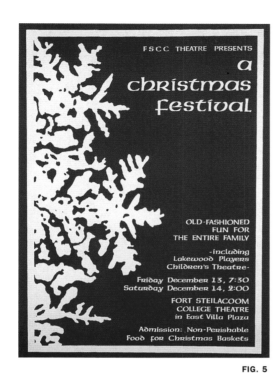

FIG. 5

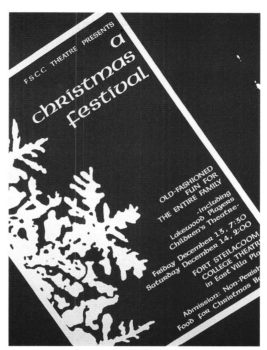

FIG. 6

FIG. 5
Chantry designed his first silk-screen
poster while enrolled at Fort Steilacoom
Community College, 1974.

FIG. 6
A prelude of things to come: Chantry's
proto-punk execution of Fig. 5.

FIG. 7
A self-promotional poster designed
as an exploration of silk screening at
FSCC, 1974. "I thought I was doing
Lubalin," Chantry explains.

FIG. 7

ASWWU film series logo, 1976.

Educational Media
nonprint graphics department, 1977.

Educational Media
"letterman's jacket" logo, 1977.

Owl Productions Theater Co., 1977.

Event typography, 1976.

Student body activities group, 1976.

Logo for a study on plate tectonics, 1978.

Art department newsletter logo, 1978.

FIG. 8
One of Chantry's self-effacing business cards featured
wildly out-of-register color, 1978.

FIG. 9
Chantry first started using a real stamp on his business card
in 1978. He continued the practice for the next twenty years.

adds complexity—a kind of vibrating time that works much the same way as vibrating color, forcing the viewer to jump between past and present, until the juxtaposed states assume a buzzing indeterminacy that confers a peculiar intensity on each.

In 1975, Chantry's interest in graphics led him to transfer to a third school, Western Washington State College (later Western Washington University [WWU]), in Bellingham, which had a visual communication education program, but he was disappointed to find that it emphasized production technology and commercial applications. Meanwhile, the school's art department saw nothing artistic in design whatsoever.

They had a great printmaking department, a terrific collection of litho stones, probably about a hundred of them. Where do you find big litho stones anymore? One day I came in with my freelance work, which was posters. Nobody knew what to make of this. They were obviously prints—created by offset litho plates. But they were commercial. Finally the teacher said this isn't art. I wanted to see what he'd do. I just wanted to see what he'd do.

Both camps failed to teach or acknowledge design history, the fine points of typography, the existence of artist's books, the genius of New York's legendary Push Pin Studios, which helped to innovate pop graphics, or the value of the very Polish posters that woke Chantry up to his love of graphic design. "The result was I couldn't declare a

major because I would be banned from both departments," he says. Instead, he grazed the liberal arts:

I wanted to be an archaeologist. That's still evident in my work. But as time wore on I realized I wouldn't fit in there. I went through a lit major, a philosophy major. Usually it took just one bad instructor to cure me of it. My philosophy instructor was a short guy who was always trying to compete with everybody and who only talked about running with the bulls. Once I answered a philosophy question with a cartoon, a man walking through a swamp. I thought it answered the question perfectly.

He ultimately received his degree in painting, an ambivalent subject. Minimalism prevailed in fine art at the time, but Chantry was inspired by Dada and Surrealism and by neo-Dadaist painters like Robert Rauschenberg and Jasper Johns. He studied the French symbolist Guillaume Apollinaire's figurative poems, the surrealist photographer Man Ray's contrived darkroom accidents, and the Dada collage artist Kurt Schwitters's assemblages. His sensitivity to language, a quality that suited him perfectly to graphic design, with its twinned emphases on words and pictures, found support in decades of canvases where letterforms appeared as both communicative and decorative elements—Picasso and Braque offered prime examples. But when he put words on one of his paintings, an instructor was so incensed that he "took it off the

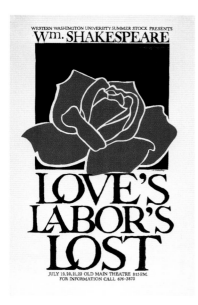

FIG. 10
For this student theater poster,
Chantry found inspiration in the work
of David Lance Goines, 1977.

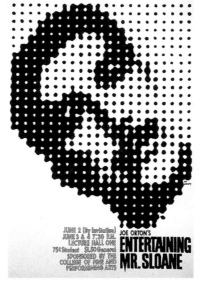

FIG. 11
Poster for campus production of
Entertaining Mr. Sloane, 1976.

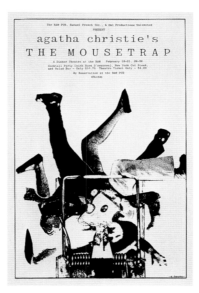

FIG. 12
Chantry glued an actual piece of
cheese to the mechanical in creating
this poster for a campus production of
The Mousetrap, 1977.

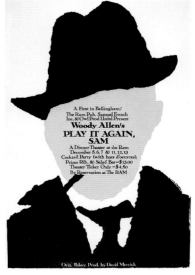

FIG. 13
Theater poster for a production
in Bellingham of
Play It Again, Sam, 1976.

easel during a crit and jumped up and down on it." Chantry got his revenge: "For the next crit I brought it back with the footprints carefully preserved, declaring it finished. I also wired a small bomb in it, and blew the sucker up. It's the first time I ever saw that professor smile."[4]

He did find one important mentor at WWU, a graphic designer in the educational media department named Kent Shoemaker, who arranged for him to join a work-study program. Using Leroy lettering and rudimentary pasteup tools, Chantry produced slide shows for lectures and did grunt work. "Shoemaker didn't teach me much but he was encouraging, especially considering that I was doing pitched battle in classrooms. I found sanctuary working in his place," he says.

Meanwhile, he was building a reputation for freelance posters that promoted campus events. Many of the graphics dating from his WWU days (1975–1978) are clear springboards of design ideas he would carry into later years and show their age mainly because of their seventies lettering styles or typographic rawness. With no access to professional compositors, Chantry executed typography with a typewriter or a Leroy lettering kit or drew or pasted the letterforms himself. He did, however, design a typeface in 1977, which he named Hamlet after its first application on a theater poster, and sold it to the font distributor Chartpak (Fig. 17). Occasionally, he

aped the style of a prominent designer, like David Lance Goines; a 1977 poster for *Love's Labor's Lost* displays a flatly abstracted, heavily contoured rose resembling the work of the San Francisco printmaker (Fig. 10). Chantry occasionally drew his own figurative illustrations, but he also began using the photocopier to "rot" found imagery, heightening black-and-white contrast and eroding fine detail. This resource was cheap, it contributed to the coherence of illustration and inexpensively rendered type, and, most important, it translated the visual language of punk posters, newly arrived on American campuses, to well-behaved college productions of Agatha Christie's *The Mousetrap* (Fig. 12) and Joe Orton's *Entertaining Mr. Sloane* (Fig. 11).

Chantry's affection for punk graphics would seem inevitable given their formal and emotional connections to his own values. Like the music itself, most punk posters erupted from untrained artists, often band members using the cheapest materials possible. "In the developing punk puritanism it was a sign of phoniness if a band had a slick poster, a professionally printed sleeve for its 45, or even new instruments," Seattle music scene chronicler Clark Humphrey recalls. The posters' harsh textures and imagery were meant to shock but also to entice viewers through a language of ink slashes, localized references, and irony. For instance, a 1984 concert poster for the Seattle band The Refuzors includes a drawing of a dead cat to invoke an

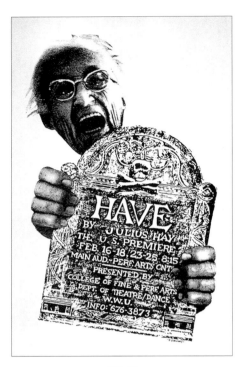

FIG. 14
Theater poster for the play *Have,* staged at Western Washington University, 1977.

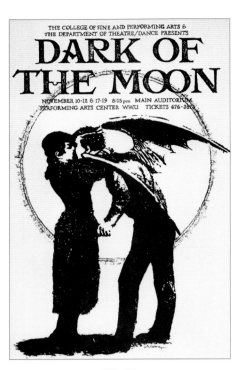

FIG. 15
This theater poster for a Western Washington University production of *Dark of the Moon* features type that Chantry pasted down letter by letter, 1976.

FIG. 16
An example of Chantry's early drafting skills, 1977. The type for this student theater poster was "altered Leroy lettering," 1977.

Play title, 1976.

Play title, 1976.

Play title, 1974.

Play title, 1978.

earlier concert in which one of the members messily swung around the corpse of a cat that had been freshly run over by a car, while the band sang "Splat Goes the Cat." According to Chantry, "The poster alone was reportedly enough to get the show closed down before the fact."[5]

Even at their formal crudest, punk graphics reached their audience with greater precision than the most carefully researched advertising campaign. In this, they supported Chantry's belief that graphic design is more subtle than advertising in connecting with a market: "Advertising is like an A-Bomb, they try to take out as many people as they can with a buck. Television! Ads in *Time* magazine! Big headlines! Blam! But graphic design's more market-specific; you're trying to take out certain people, it's more like being a sniper."[6] Such graphics were frequently the only sources of concert information in a world where promoters were few and venues derelict, and they acted as filters admitting healthy supporters of the music while screening out people who were judged to be too old or prissy to appreciate it. Punk's ageism was smarter and more self-conscious than the hope-I-die-before-I-get-old bravado of an earlier generation of rockers, as is evident from a poster promoting a 1983 concert in Seattle by electric violist John Cale, formerly of the Velvet Underground. Below a childlike stick-figure drawing, the poster's designer, D. Thom Bissett, wrote

this come-on: "You really should go and see Mr. Cale this time—he's been around a long time now and he just might die before he can tour again. Then you would never be able to tell your grandchildren how good he was . . . because you won't know. Wouldn't that be a pity."[7] Cale was forty-one at the time.

Given his experience of feeling sidelined, one can well understand why Chantry joined punk's celebration of the margins and its redefinition of rules about deportment, morality, self-preservation, and success. At home on the outskirts, he embraced a sensibility that, as described by the cultural critic Dick Hebdige, was "essentially dislocated, ironic, and self-aware."[8] Writing in 1980 about the movement, the scholar Simon Frith observed that it "seemed to challenge capitalist control of mass music. There was an emphasis on do-it-yourself, on seizing the technical means of musical production."[9] This autonomy manifested itself at the level not only of distribution, but also of individual performance. Indeed, whether they conveyed their message through such means as the Rimbaud-inspired lyricism of Patti Smith, the transvestite antics of the New York Dolls, the hyper tempos of the Ramones, or the animal-simple nihilism of the Sex Pistols, punk's purveyors on both sides of the Atlantic shared a lot with the hayseeds in an Andy Hardy movie—ready or not, in tune or out, they were determined to put on a show in the barn (or in their case, the Bowery). Tales

ABCDEF abcdefg
GHIJKL hijklmm
MNOPQ opqrstu
RSTUV& vwxyz'-
WXYZ;!? 123456
7890$¢

HAMLET

FIG. 17
Chantry's Hamlet typeface, 1977.

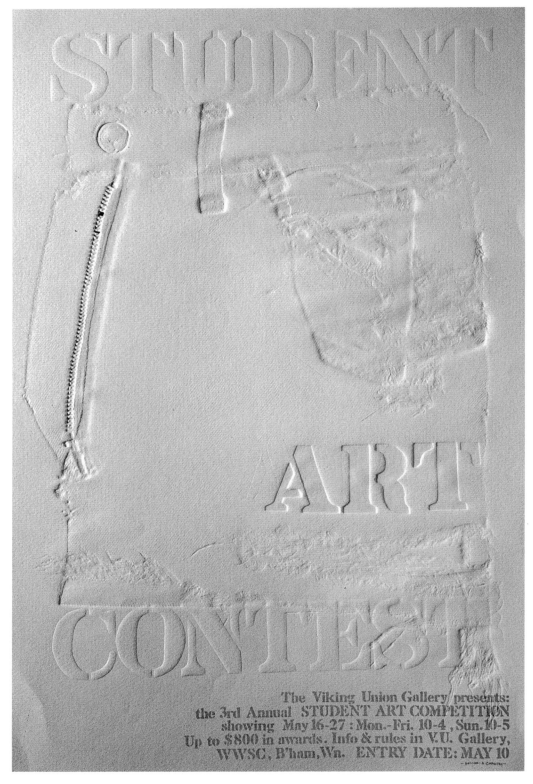

FIG. 18
Poster for an annual student art competition at Western Washington University.
Chantry varnished his favorite pair of cutoffs and embossed them on an etching press, 1977.

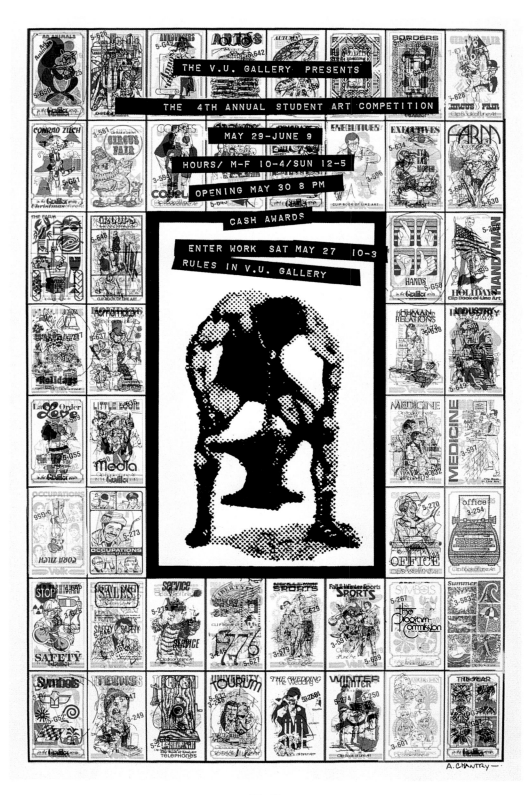

FIG. 19
This student art-show poster features Chantry's first use of type produced by label maker.
Many more examples followed in his career. He borrowed the central image, a man pulling up an anvil with
his teeth, from an old comic books ad. The overlapping background graphics came from clip art he found
in the garbage. Client: Viking Union Gallery, Western Washington University, 1978.

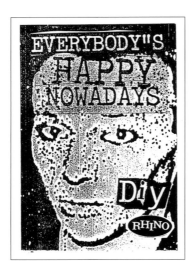

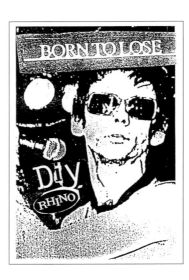

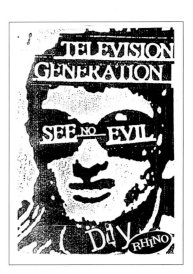

FIGS. 20–34
Above and opposite: Long after punk was dead, Chantry designed an unpublished series of giant street posters
for a Rhino Records reissue (see also Fig. 1).The two images at the top of this page were the front and back covers
for a promotional 'zine, 1994. Art director: Coco Shinomiya.

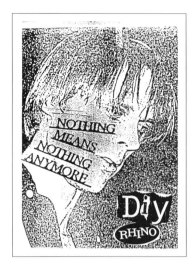

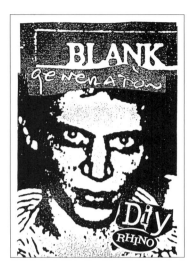

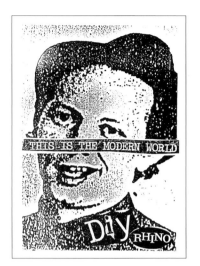

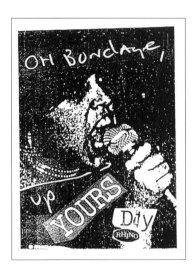

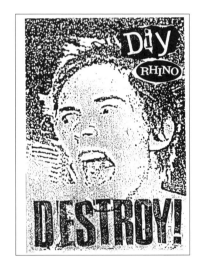

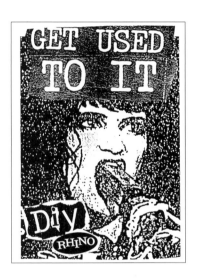

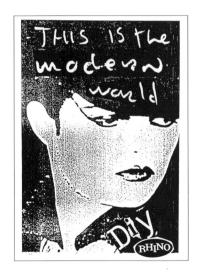

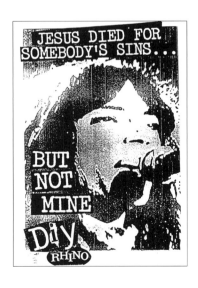

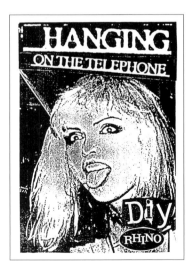

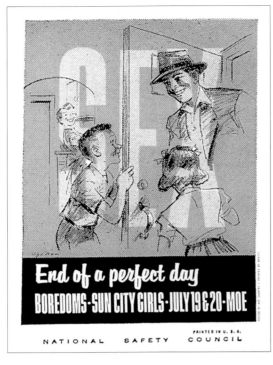

FIG. 35
Found art in a concert poster for Moe, 1995.
Chantry enlarged a postage-stamp-size lead cut of a
National Safety Council poster from the forties or fifties,
seamlessly added the bands' names, and stripped
the word "SEX" into the background.

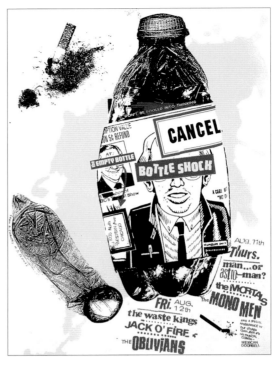

FIG. 36
Poster for 1995 "Bottleshock" concert at Chicago's Empty
Bottle club. Chantry's idea was to represent the club's floor
after the event was over. His "Cancel Soda" bottle parodied
the hip OK Soda, whose labels were designed by the likes
of underground comix artist Dan Clowes.

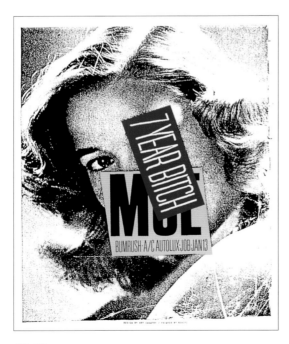

FIG. 37
Concert poster for Moe, 1995. Chantry used a worn piece
of found art and simply covered the holes with type.

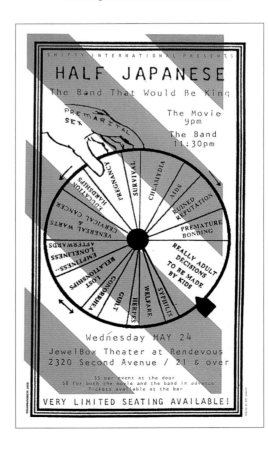

FIG. 38
Chantry adopted a religous tract he found on a sidewalk for this
concert poster for the Jewel Box Theatre at the Rendevous, 1995.

FIGS. 39 & 40
Chantry describes this Screamin' Furys 45 for Estrus as "Reid Miles's style shoved through twenty years of punk rock," 1997.

FIG. 41
45 cover for Treepeople.
Client: CZ Records, 1992.

FIG. 42
CD/LP cover for The Von Zippers a punk/garage band
from Canada. Client: Estrus Records, 1999.

of drug and instrument abuse are legion, but what sticks out from accounts of band members, apart from their appalling mortality rate, is their energy. In *Please Kill Me: The Uncensored Oral History of Punk,* Ed Sanders, formerly a singer/songwriter for The Fugs, recalls the punk aura of invulnerability even as the musicians brought their worlds crashing down on themselves:

Punks reminded me of armadillos: People whose attire was a kind of armor to protect themselves from the tentacles arising from the iridium to get them. It's kind of an Armageddonal-end-of-the-world-I'm-ready-let's-do-it-Gary-Gilmore type of thing. You know, "If it's gonna happen, let's go, I'm ready, puke on me, that's it, I'm okay, I'm wipable."[10]

According to Robert Newman, who wrote the introduction to *Instant Litter,* Chantry's compilation of Seattle punk posters from the late seventies and early eighties, the local punk scene "lacked some of the ferocity" of its counterparts in San Francisco and Los Angeles, not to mention New York and London. But "it was still threatening as hell to the laid-back Northwest ethos of the time," and the graphics representing it were a unique "urban folk art, a sort of printed graffiti with a dark, sinister edge."

As a result, band posters were a bright and brilliant spot of creativity standing in stark contrast to the rather bland, tame corporate efforts of more "acceptable" poster makers working for mainstream theaters and art groups. There was a brief period when the best graphic design in Seattle was on telephone poles and wooden walls, when the scratchy black-and-white posters for unknown punk bands were more effective than the slickest four-color glossy window posters.[11]

This was the streetscape Chantry found in 1978, when, upon graduating from Western Washington University, he moved to Seattle. After six years, three schools, and a series of false starts, he had developed a metier that not only satisfied him but also made him famous on campus. Now he was planning to relocate with his college girlfriend to the cultural center of the Northwest at a time when an underground movement he admired was coming into its own. He had every reason to feel confident. And though confidence was not an accustomed state for him, he did.

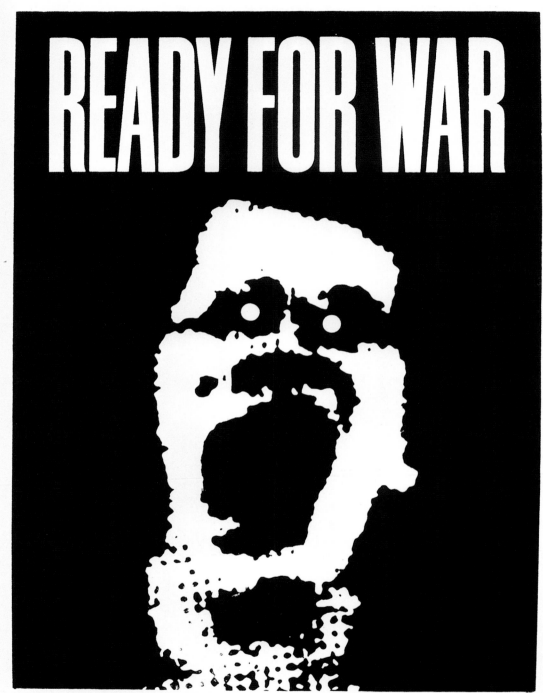

FIG. 1
The ghastly visage on Chantry's "Ready for War" poster may be the closest thing to a "happy face" he's ever done.
Client: Alonzo Critini Salon Politique, 1982.

The loud and provocative attitude of a poster and its violent nature
are so exaggerated that they transcend the limits of bad taste,
and actually give it a certain style.
Moreover, there is something even worse than bad taste,
and that is good taste.

RAYMOND SAVIGNAC

AS ART CHANTRY TELLS IT, IF HE HADN'T had a girlfriend with a good job as a flight attendant, he would have starved to death those first years in Seattle. While punk stirred the soul of the underground, most of the city clung to conservative values, befitting a metropolis whose biggest employer was the aeronautics giant Boeing. The graphics that had made Chantry popular in Bellingham struck potential clients as odd and "student." Punk posters may have been invading the streets, but so was the work of a local calligrapher, Tim Girvin, whose refined lettering and designs won a large client following and inspired many young artists, Chantry among them.

Chantry admired underground culture, but he didn't try to join it. Ironically, he discovered that the punks distrusted him almost as much as the corporate world did. "I didn't look right, I was too old," he says. He felt as if he had fallen into a generational crack; he was a few years shy of being a hippie who could have slipped into a jolly band of nonconformists, yet a few years and many credits ahead of the pierced and tattered punks, few of whom had finished high school. While he found an outlet for his graphics on their club walls and record covers, he spent his early Seattle years testing different situations, looking for a way to live decently and to work with as few artistic constraints as he could manage. Finding a creative home, or several, became a mission that would occupy him for years. In professional terms, he entered a vagabond phase in which he hopped between cultural and corporate graphics, making, breaking, and reforming relationships with clients.

One of the best of these clients turned out to be in the academic world. John Kohl of the Associated Students of the University of Washington (ASUW) hired him to design posters promoting campus lectures, concerts, and a film series (Figs. 2–5). Until then, such promotions had mainly consisted of photocopies tacked to bulletin boards. Chantry not only offered far more sophisticated designs, but he also drastically improved the production quality. He learned that to protect jobs and placate unions, the state university printer had to match any fee quoted from outside, so he obtained absurdly low bids from printer friends, which allowed him to specify four-color work at one-color prices. He also had access to a professional compositor; his first type specification exercise was for a 1979 movie calendar featuring Katharine Hepburn (Fig. 2). Still, despite this margin of professionalism, the spray-painted look of the poster's display type was in fact achieved with a spray can. The wily thriftiness that came to be a trademark of Chantry's work also was evident in lecture series posters designed to be divided into eight-and-a-half-by-eleven-inch flyers and in concert posters made from photocopies, press type, and rubber stamping.

A streak of wiliness ran through his aesthetic decisions as well. He learned to make

FIG. 2

FIG. 3

FIG. 4

FIG. 5

FIGS. 2–5
Film series posters for the Associated Students
of the University of Washington (ASUW), 1979–1980.

FIG. 6
Tina Turner concert poster for ASUW, 1981.

FIG. 7
This Romeo Void concert poster for ASUW
remains one of Chantry's favorites, 1982.

the film series posters tall and narrow so that they fit better on telephone poles, where campus announcements were commonly hung. He lifted the repeated image of a screaming man off a film strip from Sergei Eisenstein's *Battleship Potemkin* and attached buttons with campy movie portraits to the figure's lapels (Fig. 3). He tested his client's tolerance for irreverence with a photograph of a bedraggled Marilyn Monroe alongside copy that announced, "Marilyn Monroe took pills to wake up, took pills to go to sleep." When the client rejected that headline, he returned with, "Marilyn Monroe died young, stayed pretty." Finally they agreed on "Dedicated to Marilyn Monroe, who had her ups and downs" (Fig. 5).

Chantry says film series attendance rose 600 percent in a single quarter. Then the success was turned on its head. Owners of local theater chains, who couldn't compete with the university's $1.50 ticket prices, persuaded the state legislature to pass a law demanding its approval of the film series selections. "And of course they nixed anything that looked like it might make any money," Chantry explains, "or they held on to the list until the season was half over so the school would have to cancel show after show because they hadn't gotten the okay." The next year, he says, the series lost $10,000. The third year, it went out of business.

While he was working for the university, Chantry had the first of two unhappy experiences as an in-house freelancer for local designers, a situation he describes as

"indentured servitude" because the high rents and meager salaries guaranteed that he would always be in debt to his employers. In the first case, he says, he was let go so that his boss could afford to hire a tractor to pull a tree stump out of his property.

Chantry's girlfriend—he prefers to give only the name Susan—had moved to London for an airline job. He decided to follow her. Arriving in England on New Year's Day in 1980, he naively told immigration officials of his intention to practice graphic design, not realizing that the UK has strict rules forbidding foreigners from working. While debating whether to deport him, immigration held him at the airport for thirty-six hours without letting him use a phone. "All I did was sit there and cry for two days. I'm still terrified of the accents," he says. Finally, they gave him a three-month visa. He spent those months soaking up the remnants of London punk culture, looking at art, and visiting Stonehenge. When his visa was up, he returned to Seattle alone, with $50 in his pocket. He moved briefly into his mother's house in Tacoma and then his father's in Seattle, then found a cheap apartment. When Susan returned in late summer, they were married.

The next two years brought both hopeful opportunities and soul-killing frustration. Chantry continued working for ASUW and freelanced for another Seattle designer, who had been assigned the graphic standards manual for Bahamasair (Figs. 19, 20), which he

FIGS. 8 & 9
Front and back covers of *Fire & Ice*
by The Sonics, an early Northwest rock band.
Photographer: Jini Dellaccio.
Client: First American Records, 1980.

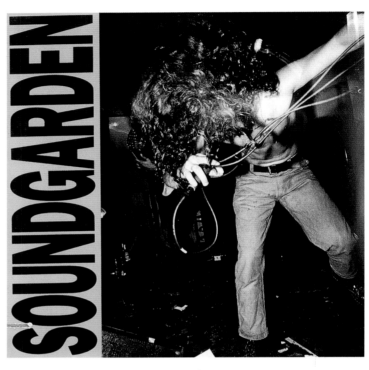

FIG. 10
LP/CD cover for Soundgarden's first major-label release.
Chantry's design refers back to his 1980 Sonics cover (Fig. 8),
linking two Northwest bands that acquired national fame.
Photographer: Charles Peterson. Client: A&M Records, 1989.

FIG. 11
George Golla's *Quiet Moods* was Chantry's first work
to win a design award from *Communication Arts* magazine.
Photographer: Tom Collicott. Client: Music Is Medicine, 1981.

FIG. 12
Misunderstood LP for the
rock/pop group Hi-Fi.
Client: S.P.&S. Records, 1981.

FIG. 13
LP for bluesman Johnny Shines.
Client: Stoney Plain Records, 1981.

FIG. 14
LP for jazzman Lee Morgan.
Client: Piccadilly Records, 1980.

FIG. 15
LP for country singer Mickey Gilley.
Client: Piccadilly Reocrds, 1981.

Record company logo, 1980.

Logo for Seattle's first punk club, 1978.

Record company logo, 1980.

Record cover typography.
Client: Piccadilly Records, 1981.

Record cover typography.
Client: Etiquette Records, 1983.

Record cover typography.
Client: Piccadilly Records, 1981.

Record company logo, 1980.

Logo for rock/pop band, 1981.

Identity for singer, 1981.

later sold to Boeing. "I had to pay him $225 a month for a space I shared with a stat camera, and I had to do all this production work for him—production meant designing as well. And then I had to do it ten times before he was satisfied. I billed him $600, and he thought that was too much and paid me $300 at $75-a-month increments. But I had to pay him rent, plus supplies." Chantry moved into another space in the building, the Maritime, with a designer who turned out to be better at acquiring important commissions than at completing them. Several times, as deadlines approached, she asked him to bail her out by designing a logo for which she would pay him $100, a small fraction of what she earned from the projects, he believes. Chantry left to share a loft with several designers, one of whom charged her male colleagues with creating a sexist environment and took revenge by trying to turn in a member of the group to the IRS for tax evasion. At that point, Chantry went out on his own.

Cultural assignments were often no more lucrative or honorable than his indentured corporate work, but they were more satisfying. For the cover of a 1981 "cocktail jazz" collection, he stretched steel guitar strings across the front and back and attached the name "Quiet Moods" (Fig. 11). It was the first project that allowed him to art direct a photography shoot and the first that won him a design award, from *Communication Arts* magazine. For an early northwest punk/pop band called Hi-Fi, he designed a 1980 album

cover that mimicked a stereo test record (Fig. 12). Unfortunately, the parody was too good to be detectable, especially in a pre-postmodern era. The record was racked in sound effects bins in record stores and sold poorly.

He also hooked up with a record company that had several labels. In a ruse worthy of the Mel Brooks film *The Producers,* the company, he says, put out music that was meant to sell—slowly. While records languished in bargain bins, the company deducted the inventory and wrote it off as a loss, paying no taxes on records that ultimately moved. The scheme collapsed, Chantry recalls. "IRS. FBI. People went to jail. They were putting out more records than any other label in America except Columbia—out of a one-room office! When the dust settled, $96 million had vanished."

Though Chantry found most of the music he worked with boring or inept, he occasionally designed a record he enjoyed, such as blues by Johnny Shines (a good candidate for his crumbling-press-type collection) and the work of 1950s–1960s Northwest rock bands like the Sonics. For the 1980 rerelease of the Sonics' *Fire & Ice* album, he ran the group's name in big sans serif letters down the left side of the album, next to their photo (Figs. 8, 9). Nine years later, he repeated the format for the first major-label release of Soundgarden, one of the few Northwest bands after the Sonics to achieve national fame (Fig. 10). ("Not an accident," Chantry says of the mimickry.)

Company logo, 1979.

Restaurant logo, 1979.

Oktoberfest logo, 1984.

Restaurant logo, 1983.
Codesigner: Scott Herren.

Real estate development logo,
1983.

Play title, 1979.

Video game controls logo.
Client: Questar, 1982.

Lecture event title.
Client: Seattle Design Association, 1983.

Emerald City logo.
Client: Seattle Chamber of Commerce, 1982.

Music festival logo, 1983.

Video game product logo.
Client: Questar, 1982.

Biotech firm logo.
Client: Karen Holum, 1982.

The back cover of *Fire & Ice,* featuring the band with period hairstyles (longer than a crew cut, shorter than a Beatles coif), was appropriated by Sonic Youth for a twelve-inch single (Fig. 9). "I wonder if they knew it wasn't vintage," Chantry broods.

In 1981 Chantry began a long relationship with Seattle theater, one of the city's most active cultural sectors, which then as now comprised many small, experimental companies. His first client in this arena was the impoverished Bathhouse Theatre, which commissioned a poster for *The Adding Machine,* about a milquetoast accountant who is replaced by technology (Fig. 21). The Bathhouse offered $50 for both production expenses and fee, but Chantry still managed to make a profit (he picked up the artwork from a vintage mouthwash ad and gave the printer a credit and a bottle of bourbon in exchange for his services). His collage of a vaguely antiquated businessman gagged by computational machinery has a grotesque wit and elegance reminiscent of John Heartfield's Weimar work and was startling enough in early 1980s America to win seven design awards. The upside-down *N*'s in the title were Chantry's tribute to Tibor Kalman, founder of the New York design studio M&Co., who famously inverted the *A*'s in *Talking Heads* for the cover of the band's 1980 album, *Remain in Light.*

For his next Bathhouse poster, *The Strange Case of Dr. Jekyll and Mr. Hyde* (1981), Chantry began fixating on the eyes of collaged subjects, a motif he returned to many times (Fig. 22). Here he ripped away Jekyll's urbane facade (represented by a vintage etching of John Quincy Adams) to reveal the demonic Hyde (a pair of eyes appropriated from a photo of the horror movie actor Christopher Lee). Like every newsstand operator, Chantry knows that eyes are where viewer and photographed subject connect most intimately, the meeting place of flesh-and-blood and ink-and-paper. But as he has also shown throughout his career, a disrupted gaze can make the image even more compelling. For instance, a poster he designed for a 1982 Bathhouse production of *Macbeth* set in the Old West of the cattle barons spreads a bloodstain over a vintage photo of a dapper man with a mustache (Fig. 23). The stain obliterates one eye and seems to creep toward the other, blinding the frozen figure. This trick of imparting more movement to the stain than to the man captures the essence of tragedy: the way fate is inexorably fulfilled regardless of any action taken to alter its course. Of this poster's framing device, Chantry notes that it gave the Bathhouse an identity and allowed him a big image area, but after five or six years he became exhausted with the technique and "drifted away to other things."

His proudest accomplishment in 1982 was an image that he still believes came closest to being his "happy face," that is, an icon so compelling and cross-culturally relevant that it transcends its origins. He has been quoted as saying, "My ultimate

FIG. 16
Sales enhancement campaign. Cover photographer: Tom Collicott. Client: Safeco Insurance, 1984.

FIGS. 17 & 18
Capabilities brochure for an architecture firm. Client: Mithun Partners, 1985.

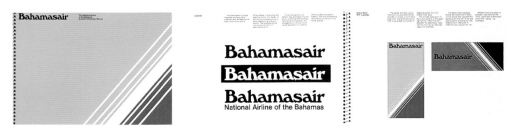

FIGS. 19 & 20
Graphic standards manual for Bahamasair. Client: TMA, 1981.

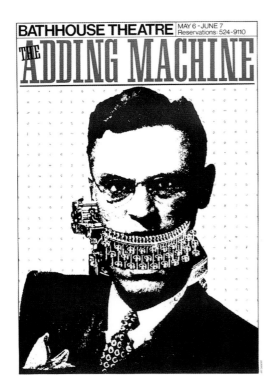

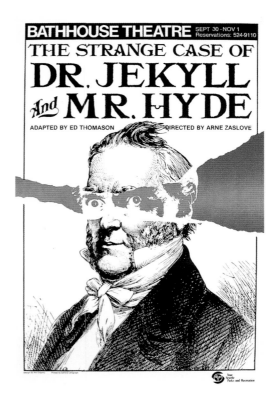

FIGS. 21 & 22
Chantry's designs for Seattle's Bathhouse Theatre evolved over four distinct phases. In the first (1981–1984) he practiced straightforward collage in posters for *The Adding Machine*, *Dr. Jekyll and Mr. Hyde*, *Macbeth* (Fig. 23) and *Eleanor Marx* (Fig. 24).

Bathhouse Theatre logo, 1982. Bathhouse play title, 1982. Bathhouse play title, 1992.

goal is to produce something that takes on a life of its own and leaves me behind. . . . The happy face is a good example, because nobody really knows who did it. About a dozen people claimed credit for it, but it seems to be our culture that designed it."[1] (The face's origins were recently credited to Harvey Ball, of Worcester, Massachusetts, who reportedly designed the glyph in 1963. Its first appearance has been traced back to a radio station in upstate New York that used it above the station's call letters. Another version was designed later in the sixties by George Tanagi, an art director in the agency of Seattle ad man David Stern.)

Chantry's equivalent of the happy face isn't happy at all, but a barely legible screaming head with two perfect white circles for eyes (Fig. 1). Positioned under the headline "Ready for War," the image appeared first on a poster for an art show by the Alonzo Critini Salon Politique, a group of artists who "got together in a basement to talk about politics in the early Reagan years," Chantry explains.

It was a scary period of time, and these people were frustrated and wanted to find some way of venting their frustrations and it kind of emerged into a fake anarchist named Alonzo Critini. They did a kind of salon show at a gallery where all these artists contributed antiwar, anti-Reagan images. "Ready for War" was something that John Cale on his Mercenaries *LP kept repeating over and over again, and it kind of scared me. I was*

mulling over how anyone really prepares for modern warfare anymore, with instant annihilation. So I worked on this ghastly figure. And what really made it were those fucking dots. It was the most horrifying thing on a wall.

Chantry saw the image spread around town—and farther. He found it on street posters that had been silk-screened with different headlines and copy. In the early nineties, it was used in a newspaper ad for a film about space vampires. "There was this space debris and these shadows, and the shadows roughly turned into this horrible screaming face, and it was mine." In addition to staring or blinded eyes—or sometimes combined with them—heads with gaping mouths became another visual motif. Like the Norwegian expressionist painter Edvard Munch, creator of the most celebrated screaming head in history, Chantry confronted his viewers with agony made more poignant and disturbing because the screaming men are mute; unable to express the source of their pain, they soak the very world in misery. Looking at this work in light of Chantry's struggles to make a living (he earned all of $2,000 in 1981), one also senses the designer's acute frustrations. Among its other meanings, "Ready for War" may have described Chantry's own preparations for battle and his noisy but still underheeded bid for attention in the competitive world of freelance design. After all, the face on the poster, which he adapted from a tiny reproduction of an opera singer, looks a bit like his own.

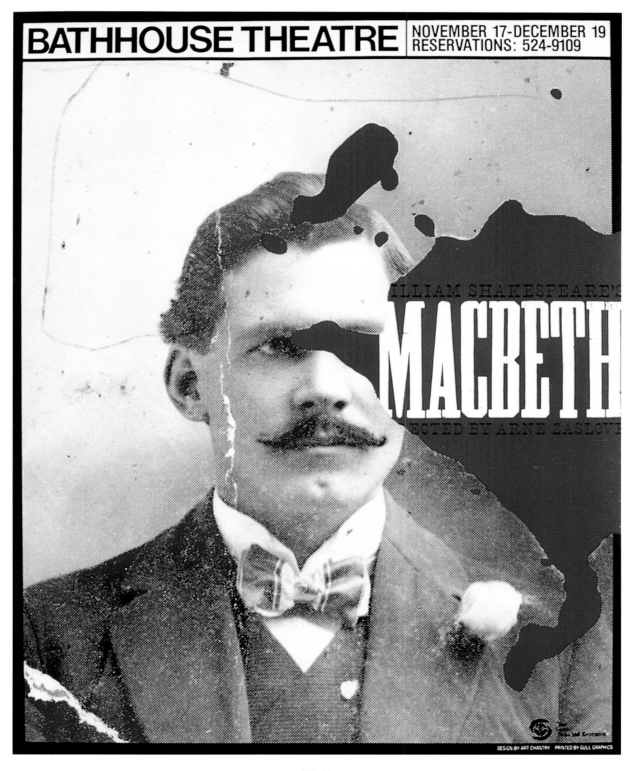

FIG. 23
For a Bathhouse Theater production of *Macbeth*, set in the Old West, Chantry continued his
practice of disrupting the subject's gaze—this time with blood, 1982.

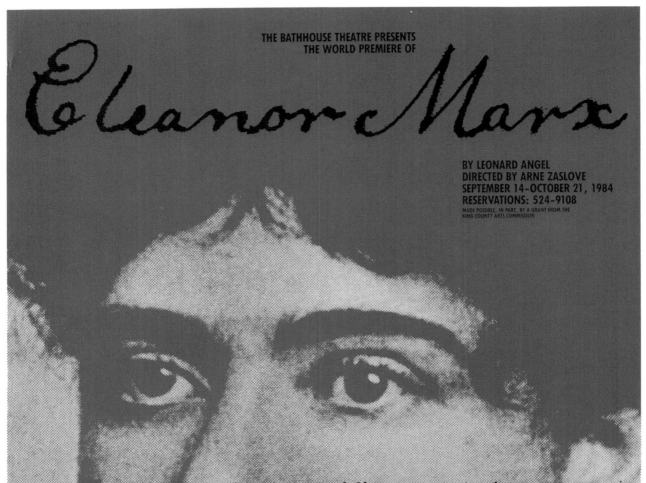

THE BATHHOUSE THEATRE PRESENTS
THE WORLD PREMIERE OF

Eleanor Marx

BY LEONARD ANGEL
DIRECTED BY ARNE ZASLOVE
SEPTEMBER 14–OCTOBER 21, 1984
RESERVATIONS: 524-9108
MADE POSSIBLE, IN PART, BY A GRANT FROM THE
KING COUNTY ARTS COMMISSION

(a speech) We are told that socialists want to have women in common. Such an idea is possible only in a state of society that looks upon woman as a commodity. Today, alas woman is only that. She has only too often to sell her womanhood for bread. But to the socialist a woman is a human being, and can no more be 'held' in common than a socialistic society could recognize slavery. And these virtuous men who speak of our wanting to hold women in common, who are they? The very men who debauch your wives and sisters and daughters. Have you reflected, you workingmen, that the very wealth you create is used to debauch your own sisters and daughters, even your little children? That is to me the most terrible of all the miseries of our modern society; that poor men should create the very wealth that is used by the man of 'family and order' to ruin the women of your class. We socialists, want common property in all means of production and distribution, and as woman is not a machine, but a human being, she cannot be held by anyone as a piece of property. (More thunderous applause.)

FIG. 24
For the Bathhouse's production of *Eleanor Marx*, Chantry dispensed with the theater logo
he had designed and burned the bottom edge of the posters with a blowtorch, 1984.

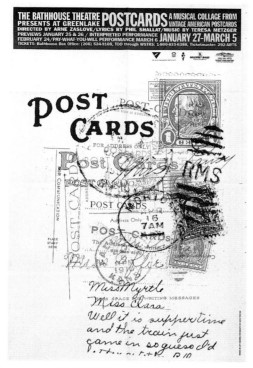

FIG. 25

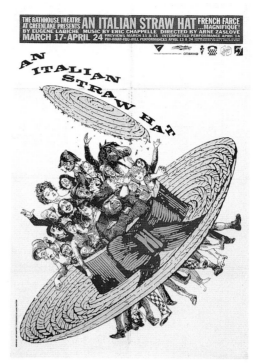

FIG. 26

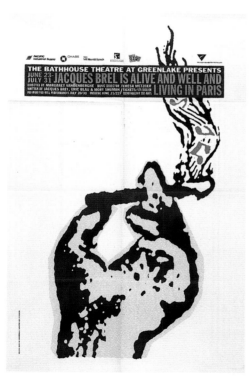

FIG. 27

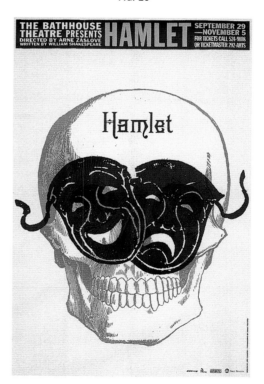

FIG. 28

In 1994, a decade after his first Bathhouse poster series, Chantry introduced a new look on newsprint,
with typography (designed by Hank Trotter) contained in a bar at the top.

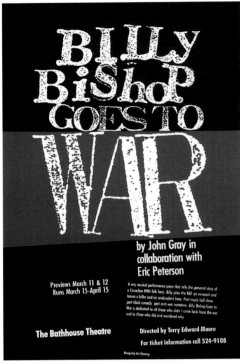

FIG. 29

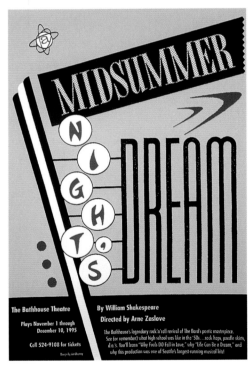

FIG. 30

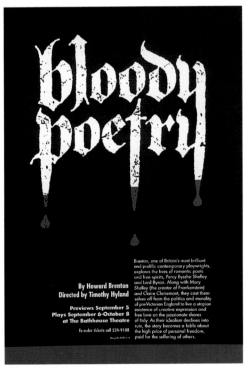

FIG. 31

FIG. 32

For his 1995 Bathhouse series, Chantry used type as the sole graphic device expressing each play's theme and limited his palette to black and white with a spot color of red (Figs. 29–31). He broke with this style when he created the poster for a production of *A Midsummer Night's Dream* set in the 1950s (Fig. 32).

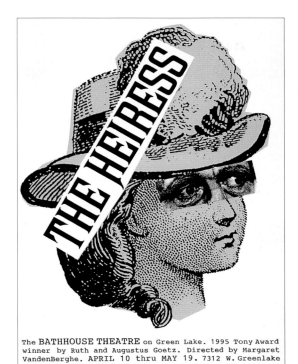

FIG. 33

The BATHHOUSE THEATRE on Green Lake. 1995 Tony Award winner by Ruth and Augustus Goetz. Directed by Margaret VandenBerghe. APRIL 10 thru MAY 19. 7312 W. Greenlake Drive N. Ticket Office: 524-9108. Ticketmaster: 292-ARTS

FIG. 34

Starring Susan & Clayton Corzatte. At The BATHHOUSE THEATRE NOV. 9 thru DEC. 22. Written by D.L.Coburn. Directed by Margaret VandenBerghe. 7312 W. Greenlake Dr. N. Ticket Office: 514-9108 or call Ticketmaster: 292-ARTS. Web:www.SeattleSquare.com/BATHHOUSE

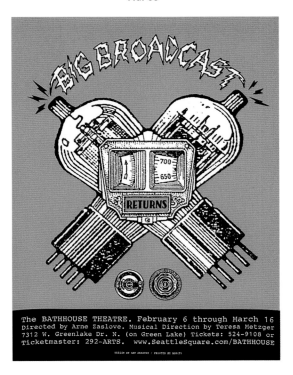

FIG. 35

The BATHHOUSE THEATRE. February 6 through March 16 directed by Arne Zaslove. Musical Direction by Teresa Metzger 7312 W. Greenlake Dr. N. (on Green Lake) Tickets: 524-9108 or Ticketmaster: 292-ARTS. www.SeattleSquare.com/BATHHOUSE

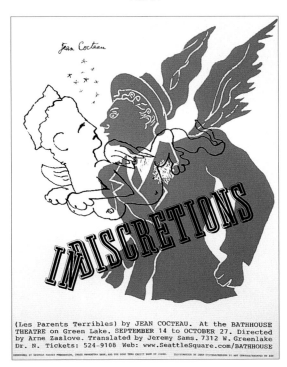

FIG. 36

(Les Parents Terribles) by JEAN COCTEAU. At the BATHHOUSE THEATRE on Green Lake. SEPTEMBER 14 to OCTOBER 27. Directed by Arne Zaslove. Translated by Jeremy Sams. 7312 W. Greenlake Dr. N. Tickets: 524-9108 Web: www.SeattleSquare.com/BATHHOUSE

The introduction of retro turquoise inspired Chantry's format for the Bathhouse's 1996–1997 season. These posters alternate between white and tinted backgrounds and feature images that draw conceptual power from a restrained use of imagery.

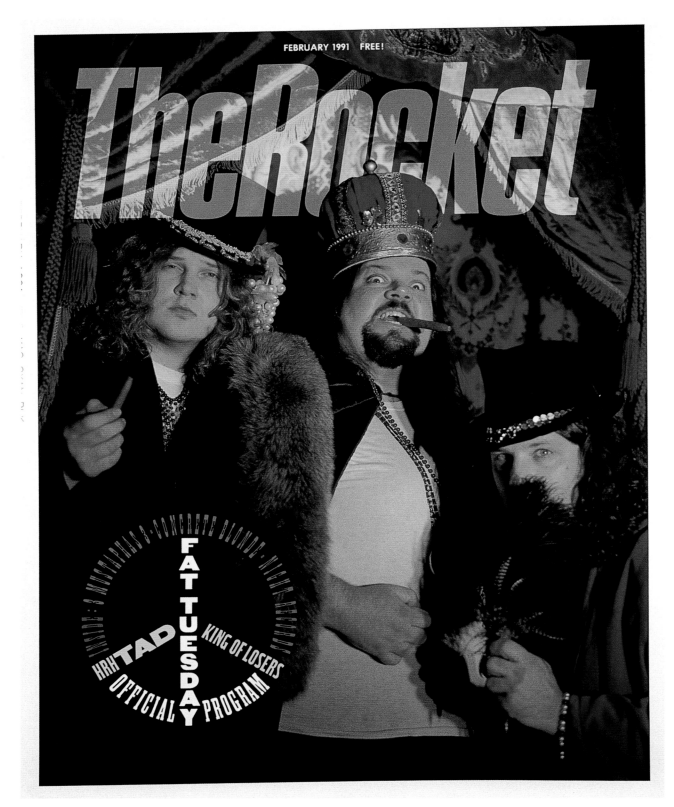

FIG. 1
TAD cover of *The Rocket*, February, 1992, featuring a peace sign in mild protest of the Gulf War.
Photographer: Karen Moskowitz.

In the corner, Red Dress, a local rock band, would be practicing,

and if it was raining, the roof would be leaking,

and you'd have to move the desks around.

I remember once the roof leaked so bad that it destroyed our entire photo library.

And if the lightbulbs burned out, you'd have to look around and try to steal another lightbulb.

I mean, it was desperate.

They were putting that thing out on a budget of nothing.

But it was the only place for these guys to do the things they did.

ART CHANTRY ON *THE ROCKET*

IN OCTOBER 1979, the *Seattle Sun,* one of the city's two alternative weekly papers, launched a monthly sixteen-page advertising insert devoted to "music and amusements." Less than a year later, a few staff members bought out the section and spun it into a monthly tabloid called *The Rocket,* covering local music and lifestyle. The offices, on then-unfashionable Capitol Hill, and later on Second Avenue, were a dump. The staff, recent graduates of the University of Washington and Evergreen State College near Olympia, engaged in interoffice love affairs and feuds, soaked up local nightlife, and barely made enough money to keep the publication running from month to month.

Twenty years later, *The Rocket* is still around, though the feat seems less improbable when one considers the subsequent accomplishments of its founders and contributors. Original editor Robert Ferrigno went on to write *The Horse Latitudes* and other popular novels. His successor, Robert Newman, is currently creative director of *Vibe* magazine, a position he also held at *Details, New York,* and *Entertainment Weekly.* Grant Alden, managing editor in the early nineties, started the alternative country rock magazine *No Depression* in Nashville.

Among *The Rocket*'s regular contributors were Lynda Barry, best known for her syndicated cartoon "Ernie Pook's Corner"; Gary Panter, an artist who designed the sets of *Pee-wee's Playhouse;* Charles Burns, a celebrated illustrator; and Raymond Pettibon, whose artworks have been exhibited in New York's Whitney Biennial as well as on the covers of Sonic Youth CDs. Writers included Matt Groening, later the creator of *The Simpsons;* Bruce Pavitt, cofounder of the independent music label Sub Pop; Ann Powers, a *New York Times* rock critic; John Kiester, now host of a local televison comedy show, *Almost Live;* Jim Emerson, a Hollywood screenwriter whose credits include the movie *It's Pat;* and Karrie Jacobs, one of the paper's original editors, who went on to work for *Metropolis, Colors,* and *New York* magazines and now edits the San Francisco–based design magazine *Dwell.* In various years, the art staff included graphic designers Mark Michaelson, Helene Silverman, Wes Anderson, Jeff Christensen, Jeff Kleinsmith, Dale Yarger, and Jesse Reyes, who shaped the looks of *Newsweek, Metropolis, The Village Voice, Quest, The Stranger, Guitar World,* Sub Pop records, comics published by the Seattle-based Fantagraphics, and books produced by Penguin USA. Original photos were supplied by Charles Peterson, famous for his shots of Seattle's grunge bands, and by nationally celebrated photographers Karen Moskowitz, Rex Rystedt, and Kevin Westenberg. In fact, *The Rocket* was an astonishing magnet for originality, a place where restless talents congregated. According to Art Chantry, who was involved with the magazine for a decade, the Pacific Northwest of the late 1970s offered them no other place to go.

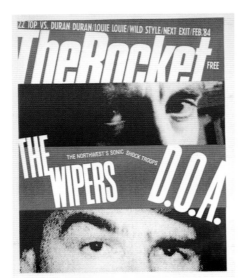

FIG. 2
Chantry's first *Rocket* cover,
February 1984.
Photographers: Rex Rystedt,
Cam Garrett.

FIG. 3
Chantry's second *Rocket* cover
featured a beatific-looking Kenny
G., a local musician not likely to
endear the monthly to Seattle's
underground, March 1984.
Photographer: Tom Collicott.

FIG. 4
For the April 1984 *Rocket,*
Chantry took a below-the-belt
swipe at David Lee Roth of
Van Halen. "He and Eddie Van
Halen were going to give us an
exclusive interview, but at the
last minute they blew us off,
so we got even," he explains.

FIG. 5
Rocket cover from September
1984, in which Chantry dropped
the logo, purportedly to mask
the acne scars of blues
musician Robert Cray.
Photographer: Rex Rystedt.

Chantry first began designing pages for *The Rocket* as a freelancer in 1983. In 1984, he became art director, holding that position on and off over the next decade and designing seventy-five covers as well as editorial layouts, promotional materials, and stationery. He recalls that, up to the early nineties, the entire art budget was $500 a month, covering photography, illustrations, and his salary. "We had our own in-house typesetting; the editor edited and typeset the copy simultaneously. The writers wrote for about ten bucks an article." For all its loony disorganization and lack of means, however, *The Rocket* offered Chantry a laboratory for experimenting with low-cost, quick-turnaround graphic techniques. It furthermore gave him a place and connections deep in Seattle's music world and relief from more mundane commercial projects that paid the bills. Though this work represented only a fraction of his design output over that decade, and though he left and returned three more times, *The Rocket* was home, or at least Chantry's version of home, a place that both tugged at and repelled him and yet whose very elasticity was a form of comfort. It is no coincidence that his graphics took a leap in originality and ingenuity when he assumed a full-time position there.

Chantry's *Rocket* layouts set the tone not only for his other assignments but also for a kind of rugged West Coast aesthetic. Certainly *The Rocket* was catching the eye of some of the most influential designers in the region. Chantry recalls receiving admiring letters from David Carson in the late eighties, who was then creating his own tour de force out of an advertising supplement, the iconoclastic southern California–based music-and-surfing magazine *Beach Culture.* Rudy VanderLans, editor of the avant-garde graphics journal *Emigre,* out of northern California, was also taking notice. Interviewed for a 1998 article in the art publication *LIMN,* VanderLans described *Emigre* as "part of a very exciting time in design some five years ago when new ideas in typography started to happen. . . . I think we were sort of the Seattle *Rocket* of the design world."[1] Commenting on the influences that helped the *Anchorage Daily News,* Alaska's biggest newspaper, win a war against its rival, the *Anchorage Times,* Galie Jean-Louis, the *Daily*'s creative director in the early nineties, cited *The Rocket*'s design as an inspiration for her own award-winning pages.[2] Chantry isn't indulging in overstatement when he notes, "It was out of *The Rocket* that a lot of the Northwest 'grunge' graphic look emerged. All the designers at Sub Pop were ex-Rocket art directors, for instance. That's why we have many of those distressed fonts that people use today."

The first full *Rocket* issue Chantry art directed appeared in February 1984, with representatives of two Northwest bands, the Wipers and D.O.A., on the cover (Fig. 2).

FIG. 6
Page from *The Rocket*,
May 1984.

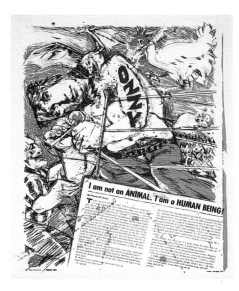

FIG. 7
Page from *The Rocket*,
March 1984.
Illustration: John C. Smith.

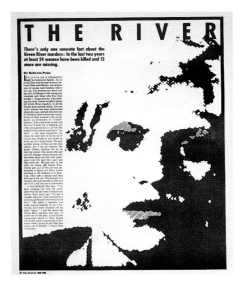

FIG. 8
Page from *The Rocket*,
May 1984.
Photograph: Seattle Police Dept.

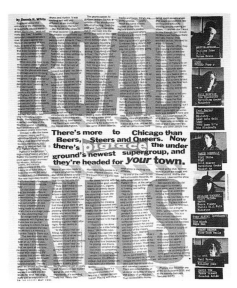

FIG. 9
Page from *The Rocket*,
May 1991.
Photographer: Arthur S. Aubry.

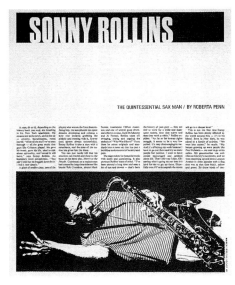

FIG. 10
Page from *The Rocket*,
March 1992.

FIG. 11
Page from *The Rocket*,
May 1991.

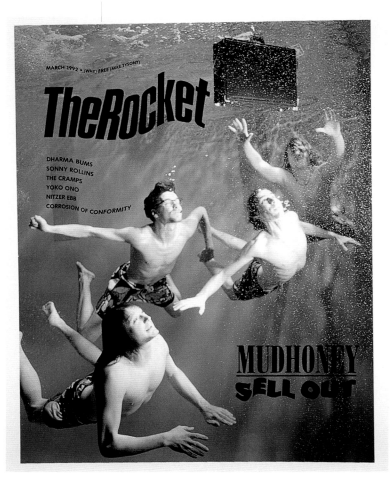

FIG. 12
According to *The Rocket,* photographer Karen Moskowitz
nearly drowned two members of Mudhoney while capturing this
image for the March 1992 cover—an ambitious parody of
Nirvana's *Nevermind* album.

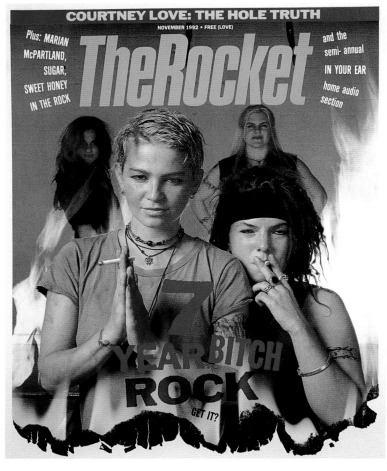

FIG. 13
Courtney Love was supposed to pose for the cover of the November 1992 issue.
"We were going to photograph her against a wall of flames. At the last minute
she refused to do it, so we got the band 7 Year Bitch. I took some paper and
created this burned edge. The fact that it turned out despite the crude process
was a kind of miracle," says Chantry. Photographer: Mark Van S.

Inside, writer Tim Cahill profiled the country music band Buffalo Chip, and the Sub Pop logo, with its familiar chevrons, made a regular appearance over Bruce Pavitt's music review column (this and compilations of works by garage bands that Pavitt packaged and distributed were the forerunners of the music label he founded in 1987 with Jonathan Poneman). "I did the whole thing by myself through about forty-eight hours straight, designing it and pasting it up as I went. It really looked like it," Chantry recalls. A loose format had been established by his predecessor, Helene Silverman, under the guidance of then-editor Robert Newman. "Rules were very important," Chantry says about the boxes around text and artwork, which were pretty much the only rules the paper knew. *The Rocket* was a free-for-all, the sort of publication that presented its editor's account of traveling to Nicaragua to present records to a local radio station with Sandinista sympathies. Newman, Chantry cheerfully explains, "came from a union family. You'd never know it now, but he was a frigging Wobbly. He used to wear this mid-calf-length black leather trenchcoat. You expected him to pull out a frigging shotgun and blow people away."

Many local musicians distrusted *The Rocket,* partly because it seemed too slick and partly because its editors, vying for credibility as arbiters of a broader stage, often bypassed coverage of Seattle bands. Charles R. Cross, who has been involved with

the magazine throughout its history, first as a contributor and eventually as chief editor and publisher, recalls that in the first five years, *The Rocket* put local bands on the cover 20 percent of the time, but in the next five years the frequency jumped to 80 percent. "In our defense," he adds, "the local bands sucked in 1981, and *The Rocket* was desperate for readership." According to the city's punk chronicler, Stella Kramer, "*The Rocket* was thought of as a piece of shit by the musicians in the center of the punk scene. It was made by these older people who'd been to college, so we thought of them as outsiders to the scene. It was a high-tech operation. It was typeset, it had offices, so it was a mainstream paper as far as I was concerned."[3] Local musicians who did get covers were not the types to win the hearts of fringe bands working downtown. Chantry's second cover (March 1984) featured a long-lashed Kenny G. ("It was the only photo with his eyes closed. He was so boring, I tried to make him look like he was falling asleep") (Fig. 3). Nor did essays such as John Kiester's sardonic June 1984 rant "Who's Killing Seattle Rock and Roll?" mend any fences:

Okay, let's fess up. Who's responsible for the sorry state of local music. . . . Is it The Rocket? *Did we discourage the legions of unseen talented, original and enthusiastic performers in the greater Seattle area by being too petty and cruel in our reviews of their first performances? Did we nip brilliant careers in the bud with our whiny, bitchy*

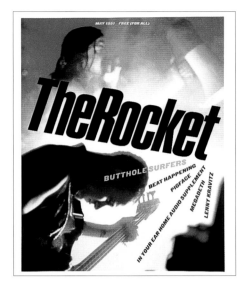

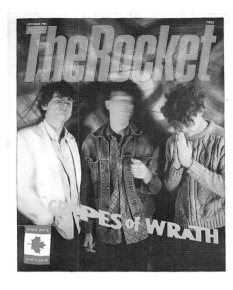

FIG. 14
Rocket cover featuring the Butthole Surfers, May 1991. Photographer: Pat Blashill.

FIG. 15
Rocket cover featuring an out-of-focus photo of the Canadian band The Grapes of Wrath, December 1985. Photographer: Kevin Westenberg.

FIG. 16
Page from *The Rocket* listing the worst rock films of all time, June 1985. Art director: Kate Thompson.

FIG. 17
Ed "Big Daddy" Roth delivered the artwork for this *Rocket* cover airbrushed on a dirty T-shirt, January 1986.

reporting style that ignores popular tastes and holds local musicians up to some arbitrary and stupid measurements determined by East Coast art school intellectuals? Was that it?[4]

By the late eighties, an annual issue was devoted to Northwest music. But even when the grunge phenomenon drew international attention to the region, the editorial direction of the paper remained skeptical. One of Chantry's most ambitious covers, from March 1992, showed the Seattle group Mudhoney selling out by chasing a cash-filled briefcase under water, in imitation of Nirvana's *Nevermind* album, which featured a submerged baby groping for a fishhook baited with a dollar bill (Fig. 12).

The Rocket served as a kiosk for local artists nonetheless, running free classified ads in the back that became a catalyst for bands starting up or acquiring new members. "That's the way any band would hook up with anybody. There was no other place," says former advertising manager Courtney Miller, who recalls Courtney Love showing up to take out an ad for musicians for her band, Hole, and grudgingly putting out her cigarette by grinding it into the rug just beyond the office door, where the irreverent staff left it untouched for a week. Press runs varied, but at *The Rocket*'s height, in 1992, Miller says, circulation was seventy-five thousand. Ads came from Seattle clubs and liquor companies, with revenue invested in color for the inside pages.

Printing was done on a nonheatset web press, "a big, massive, scary, monstrous

machine that produces really shitty quality," Chantry recalls. "Look! Ten, fifteen years later the ink still rubs off on your thumb!" As a result, Chantry learned to use crude printing technology to his advantage. Here's his account of coping with one potential press disaster:

On one page a thumbprint showed up on the plate, printing yellow on a green background. We had to stop the press, and the pressmen were all sitting around waiting for us to tell them what to do. I said, "Why don't you turn off the stop cocks on the press on that side and we'll create a split in the blue fountain where it goes from yellow to green?" And the printer got this big shit-eating grin on his face, and he said, "Yeah, we can do that."

Because *The Rocket* was a freebie, stacked in record stores, restaurants, and boutiques, it was untethered from the demands of newsstand distribution. Normally, logos must be printed high enough on a publication's cover to be visible in a display rack, but Chantry dreamed of dropping the logo to the bottom of the cover simply because such things were never done. "Bob Newman was a pretty liberal guy, but even he couldn't handle the idea," he says. For the September 1984 issue, using the excuse that he had to mask the acne scars of blues musician Robert Cray, he positioned the logo vertically and placed it almost low enough to satisfy himself (Fig. 5).

Chantry's first stint at *The Rocket* lasted nine months, but the long hours and lack of assistance quickly burned him out. Nine months later, after two successors had

FIG. 18
Poster for CoCA Cabana, a cabaret featuring performance
artists rather than night club acts.
Client: Center on Contemporary Art, 1987.

FIG. 19
Poster promoting an exhibit of Chantry's work as well as a collection
of Seattle's 1960s-era psychedelic posters, curated by Chantry.
Client: 911 Arts Center, 1986.

come and gone, Bob Newman talked him into returning for a six-month stint to train a new art director. He designed two covers, the December 1985 blurred-out portrait of the Canadian band Grapes of Wrath for the "Great White North Issue" (Fig. 15) and the January 1986 "Season's Greetings" cover, which he hired Ed "Big Daddy" Roth to illustrate with a leering Rat Fink in a Santa suit (Fig. 17). He then turned over the covers to his successor, Kate Thompson, while continuing to design layouts for features and sections. His page illustrating "Rock N Roll Stinko! The *Worst* Rock Films of All Time" (Fig. 16) complemented such zesty copy as this précis of the 1965 beach movie *How to Stuff a Wild Bikini:*

American International Pictures' response to Ingmar Bergman's The Virgin Spring. *It stars the same old repertory crew we've come to expect—Dwayne "Call Me If Frankie's Not Available" Hickman, Buster Keaton, Harvey Lembeck, and everybody's favorite pineapple princess, Annette Funicello. Offbeat casting of the Northwest's own Kingsmen as themselves.*[5]

The former *Rocket* editor Karrie Jacobs, who left Seattle in the early eighties, recalls Chantry as an important figure in the city's design scene. Compared to her struggling colleagues, "He was a grown-up with grown-up clients," she says. On top of *The Rocket,* he was working freelance for corporations like Safeco Insurance and Nordstrom; for

cultural organizations such as Seattle's Center on Contemporary Art (CoCA) (Fig. 18) and the Bumbershoot arts festival (Fig. 40); and for several fringe theaters and indie bands. In this period, too, he began teaching at the School of Visual Concepts, and he wrote and designed *Instant Litter,* his 1985 book-length compilation of punk posters.

The frantic quantity and whiplash-inducing variety of these assignments soon wore him out. Besides, as he puts it, he was "drinking like a fish." Despite his father's cautionary example, the habit began in college and steadily worsened. Chantry started having blackouts, and in the early summer of 1985, he was hospitalized for kidney stones, a condition he thinks was provoked by dehydration resulting from alcohol abuse. His marriage began to deteriorate. "Sue had just lost her father, and she had never seen me in so much pain," he says. "From that time on she couldn't trust me not to die." (The couple split up several years later.) It required two serious attempts over three years for Chantry to quit drinking. "Finally, one night in 1989, I had one good, solid relapse," he says. "If you don't drink for a while and start again, it's like you've never gone off the bottle. I had a twenty-four-hour episode that absolutely terrified me, and I haven't touched a drop since." Still, he continues to speak candidly about his alcoholism as if it were an antagonist to keep at a safe distance but not so far as to evade a watchful eye. "I decided to come out of it living a life opened to inspection,"

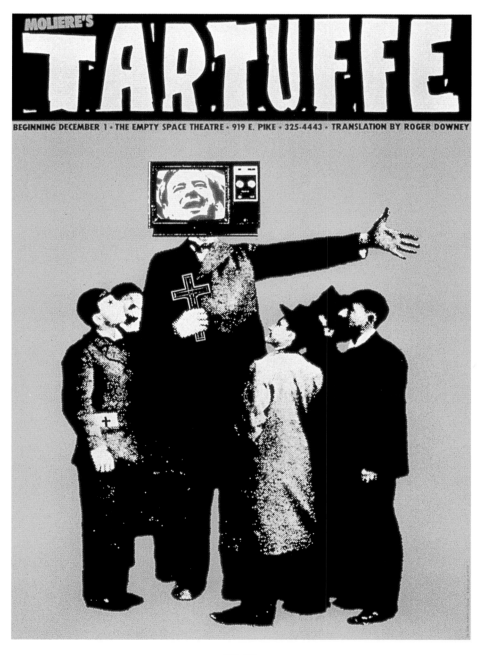

FIG. 20
Poster for the Empty Space production of *Tartuffe*, in which Molière's
religious hypocrite was portrayed as a contemporary televangelist, 1983.

FIG. 21
New City Theater poster displaying the entire season's offerings, 1984. 3-D glasses were attached by a string.

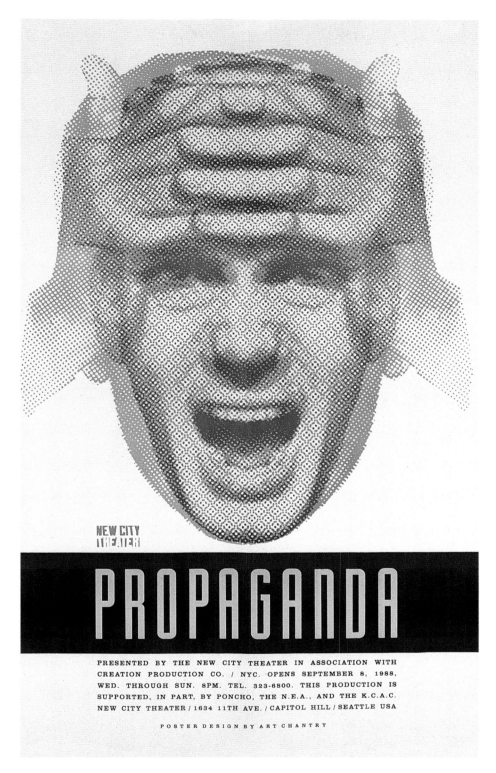

FIG. 22
Poster for the New City Theater production of *Propaganda*. Chantry's second-most famous screaming head, 1985.

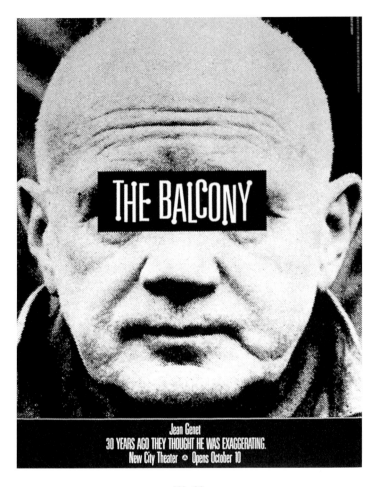

FIG. 23
Poster for the New City Theater production of Jean Genet's *The Balcony*, 1985. Chantry believes that this work is the most successful version of his motif of blocking the subject's gaze with a censor bar.

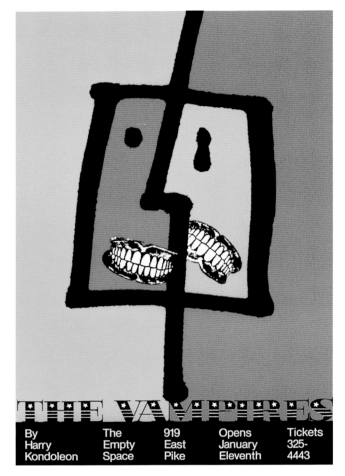

FIG. 24
Poster for the Empty Space production of *The Vampires*, 1983. The client insisted on using an oddly patriotic novelty typeface for the title.

Empty Space Theatre, 1985.

Chantry's original title typography.

Logo and play titles for 5th Avenue Musical Theatre Company, 1989.

FIG. 25
Poster for the New City Theater production of Sam
Shepard's *The Unseen Hand,* 1983. This image influenced
the costume design for the play's main character.

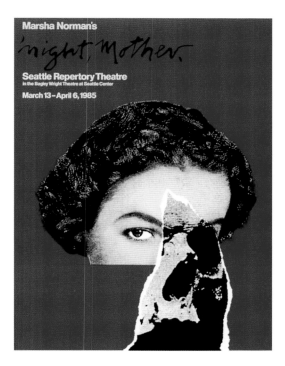

FIG. 26
Poster for Seattle Repertory Theater, 1985.
Typography: Rick Eiber.

FIG. 27
Drilled bullet holes perforate Chantry's poster
for the Organic Theater Company production of
Little Caesar, 1987.

FIG. 28
Poster for the Group Theatre production of
Split Second, about a black policeman provoked
into murdering a racist white perp, 1985.
Photographer: Tom Collicott.

FIG. 29

FIGS. 29–33
Chantry's Give Peace a Dance posters for an annual benefit concert are among his most popular works of the mid- to late eighties. His 1985 poster riffs on dance-step diagrams, in a format designed to be divided into three vertical units. The logo at far right was the first one Chantry designed for the client, Legs Against Arms.

he says. I don't cover for people. I don't hide the truth. If I have an opinion, I say it. If you can't deal with it, big deal."

In retrospect, Chantry's drinking problem seems to have strained his personal and professional relations more than his designs, which grew steadily more assured. Signature works from his *Rocket* period include a 1983 poster for the Empty Space Theatre for a staging of *Tartuffe* set in the early sixties, with Molière's religious hypocrite cast as a televangelist (Fig. 20). Chantry planted a TV set on the neck of a crucifix-bearing demagogue and used a rubber stamp to imprint the face of Jerry Falwell on the screen, thereby not only making the production more topical but also adding a third color at no extra cost. That year, he also designed a poster for an Empty Space play called *The Vampires*, with two stylized faces, one full, one in profile, divided by a jagged line (Fig. 24). He still bitterly regrets the look of the title; the client insisted that he use an American flag–inspired novelty typeface that bore no relationship visually or conceptually to the rest of the piece. Still, "the image worked so well that a local skate punk group adopted it as their logo in the eighties," Chantry says, adding that it predated by many years the Macintosh OS symbol, which resembles it, only without the teeth.

For another small theater, the avant-garde New City, Chantry designed a 1983 poster interpreting Sam Shepard's *The Unseen Hand* as a smudge of torso topped by a distorted outstretched palm (Fig. 25). The image, with its zipper of a spine, ended up inspiring the costume design for the main character. The next year, he designed an announcement for the company's floating repertory system, in which all plays were performed over the same weeks of the four-month season, but on different nights (Fig. 21). "The poster had to hang for a long time," he explains. "I needed to get people to constantly refer to it." A column of images alluding to the productions was printed in 3-D colors, and viewers were offered 3-D glasses attached to the poster by a string.

In 1985, Chantry designed a New City poster for a play called *Propaganda* (Fig. 22). "It was just an old advertising cut I was experimenting with at the time," he says. "I've become known as as the guy who does all his posters on newsprint. Frankly, I hate newsprint, but it's an inexpensive way to do massive amounts of publicity." Besides, he had been expanding the medium's possibilities at *The Rocket*. *Propaganda*'s central image, a doubled, overlapping head of a howling man, recalls the subject of *Ready for War*, among Chantry's other gaping-mouthed sufferers. He instructed the printer to enlarge the art five times its original size for further roughing up, and despite the cheap paper, it has proved far more durable than the play: although the production quickly closed, the poster appears in the first volume of *Design Literacy*, a 1997 compilation of

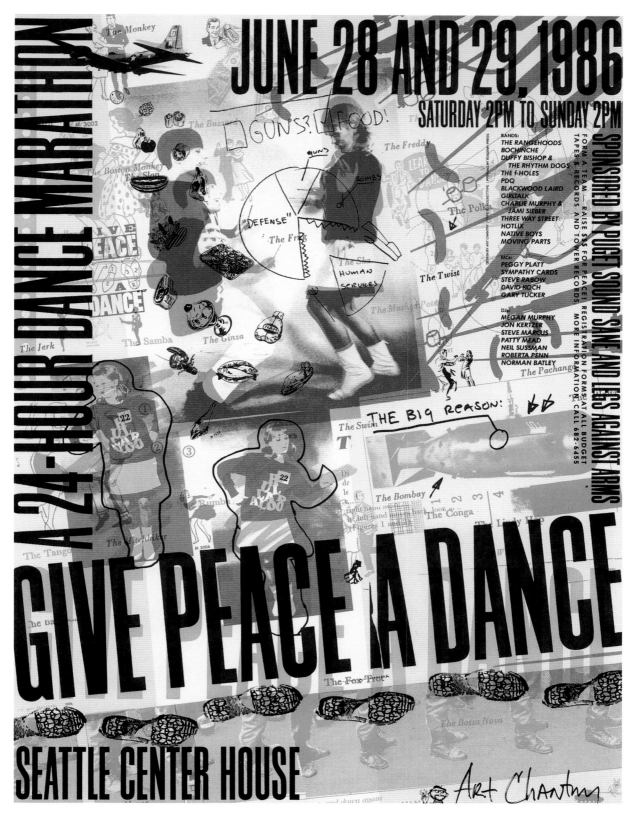

FIG. 30
Chantry executed a "fake Rauschenberg" for his 1986 Give Peace a Dance poster. Client: Legs Against Arms.

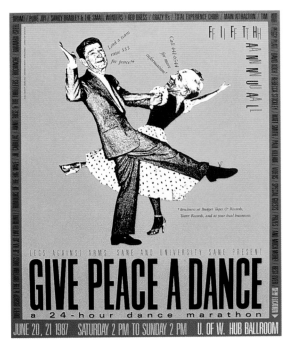

FIGS. 31 & 32
A gleeful Reagan and Gorbachev, dressed alternately in drag, kick up their heels on the 1987 Give Peace a Dance poster.
Client: Legs Against Arms.

FIG. 33
Chantry trimmed his 1988 poster to convey the sense of force with which
the dancing couple is kicking an atomic bomb out of their party.
Client: Legs Against Arms.

BOW WOW HOUSE / *a mighty big show of mass me dia design / publication & posters by seattle design ers wes anderson, lynda j. barry, steve bialer, d. tho m bissett, art chantry, jeff christensen, jim christie, randy eriksen, lynn hamrick, norman hathaway, ri ck jost, mark michaelson, robert newman, jesse rey es, helene silverman, carl smool, kate thompson, d ale yarger / october 3 thru october 31 / opening oct ober 2 (7-9) at nine-one-one (911 e. pine) / if you wo uld like more information we suggest you look up t he phone number / sponsored in part by cornucopi a magazine distribution and the rocket.*

FIG. 34
Newsprint poster for a Bow Wow House gallery show by "cool starving media artists," many of whom were associated with *The Rocket,* 1984. Chantry describes as "snotty" both the nonhyphenated line breaks in the copy and the suggestion that viewers who wanted more information should look up the gallery's phone number. (The gallery had no phone.)

FIG. 35
Feature page demonstrating Chantry's refined layout approach during his brief third stint at *The Rocket,* September 1987. Note the *E* for Elvis.

iconic graphics edited by Steven Heller and Karen Pomeroy. Heller recently explained his choice by saying that he found the *Propaganda* poster "revealing of how Chantry uses found objects and primitive techniques to evoke a sense of urgency and immediacy. That face is burned into my mind."

Another breakthrough client from the period resulting in anthologized work was Give Peace a Dance, an annual twenty-four-hour benefit concert whose posters Chantry designed for several years, beginning in 1984. His 1985 commission riffs on old-fashioned dance-step diagrams, here illustrated by shoes with peace signs on the soles (Fig. 29). But mixed into the playful evocation of mid-century suburban couples aspiring to be Fred and Ginger is a rationalist approach to information graphics recalling the mid-century likes of designers Ladislav Sutnar or Will Burtin. The horizontal format is divisible into three parts, with the shoes dancing from section to section—"cheaper to hang," Chantry explains (at the time, a single company took on all commissions for posting notices in Seattle's public venues and charged by the square inch). "It was actually printed in tempera paint because the silk screener didn't know what he was doing. The green literally washed off the poster," he adds.

The Give Peace a Dance series is remarkable in its stylistic variety. For the 1986 event, Chantry executed what he calls a "fake Rauschenberg," a dense, colorful layering

of inked-over photos that also reflects his allegiance to punk (Fig. 30). Chantry has said that his goal in appropriating graphic forms is to be more like Warhol than like Rauschenberg. He has the pop artist's delight of challenging definitions of art and originality while creating works that are recognizably his own, and he credits Warhol with the "whole idea of my work being a multiple product that serves a commercial function in the short term and an artistic function in the long term—but I still go back and do a few Rauschenbergs just to keep my memory fresh." For this poster, "The client's 'committee' had a big list of ideas, so I just told them I'll use all of them. And I did." The slightly skewed type, which bleeds off two sides of the poster, was inspired by postage stamps designed by the Dutch graphic artist Jan van Toorn.

In 1987, as perestroika and glasnost were rattling Soviet socialism, Chantry received international fame for his next Dance poster by showing the leaders of the world's superpowers—Ronald Reagan and Mikhail Gorbachev—doing a polka. Two versions were printed, one with Reagan in drag, the other with Gorbachev wearing the skirt and bodice (Figs. 31, 32). Both versions have been reproduced over the years, but the popularity of each waxes or wanes according to the political climate, Chantry says. "At first everyone noticed and wanted the Reagan-in-drag one, but as the Eastern bloc broke up, "Gorby drag" became big. Then as Gorby's popularity faded,

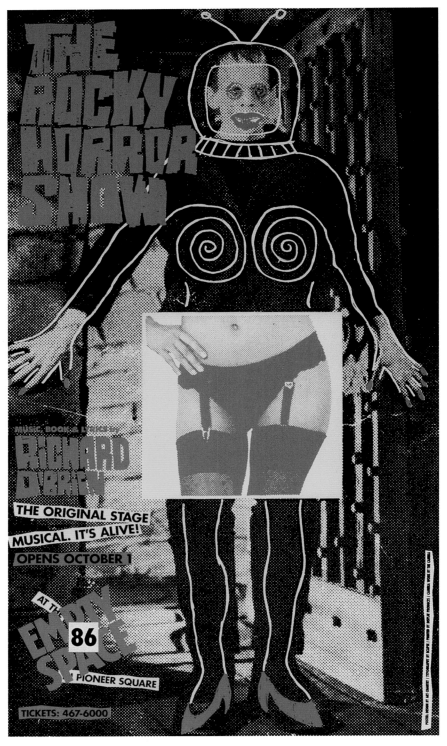

FIG. 36
Poster for the Empty Space production of *The Rocky Horror Show*, 1986.

FIG. 37
Poster for the Empty Space production of
Scaramouche, 1987.
Illustrator: Jesse Reyes.

FIG. 38
Poster for the Empty Space production of
The Overgrown Path, 1988.
Illustrator: Gary Jacobsen.

FIG. 39
Poster for the Empty Space production of
Rat in the Skull, 1988.
Illustrator: Carl Smool.

"Ronnie drag" became the one everyone remembered." The works toured the Soviet bloc and Nicaragua and were part of the first show of American posters in Cuba since the blockade. They were also among the relatively few nonmodernist designs featured in "Graphic Design in America," a 1989 exhibition curated by Mildred Friedman at the Walker Art Center in Minneapolis, perhaps, Chantry believes, because the typography comes closer to modernist than anything else in his career. But the greatest compliment was paid by the president of Ukraine, who visited his studio to secure autographed copies.

Conceived at the time of the INF treaty limiting the deployment of nuclear weapons, Chantry's final Dance poster was intended to show a football player kicking an atom bomb out of the frame with such force that the whole work would be knocked off kilter, an illusion he planned to enhance by trimming the bottom at an angle. "But Give Peace a Dance couldn't deal with the idea of having a football player on their peace poster so they made me take him off, and I put up a fight because it ruined the whole idea of this weird cropping," he explains. At this juncture, the designer Jesse Reyes offered a photograph he had found of a dancing couple in place of the athlete. "As far as I know it's the first time in the history of Seattle that people of color showed up on a poster," Chantry says. "And the client couldn't object to that" (Fig. 33). Carrying forward experiments with color reproduction that he

had tried out at *The Rocket,* he photocopied the image until it rotted and transferred it onto acetate sheets, one for each ink color, with the leg of the male dancer cut apart and repositioned on each overlay to suggest a kicking motion when the layers were combined. "The idea was that the printer could just shoot the mechanical: one piece of film, burn the plate, put it on the press. No stripping, no screens, no knockouts," he says. "I think I got it printed for $400."

Chantry returned briefly to *The Rocket* in 1987 to execute a redesign under Charles Cross, who had bought the magazine from a consortium made up of its former staff and was now chief editor as well as publisher. A close friend who had worked with Chantry on a number of pay-the-bills projects in the early 1980s, including packaging for a line of pet punk rocks (the client "would basically take a rock and stick an eyeball on it in a weird way and put a mohawk on it," he explains), Cross helped finance *The Rocket* through *Backstreets,* a Bruce Springsteen fanzine he also published. Chantry's idea was to make the new layout as rigid as possible to support artwork and fight the chaotic, poorly designed ads. "I looked at it like a clothes rack on which I could hang really crazy frillies. I let the illustrations and photographs basically do all the frilly work," he says. The design of a reminiscence by Elvis's drummer, D. J. Fontana (September 1987), is indicative of the newly restrained approach—Chantry used no rules and laid out the

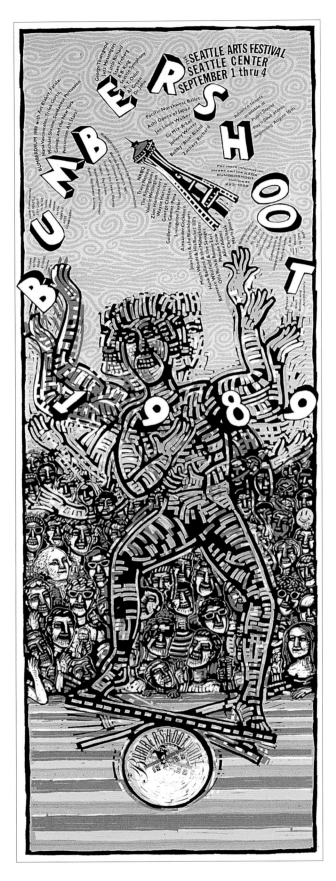

FIG. 40
Poster for Bumbershoot, 1989.
Illustrator: Carl Smool.

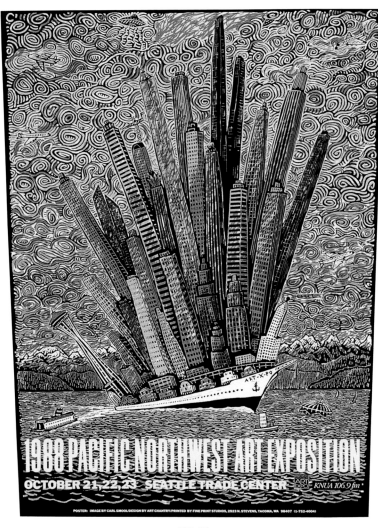

FIG. 41
Chantry collaborated with the illustrator Carl Smool
on this 1988 Pacific Northwest Art Exhibition poster.

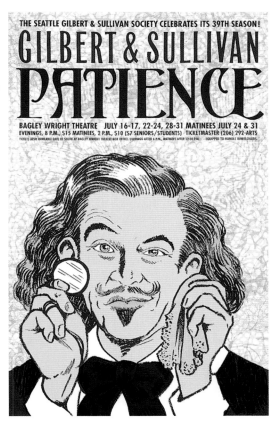

FIG. 42
Poster for the annual production of the Seattle
Gilbert & Sullivan Society, on which Chantry
collaborated with illustrator Mark Zingarelli, 1992.

type in a single, uniform column of Times Roman. Note that the black background forms an *E,* for Elvis (Fig. 35).

When Cross, in Chantry's view, insulted one of their freelance photographers by killing a cover concept that the photographer had traded favors to secure—and even more offensive to the designer, by substituting Bruce Springsteen, who had just released his *Tunnel of Love* album—Chantry left *The Rocket* again. The accounts of the two men differ in their particulars, but Chantry and Cross agree that the stresses of putting out a money-hemorrhaging magazine contributed to the erosion of their friendship.

Among the conflicts that cracked apart the relationship, one can easily see why Chantry recalls a dispute involving his artist collaborators, whom he always respected for their value to *The Rocket* and much more. A skillful illustrator, Chantry seldom executes his own drawings. "I tried really hard not to get stuck in the illustration camp; I'm a collage artist. Illustration has a life span of five years, and I wouldn't survive that," he has said. Another time he insisted that the Empty Space Theatre "was so scared of my posters after a certain point that the only way I could get work was to hire illustrators to do the image." This statement is greatly exaggerated, considering that Chantry illustrated the Empty Space's *Rocky Horror Show* poster, which hung in the Louvre as part of an exhibition of the most memorable posters of 1986, sponsored by UNICEF

(Fig. 36). However, several Empty Space promotions at the time do show off the work of different artists, including Jesse Reyes (*Scaramouche,* 1987), Gary Jacobsen (*The Overgrown Path,* 1988), and Carl Smool (*Rat in the Skull,* 1988). In each poster, Chantry's classical design lays back to support the image so that Reyes's *Scaramouche* balances on a hand-lettered title that is fully integrated with the artwork (Fig. 37), Jacobsen's flora takes up three-quarters of the area beneath lines of recessive type (Fig. 38), and Smool's rat and skull leave an indelible impression that is at once beautiful and awful in its literalness (Fig. 39).

Smool is one of several artists with whom Chantry has had a long, fruitful relationship. The illustrator's early work consisted of drawings laboriously constructed out of pieces of border tape. Later he added Zipatone dots to the tape, and then, with Chantry's encouragement, shifted to scratchboard, the medium he used for *Rat in the Skull.* At first, Smool and Chantry agreed that they would use neither rats nor skulls to advertise the play, which is about political torture in Northern Ireland. But in the end they decided that no other images would work. "And of course, we used these really horrible gray and brown monochromatics," Chantry recounts, "and made it go out of register at the top just enough to hurt." The play was produced over the winter holiday season while other theaters were mounting Christmas pageants, which

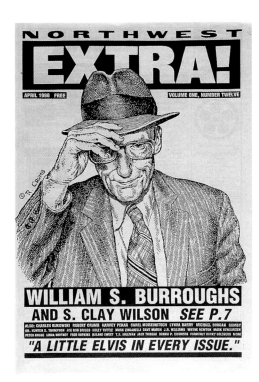 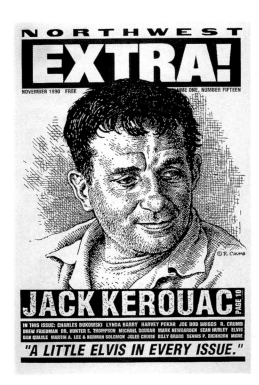 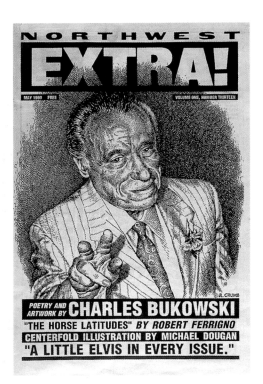

FIGS. 43–45
These portraits of William S. Burroughs, Jack Kerouac, and Charles Bukowski were commissioned from Robert Crumb while Chantry
was art directing the covers of *Northwest Extra,* a monthly culture 'zine published out of Olympia, 1990.

enhanced the shock value even further. Its producers expected low attendance—Chantry describes the drama as "intense, dense, vicious, and nasty," staged for integrity, not profit—but to their surprise a respectable number of people showed up. Exit surveys revealed that 60 percent cited the poster as the reason. The figure for successful plays, Chantry adds, is usually 5 to 10 percent.

That same year, Chantry worked with Smool on the poster for the 1988 Pacific Northwest Art Exhibition. It shows a bouquet of skyscrapers transported by boat over Puget Sound; several of their windows, along with stars and a flying saucer in the background were printed in glow-in-the-dark inks so they would light up at night (Fig. 41). Chantry then proceeded to undercut subtly the romance of this image by specifying that the poster be slightly wider at the top than the bottom to comment on the squeeze occasioned by Seattle's rapid growth. He also points out that Seattle's iconic Space Needle is falling off the boat, and that Smool drew the small buildings at the base of the skyscrapers to resemble skulls.

His most ambitious collaboration with Smool occurred the next year. Bumbershoot, the local arts festival, is a hugely popular event with an elaborate program of promotional graphics. Chantry's 1989 poster featured a juggler and crowd scene collaged from several small artworks executed by Smool in scratchboard,

blown up to six feet tall and printed in four Day-Glo colors and black ink, with a pearlescent varnish (Fig. 40).

A similar cheery lack of technological orthodoxy grew out Chantry's collaboration with the illustrator Mark Zingarelli. Among other projects, they produced an annual poster series for the Seattle Gilbert & Sullivan Society from 1987 to 1995 (Fig. 42). Zingarelli, who was then based north of Seattle, would fax Chantry a pencil sketch, which, the designer explains, "digitized into a nice halftone" while retaining the look of a pencil drawing. Then Chantry enlarged the drawing on a photocopier, hand lettered the text in the style of Victorian wood type, and built the tints and background textures with overlapping PMS colors.

His passion for revivals found an outlet in old artistic talents. Not only did he hire "Big Daddy" Roth, who was then working as a sign painter at Knott's Berry Farm, for a *Rocket* gig, but he approached the *Mad* magazine cartoonist Don Martin to draw a nativity scene for the January 1991 holiday cover (Fig. 47). Before the underground comics genius Robert Crumb enjoyed a second wind of fame from an eponymous 1995 documentary film, he did portraits of Jack Kerouac, Charles Bukowski, and William S. Burroughs for *Northwest Extra,* a tabloid 'zine Chantry art directed (Figs. 43–45). Enamored of the designs of vintage paperback science fiction novels—he especially

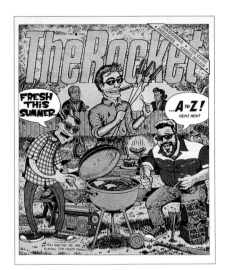

FIG. 46
Rocket cover for the
Summer Fun Issue,
August 1987.
Illustrators: Peter Bagge,
Michael Dougan,
and Mark Zingarelli.

FIG. 47
The *Mad* magazine cartoonist
Don Martin illustrated this
nativity scene for *The Rocket*'s
January 1991 cover. "We got
mail from people who thought
it was anti-Semitic—something
about the way Joseph looks,"
Chantry relates. "We said, 'Huh?'"

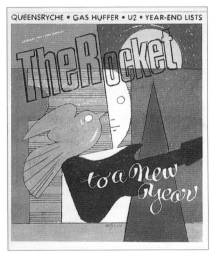

FIG. 48
Nathan Gluck, an assistant of
Andy Warhol for seven years,
illustrated *The Rocket*'s
January 1992 holiday cover
and lettered the New Year's
greeting in a style reminiscent
of his former employer's work.

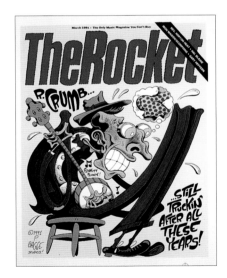

FIG. 49
Rocket cover featuring
Deee-Lite, April 1991.
Illustrator: Stan Shaw.

FIG. 50
Peter Bagge parodied his
friend and fellow underground
comics artist Robert Crumb
for the March 1991 *Rocket*.

FIG. 51
Rocket cover illustrated by
Scott McDougall, February 1992.

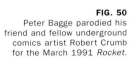

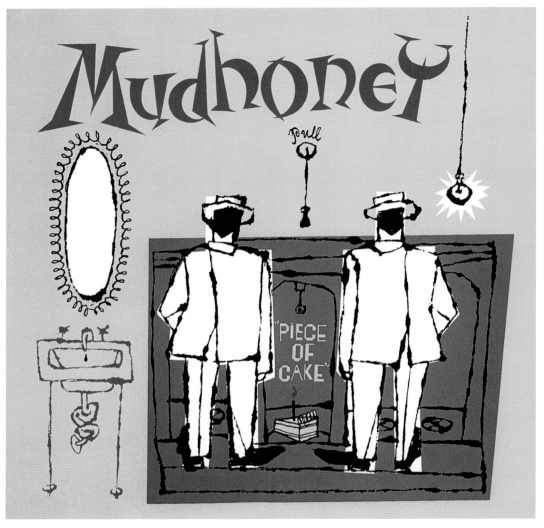

FIG. 52
Cover and booklet spread (Fig. 53) from Mudhoney's *Piece of Cake* CD/LP, 1992.
Edwin Fotheringham applied his newly acquired blotted-line technique to this work after
studying the illustrations of Andy Warhol, David Stone Martin, and Ben Shahn.
Client: Reprise Records.

likes those with the word *strange* in their title—he noticed that he was attracted to a particular style of cover art that turned out to be executed by Richard M. Powers, who had illustrated scores of books for Ballantine. Tracking down Powers in Connecticut, Chantry asked the septuagenarian for the right to reproduce one of his paintings on a 1993 CD cover for the band Man . . . or Astroman? (see "Case Study," Fig. 17). A close friendship with Nathan Gluck, who had spent seven years in the fifties and sixties as the assistant (and, by definition, the authorized forger) of Andy Warhol, led to assignments for *The Rocket* and other projects, which Gluck rendered in his own style as well as that of his former employer (Fig. 48).

Most of these heroes lived up to expectations, though Chantry was hugely disappointed when Von Dutch, the father of custom car graphics, turned in *Rocket* cover art filled with sexist, racist, anti-Christian, and anti-Semitic slurs—a remarkable feat of equal-opportunity bigotry. "This is the first guy to ever put graphics on a T-shirt, the first guy to put monsters in a hot rod, the first to put flames on a car, the first to put a mural on a van," Chantry explains sadly. "He was an amazing innovator, but he was nuts."

At the same time, Chantry cultivated younger artists who shared his interest in the graphic styles and media of bygone decades. He commissioned *Rocket* illustrations from successors to the sixties underground comics tradition, including Peter Bagge,

Michael Dougan, and Mark Zingarelli (Fig. 46). He ordered lettering and illustrations from Scott McDougall, an ex-hippie surfer who remained faithful to the hypnotic style of psychedelic rock posters (Fig. 51). And he encouraged the illustrator Edwin Fotheringham to learn the blotted-line drawing technique last seen in the work of such fifties artists as David Stone Martin, Ben Shahn, and Warhol. (Fotheringham, who also sang in the grunge band The Thrown Ups and who, along with the photographer Charles Peterson, was a housemate of members of Mudhoney, first applied the technique to an illustration for Mudhoney's 1992 *Piece of Cake* release, which Chantry designed (Figs. 52–56).) Nathan Gluck lettered the insert in Warholian calligraphy. Hank Trotter, a Montana-born photojournalist-turned-designer who worked at *The Rocket* in the early nineties, rivals Chantry in his affection and talent for parodying vintage advertising graphics and copy. The two men shared a studio on Western Avenue in this period and collaborated on projects such as a series of wry promotions for the clothing company Urban Outfitters (see chapter 6).

Papering the avenues, Chantry's work influenced a fresh generation of designers and illustrators—many his students—to work with bubble-gum colors, ironically repositioned advertising, cartoons, ravaged newspaper reproductions, and other features of his craft. According to Grant Alden, a Chantry protégé, "He trained in one way or

FIG. 53
Inside spread of
Piece of Cake CD booklet.
Illustrator: Edwin Fotheringham.
Calligrapher: Nathan Gluck

FIG. 54
Cassette cover.

FIG. 55
British release 45 cover.

FIG. 56
Cover of the CD longbox.

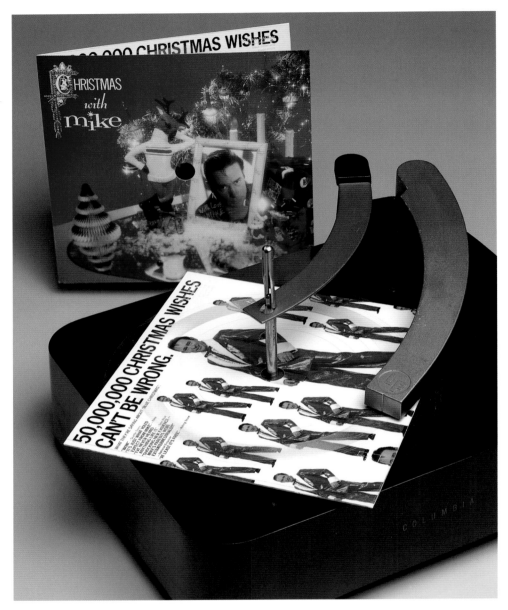

FIG. 57
Novelty holiday card for advertising agency. The flexi-disc features client Mike Mogelgaard singing "Blue Christmas"
to his clients and friends, "Just like Elvis would-a." Red lamé Santa suit tailored by Michael "Hautepants" Murphy.
Photographer: Tom Collicott, 1985.

T-shirt company logo, 1985.

Sportswear logo, 1986.

Logo for fashion stylist, 1997.

Children's wear logo, 1987.

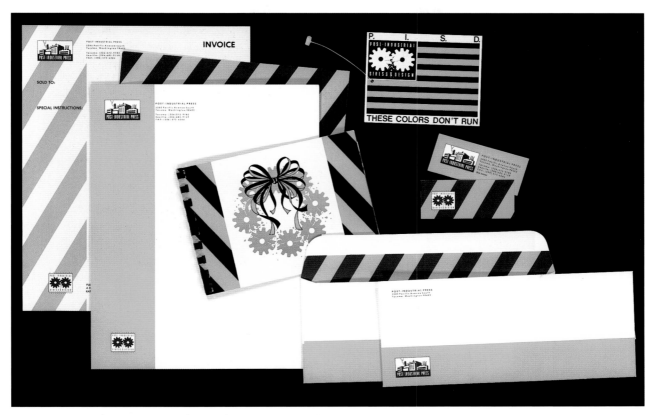

FIG. 58
Stationery (above) for Post-Industrial Press, 1986. Shown below, left to right: logo, 1985; catalog cover, 1993; corporate logo treatment, 1986.

Fashion labels and logos for Union Bay Sportswear, 1986.

Sales mark for Nordstrom, 1985. Retail shop logo, 1987. Logo for K2 snowboards, 1989.

FIG. 59
Chantry's Tool poster for a performance art cabaret at Seattle's Center on
Contemporary Art, and the black-and-white series that followed (Figs. 60–65),
inspired legions of copycats throughout the nineties, 1991.

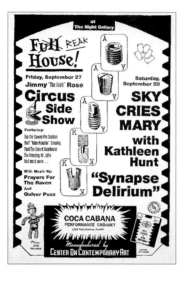

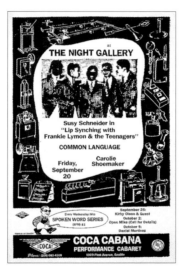

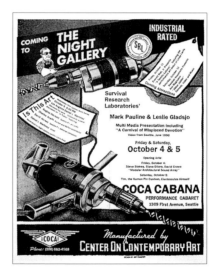

FIGS. 60–65

another virtually every graphic designer in Seattle worth their salt." Obviously, Chantry wasn't the only designer at the time who was sifting through and reassembling the history of graphics. He had a counterpart in Charles Spencer Anderson, the Minneapolis designer whose "bonehead" style, appropriating advertising cuts from the 1920s and 1930s, was much admired by his peers. (Chantry and Anderson trade clip art to this day.) In New York, Tibor Kalman of M&Co. was celebrating untutored graphics from different epochs, and Paula Scher was winking at the modernism of the Russian Constructivists and the Bauhaus. Still, Chantry had transformed an infatuation with commercial art—the very phrase had gone pleasingly quaint with efforts to dignify design—into an expression of his milieu. Says Fotheringham, "The best part is that a lot of people see his work and attribute it to a Seattle aesthetic. And it's not Microsoft, it's not Starbucks. It's not that decorative quota design that's just meant to bring in a monthly revenue."

But in reflecting a culture as well as an individual, Chantry's art ran the risk of behaving like other subcultural expressions; it threatened to leave its originator behind. Legions of Chantry imitators sprang up, and in Seattle's competitive freelance market, Chantry was torn between the instructor's desire to invest himself in his disciples and the pragmatist's need to stake out and hold on to a turf. "I see Art Chantry's influence

every day when I go into downtown Seattle and notice some hipster with his arm covered with tattoo ink wearing a gas station shirt," Mike Stein, founder of the Chuckie-Boy record label, says. "The same is true of his approach to typography and jumble of imagery: it's so thoroughly percolated into mainstream culture here, it's almost like the air and light—and like the air and light, it is taken for granted." Believing (and putting into practice the conviction) that the most influential designs have invisible authors, which leaves the work ripe for pilfering, yet finding equity in his name and satisfaction in being recognized, Chantry still struggles with the dubious compliment of imitation.

When, in 1991, he produced one of his most important designs, however, he was almost happy to tempt copycats. For a performance art series called the Night Gallery at Seattle's Center on Contemporary Art, he created a red, black, and white poster that shows not a single performer or even a piece of one—not a head, a leg, a flash of bosom, or a crotch. Instead it displays hardware lifted from 1950s tool catalogs and industrial ads, over which patches of text give information about the acts in a manically upbeat style that copywriters have long abandoned (Fig. 59). The only human element consists of a few fingers wrapped around a drill shaft. To create the typography's "clash," or low-tech unevenness reminiscent of letterpress, he mixed Futura and Franklin Gothic.

FIG. 66
Following his Tool poster for CoCA, Chantry designed a CD cover for the band
Liquor Giants, whose name reminded him of a low-budget retailer. Reproducing the look
of a grocery store circular, in which he re-created as much copy as he stole, he saw
this work as a natural progression of his infatuation with old advertising styles.
Client: Lucky Records, 1992.

FIG. 67
Old ads continue to infiltrate Chantry's recent work, as on this 45 cover
for The Hellacopters, a 1970s-style hard-rock band from Sweden.
Client: Estrus Records, 1998.

The Tool poster, as it is known, as well as a series of related promotions for CoCA (Figs. 60–65), predated a wave of industrial imagery in mid- and late-nineties graphics. Because the work was so startling, Chantry reports that it received better reviews than the art shows: "I got lots of confused press and analysis." Hank Trotter recalls the "epiphany" of turning a corner and first seeing the Tool poster on a wall. "I couldn't believe that somebody would pay to have it printed and put it up, because it was what I wanted to do but I couldn't find the clients." Trotter adds that Chantry succeeded in such endeavors by designing almost for free. And yet, "he wasn't a studio taking in some pro bono job and giving it to a junior designer just because they wanted to take a tax credit or get a fancy piece done. He was also a co-conspirator in art schemes and was very involved in creating ideas and bringing people together. It went beyond graphic design."

Chantry could almost afford to work for CoCA because he had returned to his day job. His final and longest stint at *The Rocket* lasted from 1990 to 1993. Collaborating with managing editor Grant Alden, who had assumed a large part of the editorial direction under Cross, he once again set about reinventing the magazine. This time, he had two advantages. The first was perspective. One day advertising manager Courtney Miller decided to decorate the offices (now on Fifth Avenue)

with *Rocket* covers from the mid-eighties on. She hung them around the periphery of the main room "like a little frieze," Chantry recalls. "Looking at it was such a valuable exercise. I'd see it going through periods of good and bad, depending on the art director and time, and I got a chance to look at my own work. I began to realize that there was really one kind of cover that looked best. For about two years, I churned out that cover." Its features were dramatically cropped or blurred photos overprinted by bold, translucent type, the culmination of his experiments with knocking out one of the colors on press to reduce the density of ink and alter the palette. Inside, Chantry "was always disrespectful of the type," he says. "It was rigid, nasty, hard edged with a zinger in it, very clean, but it would blow up on you if you didn't look carefully." The logo grew progressively more restless. For six months, from January to June 1993, he spun it 360 degrees, so that it migrated down the right edge of the cover, flipped upside-down at the bottom, and crawled back up the left edge, finally to be restored to its orthodox position on top, behind a photo of Shannon Funchess, vocalist for the Seattle band Imij (Figs. 70–74).

This was Chantry's last *Rocket* cover. He left the magazine in 1993, soon followed by Alden and Miller. Finally, *The Rocket* was breaking even, thanks to the biggest boon of all—the explosion of grunge music in the early nineties—and Cross,

FIG. 68
This concert poster for 3B Tavern represents, in Chantry's words,
"the logical conclusion of my stolen-ad look," 1996.

FIG. 69
Chantry achieved amazing subtlety with this June 1991 *Rocket* cover featuring Tony Benjamins, singer and bassist of Forced Entry.
Note the transparency, not just of the type but also of Benjamins's exposed eye. Photographer: Mark Van S.

FIGS. 70–74
Over Chantry's last six months at *The Rocket*, from January to June 1993, he rotated the logo on the cover 360 degrees. Photographers: Willem Koolvort (Feb. 1993). James Rexroad; Designer, Jeff Kleinsmith (March 1993). Lance Mercer (April 1993). Kenji Kubo (May 1993). Sean O'Tyson; Lettering, Pablo (June 1993).

who believed he was now in a better position to compete with the local weeklies, wanted to be closer to it. Though he remains coeditor, he sold a controlling interest in 1995 to Bay Area Music, a network of small papers that offered a broader advertising base and wider distribution. Even so, *The Rocket,* which went to a biweekly schedule in 1992, the same year it launched an edition in Portland, Oregon, has lost much of its eminence through the decline of Seattle's underground, the defection of talented staff, and competition from a reinvigorated *Seattle Weekly* and from *The Stranger,* now the city's leading alternative monthly. Though he says that "the paper's better than it ever was, editorially," Cross acknowledges that, "unfortunately, the quality of *The Rocket* is affected by the quality of bands. The bands in 1991 were more exciting."

Grunge combined the old minimalist thumpings and abrasive attitudes of punk rock with the newer wails and dark-force mysticism of heavy metal. The sound had evolved via longtime Seattle bands like Green River and the U-Men, but snapped into clearer definition with a single released by Mudhoney in 1987, "Touch Me, I'm Sick." According to writer Clark Humphrey, "Touch Me, I'm Sick" was "perhaps the first and purest evocation of the sludge-punk ethos (and almost a measure-by-measure copy of the Sonics' "The Witch").[6] Chantry remembers being happily stunned the first time he heard the song—"I had to pull my car over to the side of the road." Driven by a juggernaut of

electric guitar that muffles even the ranting vocals, it was influential enough for Cameron Crowe, in his 1992 film, *Singles,* to cast Matt Dillon as an oafish Seattle guitarist performing a parody version, "Touch Me, I'm Dick," which Mudhoney recorded for the soundtrack.

As the record producer Jack Endino noted in the documentary *Hype,* Seattle's weather made it "only natural that you'd want to go downstairs in the basement and make music." Incestuous connections were fostered in a small metropolis: musicians jumped from band to band, or groups broke up and re-formed under other names, so that a family tree of Seattle rock in the early nineties (one was actually published in *Loser,* credited to Jo-Ann Greene and Dave Thompson) tracks the bass player Jeff Ament through thirteen new or reconfigured bands—from Deranged Diction to Pearl Jam—in little more than a decade.[7] Dozens of small labels were started up by musicians (such as Dave Crider of the Mono Men, founder of Estrus Records in 1987) or by frustrated musicians (such as Jonathan Poneman, cofounder with Bruce Pavitt of Sub Pop).

Chantry, who knew Pavitt through *The Rocket,* had made a natural transition to freelance for Sub Pop, designing covers and posters. His first official project for the label was a 1989 record cover in two colors that he "pushed to the max" for the

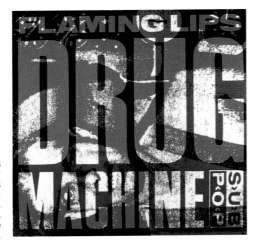

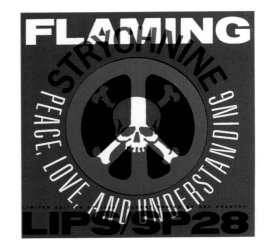

FIGS. 75 & 76
Chantry's first "official"
Sub Pop project was this
Flaming Lips single, 1989.
To differentiate the U.S.
and European releases,
he simply reversed the
color schemes.

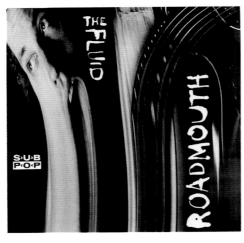

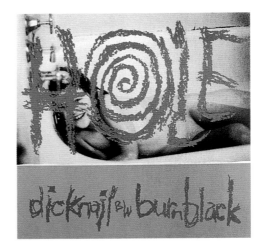

FIG. 77
For this Fluid album, Chantry
used a photo whose image was
reflected off black plexiglass.
Photographer: Charles Peterson.
Client: Sub Pop, 1990.

FIG. 78
45 cover featuring a nude
twelve-year-old Courtney Love.
"It took us three different tries
before we found a printer who
would touch it," Chantry says.
Lettering: Courtney Love.
Client: Sub Pop, 1990.

band Flaming Lips, entitled *Drug Machine* (Figs. 75, 76). Unofficially, he recalls having introduced the chevrons in Sub Pop's logo in 1984, over Pavitt's *Rocket* review column:

Helene Silverman was art director when the column started and was totally in love with digital type, which had just hit the market. Wes Anderson, who was assistant art director, took the original title, "Sub Pop USA," and flexed it to fit two columns so it was long and extended. I hated flexed type. The first thing I did when I was art director was to replace it with Microgramma or Eurostyle—some naturally extended typeface—but it didn't quite fit. I had gaps, so I filled them with chevrons from a rub-down transfer sheet of Microgramma or Eurostyle. Then I put the USA in underneath sideways, just to be funny.

The anecdote is less of a boast than a history, like so many others he narrates, of how iconic graphic forms develop from what seem to be inconsequential gestures. He makes a similar point about Nirvana's logo, which first appeared on the band's 1989 *Bleach* album, designed by Lisa Orth, another *Rocket* art director. "At this point, no one would work for Sub Pop because they couldn't pay their bills," Chantry relates. The label's problems in finding a distributor had been pulling it deeper into the red—so much so that a 1991 *Rocket* cover designed by Chantry questioned the

company's solvency with his headline "Sub Plop?" (Fig. 82). Too obliging to refuse the assignment, Orth approached Grant Alden, who was then typesetting as well as editing *The Rocket,* told him she had a job for some new band called Nirvana, and asked him to output whatever typeface he was working with. Alden happened to be using Onyx, Compugraphic's version of a condensed Bodoni. "That became their logo," Chantry sums up, "put on a million T-shirts. Lisa and Grant were paid maybe fifteen bucks. It's a screaming example of how graphic design works."

Many reputations were made with that line of Onyx. No one was prepared for the eventual popularity of *Bleach,* which Jack Endino had recorded for slightly more than $600, followed by the platinum success of Nirvana's next album, *Nevermind,* released in 1991 by DGC. Along with a cluster of other groups that broke through—two more Sub Pop bands, Mudhoney and Soundgarden, as well as Pearl Jam and Alice in Chains—Nirvana attracted the national press to Seattle, which naturally turned for insights to *The Rocket* as the only local paper with any authority. "In one day alone, seven different media crews (from *Rolling Stone* to the *Christian Science Monitor*) came to interview anything in the *Rocket* office that moved," Chantry recounts.[8] At the same time, Seattleites read *The Rocket* for news about the global phenomenon in their own backyard.

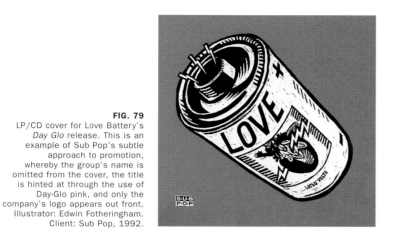

FIG. 79
LP/CD cover for Love Battery's
Day Glo release. This is an
example of Sub Pop's subtle
approach to promotion,
whereby the group's name is
omitted from the cover, the title
is hinted at through the use of
Day-Glo pink, and only the
company's logo appears out front.
Illustrator: Edwin Fotheringham.
Client: Sub Pop, 1992.

FIG. 80
Reid Miles's Blue Note work
influenced this cover for the
Monkeywrench.
Photographer: Charles Peterson.
Client: Sub Pop, 1992.

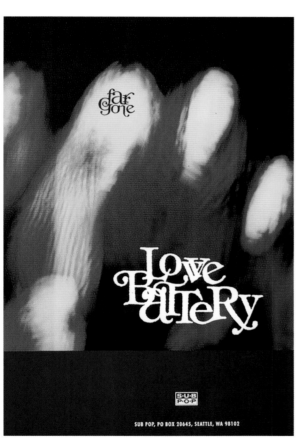

FIG. 81
For this promo poster for Love Battery's *Far Gone* release,
photographer Karen Moskowitz shot dozens of band portraits,
but Chantry chose to use an exposure from the end of the
spool that was accidentally blurred.
Client: Sub Pop, 1993.

FIG. 82
"Sub Plop?" is the question posed on the cover of the
August 1991 *Rocket*, showing Sub Pop cofounder Bruce Pavitt
in the foreground. The label was in dire financial straits but
would soon recover thanks to the success of Nirvana's *Bleach*
and Mudhoney's *Every Good Boy Deserves Fudge* releases.
Photographer: Charles Peterson.

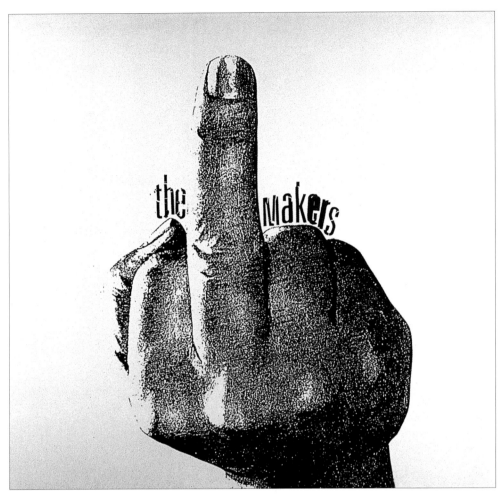

FIG. 83
"In the entire history of rock and roll, no one has ever done this," Chantry insists
about the elevated middle finger on a 1995 Makers LP/CD for Estrus Records.
"How come?" The acknowledgments on the back, featuring several styles of old
press type (as one ran out, Chantry filled in with another), conclude with a reference
to "all the clubs that ripped us off and/or kicked us out."

Chantry and *The Rocket,* as well as many of the musicians themselves, were bemused by the attention and skeptical of its value. ("'Grunge' wasn't a style; it was a marketing term," Chantry insists.) The more broadly defined Seattle rock became for the masses, the less that definition mirrored reality. Suddenly people were talking about a Seattle "sound" and a "scene" in reference to bands that had been performing in a similar vein for years, or in Nirvana's case weren't even from Seattle, or in Pearl Jam's case had a slightly dubious provenance, considering that front man Eddie Vedder was an Angeleno. Meanwhile, teenagers with questionable musical skills were signing recording contracts.

The attempt to pinpoint grunge as a cultural manifestation, as opposed to a few lucky and talented groups and a large number of mediocre and derivative ones, reached an extreme when the *New York Times* Styles section published a list of grunge slang terms that turned out to have been fabricated by Megan Jasper, a twenty-five-year-old in the radio sales department of Sub Pop, whom a gullible *Times* reporter had the misfortune of interviewing. Insisting, for example, that "wack slacks" was current parlance for old, ripped jeans, that "swingin' on the flippety-flop" meant hanging out, and that "harsh realm" described a lousy experience, Jasper became a hero to Seattle's underground. (Topping off the irony, "harsh realm" did enter common parlance as the name of a television show.)

The grunge scene may have been a farce, but the attention and money it shunted to Seattle generated new opportunities for Chantry. His work was demanded by more than a dozen labels, and he demonstrated versatility not only in completing projects for different clients, but in building distinctive identities for each. Most instructive are the large bodies of graphics he has produced for Sub Pop and Estrus. As he defines the difference, "Sub Pop had that elegant, clean look that was hard-assed at the same time, and in your face, and playing games. They didn't like to put the record title on the front. Estrus, on the other hand, prides itself on its lack of subtlety. They don't want to attract the general public. They want to speak to the people they want to speak to." An extended middle finger on a 1995 Makers cover is, Chantry explains, Estrus's "position statement" (Fig. 83). And a similar devilish attitude, shared by the label's founder and president, Dave Crider, led Chantry to print the liner notes for an LP by the Japanese band Teengenerate on the inside of the cover, so that listeners have to rip up the cardboard to read them.

Crider, who first worked with Chantry in the late 1980s on a Sonics tribute album, describes their collaboration as "steamrolling to the point that Art is pretty much the graphics department of Estrus Records and a big part of the label." He agrees with Chantry's summation of the Estrus look, though he adds that the spirit of

A small sampling of Chantry's Estrus logos, 1990–2000.

bravado still admits a wide variety of styles and solutions. Overall, Crider observes, Chantry's design has a deceptive simplicity that leads people not only to skim past its subtleties but also to rip it off poorly: "People will say, 'That punk stuff is great; I'll get a Xerox machine and do that,' and yet it never looks right. That Chuck Berry guy didn't play a whole lot of notes either, but he did it quite well."

Clients like Crider foster Chantry's ingenious and subversive streaks, yet they also profit from his much broader range of skills. As the case studies in the appendix show, music, with its complicated packaging and promotional systems, and with fans who delight in in-jokes and pick up on subtle references, is arguably Chantry's ideal graphic medium. Moreover, if a designer can manage the whims of formats, clientele, and audience in the music world, he or she can manage them anywere. For every aspect of his future career, *The Rocket* served Chantry well as a launch pad.

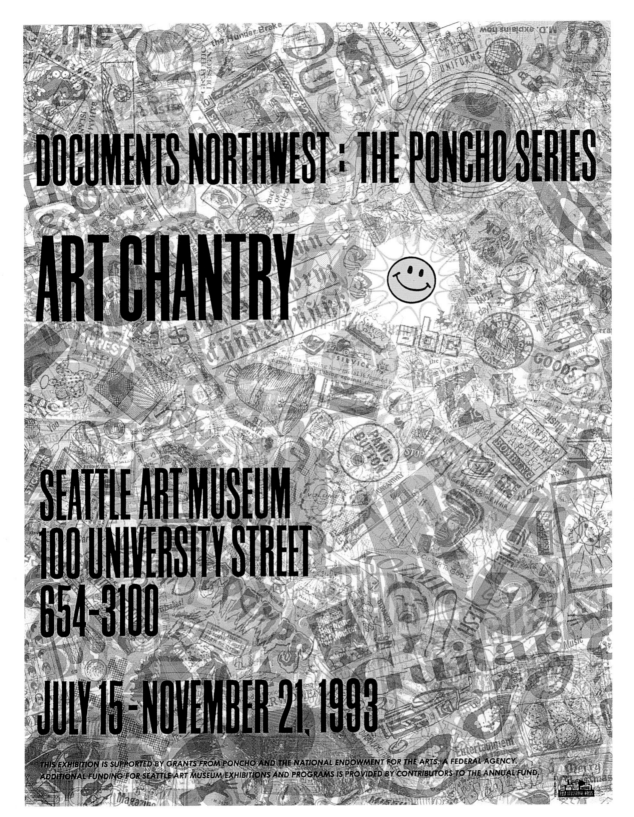

FIG. 1
Poster for one-man retrospective of Chantry's posters at the Seattle Art Museum, incorporating twenty years of personal history in clip art, 1993.

The people who commission posters are simple people;
they must be helped, tricked if necessary,
but not feared.

SAUL STEINBERG

IN 1993, ART CHANTRY RECEIVED PERHAPS the greatest compliment ever bestowed on a graphic designer by the noncommercial world: a museum exhibition devoted exclusively to his work. The Seattle Art Museum's one-man show of Chantry's posters, which ran from July to November, occupied a large gallery in the Robert Venturi–designed building; for the promo poster, Chantry used masses of clip art alluding to friends, family, and professional influences—an archaeological dig of his almost forty years layered in spring colors and pearlescent varnish (Fig. 1). The exhibition's curator, Patterson Sims, brought construction scaffolding into the room for displaying the works, and the show's highlight was an actual poster-encrusted telephone pole.

In the accompanying catalog, Sims proposed to right an imbalance between commercial and fine art in the eyes of connoisseurs: Here "the avid annexation of graphic design by contemporary artists" would be "countered with an art museum recognition of a highly gifted graphic artist. . . . [Chantry] is a natural at what he does, a figure of semilegendary status in a city that has developed a national reputation for its affection for posters and their spirited, savvy designers."[1]

Sims had no trouble convincing the public that Chantry's work belonged in a museum—the show drew what was then the second-largest attendance in the young institution's history, and it inspired ad agencies, design studios, and even the *Seattle Weekly* to erect indoor telephone poles for posting notices, Chantry says. Art critics, however, were not easily persuaded that contemporary street posters, some produced as recently as a few months before, were in an appropriate venue. Writing in the *Seattle Post-Intelligencer,* Regina Hackett lamented that "instead of looking authentically gritty," the scaffolding and utility pole "[came] across as slumming." But her gripe was with the installation, not the work or even the premise: "As contemporary art has become less hierarchical, less prone to distinguish between high and low, artists such as Chantry are getting the attention they have long deserved but not necessarily sought," Hackett concluded.[2]

To some extent, Chantry's work was still undefinable—was it art or design? was it too commercially directed to be the one and too personally expressive to be the other?—yet he nevertheless had a clear identity in both spheres. He was known as an interpreter of hardscrabble artistic movements and a champion of social and political underdogs. "Art is the chronic advocate for the unpopular position, and he approaches graphic design as if he were a political fine artist," observes his former *Rocket* colleague Grant Alden. "When the Gulf War happened, *The Rocket* was the only newspaper that I knew of in the Northwest, and certainly in Seattle, that was opposed to it. Art said one of the smartest things, which was that the left wing needs to find a way to reclaim

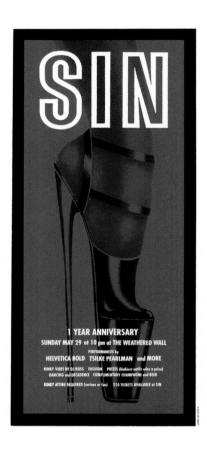

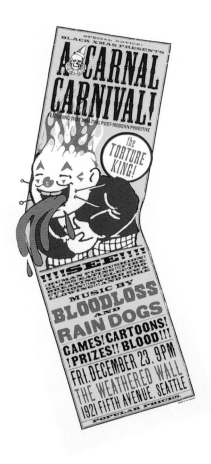

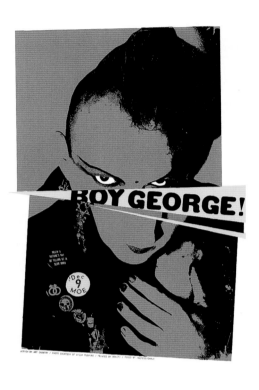

FIG. 2
Poster for a drag event celebrating
the first anniversary of the S&M store Sin, 1995.
("Helvetica Bold" is the drag identity of
sex-advice columnist Dan Savage.)

FIG. 3
Poster for Carnal Carnival, 1994. Chantry's interest
in subcultures has led him to collaborate with
a group living at perhaps the greatest intensity
and farthest remove from the norm—performance
artists enacting public displays of masochism.

FIG. 4
Boy George at Moe, 1995.
Photo supplied by Wilum Pugmire.

the American flag. We didn't. But that's something I still think about with some regularity." As the country recovered from an early-nineties recession and entered the longest period of prosperity it had ever known, Chantry grew less rather than more complacent. His activist edge became sharper, though he confined his interests mostly to local causes, from designing a provocatively packaged recording of instrumental music to protest the Washington state legislature's ban on "obscene" rock lyrics (an offshoot of Tipper Gore's national crusade) to creating posters for an annual Seattle rock festival promoting hemp as a substitute for wood pulp in paper production (Figs. 20–23).

His graphics became sharper, too; more and more they were playing the role of a devil's advocate, countering the propositions set forth by mainstream culture. In their rough textures and layers, they rebutted the slickness of advertising as well as the prissy derangement of many deconstructionist designs, which were beginning to crop up in TV commercials and annual reports. In their knowing parodies of commercial artifacts, they sassed postmodern styles and society's thoughtless nostalgia for what it believed was a more innocent past. In their frequent demonstration of greater simplicity, sometimes abandoning imagery and making type do all the work, they argued against their creator's own earlier approaches. Chantry's posters for the New City and Bathhouse theaters, for example, which he began designing in the

early eighties, had, by the nineties, become exercises in reduction (see pp. 63–65). His collage style was always deformative, of course—a ripping, smearing, recontextualizing interpretation of found imagery—but now he had more to take apart. And his reconstructions were different. He was finding new ways to put the pieces back together.

And this was happening not just in his work. After Chantry's marriage broke up in 1991, he moved into SCUD, an artists' collective founded in the mid-1970s and torn down in 1998. (Its quarters were also known as the Jell-O Mold Building because of the many doughnut-shaped metal containers tacked to the facade by an artist in 1990.) Located in Belltown, a gritty district in downtown Seattle, SCUD originally stood for Subterranean Cooperative of Urban Dreamers, but during the Gulf War, when Chantry moved in, the acronym was more commonly associated with the name of the missiles Iraq was firing on its neighbors, a coincidence that led alarmed post office workers to open letters addressed to residents.

SCUD, Chantry says, was "one of those hubs on the wheel of weirdness":

Yuppies would shoot the windows out of the building from their condos. Jack Kerouac once lived there. Steve Fisk lived there. Nirvana recorded in that building. William Burroughs would visit. An old SDS guy from Berkeley lived in the building under assumed names for twenty years. He was real good friends with Betty Shabazz.

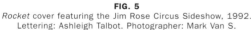

FIG. 5
Rocket cover featuring the Jim Rose Circus Sideshow, 1992.
Lettering: Ashleigh Talbot. Photographer: Mark Van S.

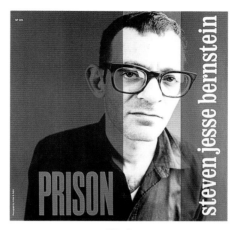

FIG. 6
Record cover for Steven Jesse Bernstein, a Seattle
poet-musician "imprisoned" by mental illness.
Photographer: Arthur S. Aubry. Client: Sub Pop, 1991.

FIG. 7
Rocket feature on Survival Research Laboratories,
May 1986. Photographer: Ed Colver.

Angela Davis would visit. Genesis P. Orridge was up there a lot. Remember those two vicious drunks who would argue and some guy would record them? He was there. It was a great place to be for a while, kind of like The Rocket, *though SCUD was deeper in the underground.*

In the eighties Chantry had pushed his own physical and emotional limits. Now, both in and out of SCUD, where he remained for two years, he watched other people dance to the edge and sometimes topple over: an underground comics artist who was obsessed with death and organized trips to find memorabilia like babies' coffins; a poet who ranted brilliantly through schizophrenic episodes and eventually took his own life; a transvestite who ignored taunts as he walked the streets of Seattle in a vampire costume and who gamely sought to keep his place in the Mormon church, even as he wore a dress to his excommunication hearing. Chantry admired these friends' searing, macabre passions, all the more as he reclaimed some equilibrium in his own life. He designed for and with them and felt electrified without imitating their self-annihilating impulses.

He was especially fascinated by performance artists who engaged in public displays of masochism. Here was the ultimate subculture, for what life could be lived more intensely and at a greater distance from the norm? One friend and client, Jim Rose, for example, organized a sideshow whose members indulged in a range of disturbing acts. Pointing to the group's picture on a *Rocket* cover, Chantry described the performers one

by one: "This guy would swallow swords and eat fire. This guy had piercings all over his body, and he would lift heavy weights hooked into them, including all those places you would wonder about. This guy is now tattooed head to toe with puzzle pieces. That's Jim Rose. He actually had darts stuck in him; he'd eat glass" (Fig. 5). For a 1994 Carnal Carnival event, Chantry designed what he believes might be the first "bent poster" in history, showing a masochistic clown known as the Torture King doubled over in sublime agony (Fig. 3). "We bent the posters one by one over our knees. It was a very painstaking, time-consuming process," he says.

Other acquaintances abused inanimate objects. The performance group Survival Research Laboratories won a *Rocket* article for building large robotic apparatuses out of junk and draping them occasionally with animal parts (Fig. 7). At least once, they used napalm in the act. Then there was the Seattle artist Dale Travous, who constructed plasma generators and giant Tesla coils, which sucked vast quantities of energy out of the city's grid, creating explosions or towers of shooting sparks. Chantry featured Travous's demonstrations on record covers he designed for the bands Man . . . or Astroman? and Pigeonhed (see "Case Study," Figs. 6, 33).

Among the eccentric do-it-yourselfers who inspired him, perhaps the oddest was Von Dutch (1929–1992), the father of hot-rod art. Born Kenneth Howard, Dutch

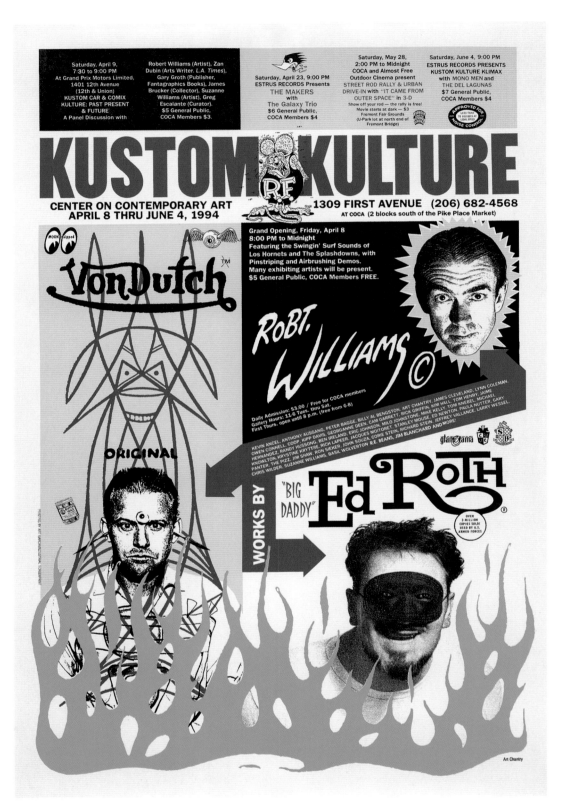

FIG. 8
Poster for "Kustom Kulture," a traveling art exhibit about the "holy trinity" of hot-rod artists: Von Dutch, Robert Williams, and Ed "Big Daddy" Roth. This was Chantry's greatest hit after his Tool poster, but he is quick to run it down. "The chaos offends me," he says. "But of course that's part of the idea." Client: Center on Contemporary Art, 1994.

FIG. 10
Poster for "Nirvana," a CoCA exhibition laced with Situationist diatribes about art's relationship to the marketplace, 1996.
Vacuum-forming: Matt Skenandore.

FIG. 9
Poster for a Center on Contemporary Art exhibition about machines constructed by artists, 1990. The work makes a veiled reference to North Carolina senator Jesse Helms (his is the face behind the gas mask), who was actively trying to curtail funding for the National Endowment for the Arts, one of CoCA's chief sponsors.

grew up in Los Angeles, where he could be seen roller-skating up and down Sunset Boulevard playing the flute and wearing a third eye glued to his forehead. "He'd have a couple of pinstriping brushes sticking out of his ears, and his shirt would be airbrushed with images of monsters," Chantry relates. According to Pat Ganahl, senior editor of *Rod & Custom* magazine, Dutch "turned the craft of pinstriping—used for centuries as ornamentation on furniture, musical instruments, carriages, bicycles, and early motor vehicles—into a completely new, enigmatic and intriguing art form."[3] He was also a master machinist. "He would make his own hi-fi equipment out of musical instruments," Chantry says. "He had speakers made out of trombones and French horns. He was also one of the first guys to scratch-build a hot rod, taking a part from here, a chunk of metal from there, putting it on his grinding wheel, and voilà!"

In other words, Dutch was the prototype of a subculturist, an outsider genius who translated raw metal and paint into a Bosch-like language of demons and flames (the latter were borrowed from World War II aircraft, where they appeared near the exhaust manifold, a placement later imitated on cars).[4] His logo, the flying eyeball, suggested mystical powers of detachment and omniscience and inspired the bloodshot eyes of Rat Fink, the cartoon mascot of his disciple Ed "Big Daddy"

Roth. Alcoholic, virtually a transient, Dutch directed his energies toward the expression of his own mad visions, which gave them, in Chantry's view, an irresistible purity. They also appealed to a post–World War II group of dislocated young men in southern California with a passion for cars. Like Dr. Frankenstein plundering cemeteries for raw material with which to build his creation, members of this culture scoured junkyards to make and animate extensions of themselves—vehicles that were symbols of power and aspiration. For this reason, the custom car graphics that Dutch popularized weren't just decorative; their pinstriped curlicues boasted of easy handling, and their flames threatened a fiery death to competitors. True hot-rodders, who stripped down the vehicle to its essentials, disdained custom cars because of their showiness, Chantry explains. But the adornment signified the artistry invested in each car's mechanics and the individuality of its customizer. The automobile became a superhuman enhancement of the driver, who was reduced to a point of intelligence behind the wheel.

Kustom Kulture, Chantry's direct homage to custom car design, is a 1994 poster that promoted a traveling exhibition of that title at Seattle's Center on Contemporary Art (Fig. 8). Dedicated to the "holy trinity" of the craft's chief innovators, Ed Roth (Father), Robert Williams (Son), and Von Dutch (Holy Spirit), the poster was Chantry's

FIG. 11

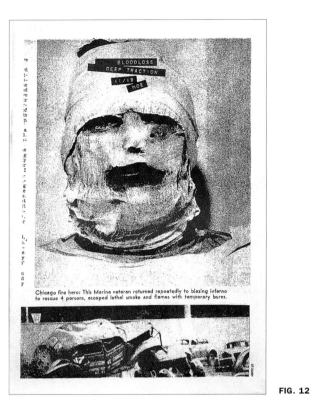

FIG. 12

FIG. 13

FIGS. 11–13
Concert posters featured in The *Moe-tivator,*
a promotional publication for the Seattle club Moe,
which finessed the city's poster ban, 1994.

FIG. 14
Chantry was an obvious choice for cover designer of
The Stranger when the Seattle alternative weekly reported
on the poster ban, 1997. Art director: Dale Yarger.

FIG. 15
First cover of *Slant,* in-house publication of Urban Outfitters, 1995.

FIG. 16
Page from *Slant,* 1996.
Co-designer: Jamie Sheehan.

Moe T-shirt designs, 1993–1995.

most popular after his Tool series. He used vibrating colors to set the viewer's eyes rattling and cast Dutch and Roth into green flames, alluding not just to their designs but also to their rabid right-wing politics, which he had first encountered when Dutch turned in a hate-filled *Rocket* commission (see chapter 5). Within this scheme, Chantry represented Von Dutch as the "mad visionary," Ed Roth as the "evil jester," and Robert Williams as the "contemporary wizard." "I was trying to create a fake religious structure, but it's also supposed to look like *Car Craft* magazine," he says. Though a silk-screen version is one of his biggest sellers, he is quick to put down the poster: "The chaos offends me, but of course that's part of the idea."

Ironically, Kustom Kulture helped to raise public consciousness about this subculture just as Seattle's city council was voting in 1994 to ban posters as an outdoor advertising medium, a move that Chantry and others believe helped to throttle the life out of the underground. After two failed efforts in the eighties, the Poster Ban Ordinance was pushed through by city council member Jane Noland, who insisted that the staples used for attaching the notices injured utility workers climbing telephone poles. Noland's statement defied credibility. ("Now I don't know about you, but the last time I saw anyone scaling up or down a utility pole was in an episode of 'Green Acres,'" quips the website of JAMPAC, the Joint Artists and Music Promotions Political

Action Committee, based in Washington state, which demands that the city make good on its promise to erect kiosks.)[5] Noland and her supporters also claimed that the posters clogged sewage lines, a charge they were forced to retract when it was demonstrated that the drains were in fact being filled with mud from new construction. Another argument was that the paper-laden utility poles were targets for arsonists; in fact, Chantry says, the city itself inadvertently ignited a few poles on Broadway in its effort to strip them of their thick encrustations.

The true source of Seattle's distaste for street posters, Chantry insists, was buried in these feeble charges: the posters were untidy, and the council members who resented the mess were backed up by local business leaders irritated by this free advertising medium (not that posters are truly free, he points out: "they're labor-intensive and in the end probably more expensive than buying an ad"). Under the ordinance's provisions, even lost-pet notices are forbidden, but rock posters were the real target, Chantry says; the act was "really an attempt to prevent an otherwise disenfranchised minority from having a chance to converse. Some of the clubs couldn't even afford telephones." The fine for an illegal posting in Seattle is $500 per poster, extracted from each person or entity involved, including the designer, the club, and the individual who tacked up the notice.

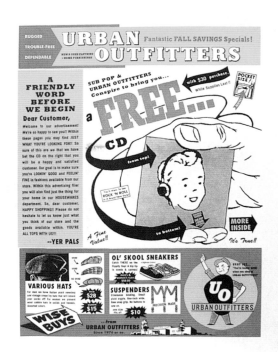

FIG. 17
Mailer for Urban Outfitters, designed,
at the client's request, to be "Tool-looking," 1995.

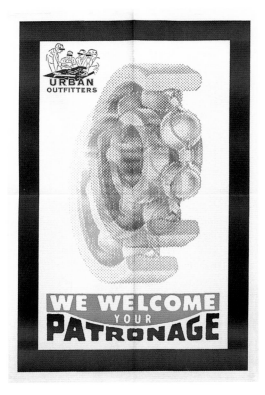

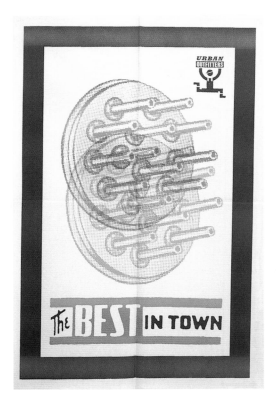

FIGS. 18 & 19
Part of a series of newsprint posters for Urban Outfitters, 1996. The stores distributed 3-D glasses at the door, but since
the works weren't actually printed three-dimensionally, "the glasses," Chantry says, "only gave people headaches."

FIGS. 20 & 21
Hempfest is an annual event in Seattle dedicated to overturning federal legislation that forbids the growth of hemp in the U.S. Since 1994,
Chantry and Jamie Sheehan have designed the festival's poster on hemp paper to demonstrate the material's effectiveness.

Though they didn't disappear entirely from cafés and clubs, Seattle's posters lost their rawness. No longer burbling up on the streets chaotically, alluding to events themselves organized spontaneously and on shoestring resources, they were replaced, indoors, by an artier crop—multicolored, silk-screened prints made slicker by the growing use of desktop computers. In Chantry's view, what was occurring was the malling of mass media, a graphic gentrification that signified the way underground culture itself was becoming suppressed. A crucial link connecting the performer to a potential audience was severed at a time when few other media, including alternative newspapers and radio stations, existed to unite them. Combined with skyrocketing rents and strict liquor laws inherited from Prohibition, the ban helped to stifle Seattle's cultural vibrancy, contributing to what recent opinion writers for the *Seattle Post-Intelligencer* describe as a city that has "become hostile to live music, street art, sidewalk cafes."[6]

Chantry took immediate action. Since the law made no mention of the public display of magazines, he created *The Moe-tivator,* a poster-size newsprint tabloid for one of his regular clients, the Seattle rock club Moe, and commissioned artists and designers to create a single or double-truck image for each of its eight to sixteen pages (Figs. 11–13). Now he had effectively eight to sixteen posters bound together

to promote Moe's bands, and he affixed the lot to telephone poles without being fined. Five issues were produced, and each edition quickly disappeared from the streets, not because neatniks were disturbed but because the magazines became collectibles. One of the saddest results of the ban, Chantry believes, is that it helped turn posters from a source of information into a commodity. Just as he had almost persuaded the artist Jacob Lawrence to contribute to the sixth issue of *The Moe-tivator,* the client decided that the costs outweighed the benefits and canceled the project. Chantry continued to be identified with challenges to the ordinance, however. When *The Stranger* ran an April 1997 feature on the ban, he was asked to design the cover (Fig. 14).

Though underground activity diminished after the ban, tolerance for playful approaches grew independently among some mainstream clients. One such was Howard Brown, art director of the Philadelphia-based retailer Urban Outfitters. Impressed by *The Moe-tivator,* Brown hired Chantry to design the prototype for an in-store magazine, *Slant,* with oversize newprint pages featuring works contributed by an array of artists (Figs. 15, 16). Brown's taste for anti-design also led him to commission catalogs from Chantry that overflowed with retro clip art and "bonehead" copy written by Hank Trotter. Chantry designed newsprint display posters as well, with out-of-

FIG. 22 Front
The 1998 "Hemp Money" poster for Hempfest (Figs. 22 & 23) was lettered
by psychedelic-poster artist Scott McDougall.

FIG. 23 Back

register multicolored type that looked as though it should have been readable with 3-D glasses but wasn't (Figs. 18, 19). "The store was wallpapered with these things. All they would do is give you a headache," Chantry says, adding, "On every poster I'd do a stupid logo. I was trying to find arcane machine images that made no sense at all."

As for more direct political engagement, in 1994 Chantry met the designer Jamie Sheehan, who asked him to collaborate on posters for Hempfest, an annual festival that raises money to reverse legislation restricting the production and marketing of hemp in the United States. "I don't give a shit about marijuana, but I really support hemp causes," he says.

So long as the seeds are sterilized it's legal to sell them in this country for cooking, but you still can't make paper out of hemp. Instead, we're cutting down old-growth forests, and in this state, they've been devastated. Our salmon runs are becoming extinct because of the pollution from the clear cuts. You can get more museum-grade paper out of one acre of hemp than you can out of five acres of trees. So why can't we produce it? Industrial hemp is grown for fiber, not bud. There's no THC; you can smoke a whole acre and not get high. You can throw seeds on the ground and they will sprout and grow like dandelions. But the government makes it expensive because of the high security surrounding the crop.

Using hemp paper imported from Hungary, Chantry and Sheehan designed their first Hempfest poster as a cigarette box parody with an imitation Surgeon General's warning spelling out the plant's virtues as a paper substitute and reliever of nausea for patients undergoing chemotherapy (Fig. 20). Another version was printed on hemp burlap. The next year, "after the cops gave everybody such a hard time at the first Hempfest," their poster featured an antiquated photo of a policeman wearing surgical gloves (Fig. 21). "It's supposed to look like a *Reefer Madness* advert," Chantry explains. For the 1998 version, Chantry and Sheehan did a psychedelic riff on the dollar bill. After printing the intricate two-sided design, which was filled with joking allusions to hemp, they rubber-stamped the message "I grew hemp" as a dialogue bubble emanating from the lips of George Washington (Figs. 22, 23).

By the late nineties, with double entendres and anatomical references ready for prime-time TV, even advertising could tolerate some earthiness, especially for a good cause. The Seattle advertising agency Cole and Weber asked Chantry to design a print campaign promoting condom use among gays, women, and minority groups in the style of his Tool poster. For the version directed at gay men, Chantry featured another clean-cut policeman. This one flourishes a condom next to the headline "I take one everywhere I take my PENIS!!" (Fig. 24). Eventually, the

FIG. 24
Chantry was approached by the Cole and Weber ad agency to apply his Tool style to a poster promoting condom use, 1997.
Ultimately distributed by the Washington State Department of Health and Social Services, the Penis Cop poster,
as it is commonly known, won a bronze Lion at the Cannes festival for international advertising.

FIG. 25
Moe rejected this poster for a Flaming Lips concert as offensive to women. In fact, the body belongs to a male transvestite, 1995.

FIG. 26
Pearl Harbor Day concert poster for Teengenerate, a Japanese punk band, printed on metal sheets and pierced with bullet holes, 1995. Shooters: Michael "Dead Eye" Decker, Collin "Sure Shot" Shutz, Jamie "Buckshot" Sheehan, and Arthur "Chicken" Chantry.

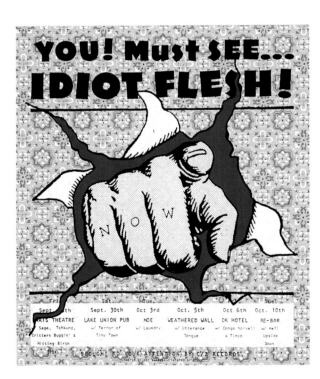

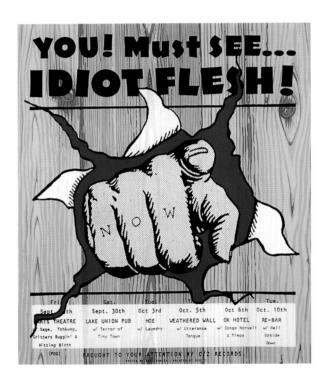

FIGS. 27 & 28
Posters for Idiot Flesh printed on wallpaper samples. Client: C/Z Records, 1995.

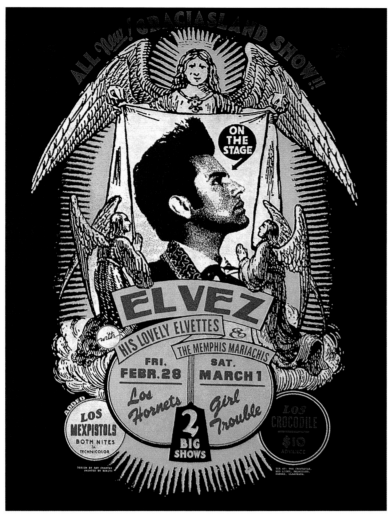

FIG. 29
Poster for El Vez silk-screened on black velveteen
"for that proper East L.A. look," says Chantry, 1997.

FIG. 30
Chantry silk-screened this poster for Moe with silver ink on a
twelve-inch vinyl LP. Only one nail was needed to hang it, 1995.

FIG. 31
Votive candle wedding invitations, 1994. Client: Nancy Hom.

idea was sold to the Washington State Department of Health and Social Services, which presented the image on bus cards, fliers, and a painted building sign as well as posters. Penis Cop, as the work is dubbed, won Chantry several awards, including a Bronze Lion at the 1996 international advertising festival in Cannes, France.

Roughing up the sensibilities of the establishment has always been a temptation for Chantry. His roots are in the sixties, when *pornography* was not a dirty word for liberals—when highbrow editors were threatened with prison sentences for sexual material that is laughably tame by today's standards, and when the word *lewd* branded the books of J. D. Salinger as readily as the peep shows in Times Square. Prudery then was often seen to be aligned with conservative attitudes such as support of segregation and of the war in Vietnam, while free love was frequently an act of social defiance as much as a personal indulgence. Today, flagrant sexual imagery has lost some of its First Amendment edge, on the one hand because it meets fewer challenges in America's far more tolerant climate, and on the other because activists have persuasively linked pornography to violence against women. Still, such imagery continues to challenge right-wing values when it makes an appearance in underground comics, music, and art.

It's no surprise that when Chantry adopts pornography, he often picks up images

from earlier decades, mixing irony, even quaintness, into the theme of arousal. His subjects are nudes from 1950s men's magazines—not *Playboy,* but more precious ones with names like *Cocktail* and *Satan.* He borrows their line drawings of perky women lounging in champagne glasses, sprites rather than vixens. Or he represents meaty porn queens from the decade. More real but no less campy than the bubbly girls, they also allude to a time when guilty pleasure could be had through much milder displays of flesh. The twist in Chantry's retrosexual imagery is that it evokes so much innocence and is even celebratory. "I'm lifting it out of our parents' generation and reintroducing it with a whole new set of meanings," he explains. "Female sexuality has become a source of empowerment and beauty for some women."

As a result, Chantry is bewildered by accusations of sexism in his work, which largely result from misunderstandings. For instance, the club Moe rejected a poster design for the band Flaming Lips as offensive to women, though the fiery crotch in the work clearly belongs to a transvestite (Fig. 25). (Strangely, the club chose to replace the image with one of a breast crawling with flies.) More to the point, women band members themselves use pornography as a weapon stolen from their aggressors and turned against them, Chantry notes, offering Courtney Love as an example. Though most female musicians involved in the punk and grunge scenes were expelled "as soon

FIG. 32
Legends of the Accordion CD cover for Rhino Records, 1996. Art director: Coco Shinomiya. Note the "accordion" fold.

FIGS. 33–35
The tastelessness of Chantry's imagery for a CD release by The Thrown Ups, a Seattle grunge band, is rivaled only by the song titles, including "Your Band Sucks," "Sparse Tits," "Hairy Crater Man," and "Scabby Like My Love." Still, the design is strikingly refined. Co-designers: Leighton Beezer, Marla Katz, and Judah. Client: Amphetamine Reptile, 1997.

FIGS. 36 & 37
Chantry silk-screened Day-Glo inks on the front and back covers of a single by the band Impala
to create the effect of a window display card for a strip joint. Client: Estrus Records, 1996.

FIG. 38
Chantry describes The Inhalants as "a super-purist lo-fi punk band from Austin, Texas. The members had a list of about thirty things
they didn't want on this LP, including their picture, the songs, and the titles, but said nothing about what they did want." His solution
was a black sleeve holding a white disk that is bare of everything except the band's appropriately square photo on the label.
Client: Estrus Records, 1995.

FIG. 39

In the mid-1990s, Chantry redesigned *Boycott Quarterly*, a magazine that reported on active boycotts. He anchored the cover of each issue with a redrawn corporate logotype that illustrated the main feature. The winter 1997 cover makes a sharp comment on racist employment practices uncovered at Texaco. Illustrator: Jamie Sheehan.

FIG. 40

"Hands Off Washington" benefit concert poster, 1994.

Washington Music Industry
Coalition logo, 1992.

Pike Place Market Foundation
logo, 1994.

Benefit record cover
typography, 1989.

Logo for Art Targets AIDS
benefit at CoCA, 1993.

Earth Police logo, 1987.

T-shirt for Seattle ACT UP, 1989.

FIG. 41
Poster for the annual Fremont Fair. The client refused to allow Chantry to show the statue of Lenin that is the once bohemian neighborhood's best-known symbol, so Chantry improvised—a Lenin-meets-Lennon approach, 1998.

FIG. 42
This cover for the final
concert recording of punk
legends Poison Idea was
pieced together with old
record covers and duct tape.
Client: Sub Pop, 1996.

FIG. 43
The Crown Royals are
a soul/funk/jazz review
from Chicago that includes
MacArthur award winner
Ken Vandermark.
Photographer: Marty Perez.
Client: Estrus Records, 1999.

FIG. 44
The title of this 45 by the
band Pond is simply "Moth."
Client: Sub Pop, 1996.

FIG. 45
A reissue of classic cuts
by the original Northwest
punks, The Sonics.
Photographer: Jini Dellaccio.
Client: Jerden Records, 1994.

FIG. 46
This cover was inspired
by a band member's
remark that the group
had spent way too many
years playing in bars.
Client: Estrus Records, 1997.

FIG. 47
This Von Zippers single
Twist Off was designed
to look like a used bottle
cap from the band's
favorite Bavarian lager.
Client: Estrus Records, 1998.

FIG. 48
For Steve and the Jerks,
a band infatuated with the
comedian Steve Martin,
Chantry printed the LP's
cover photo upside down and
tossed in the universal icon
denoting "This End Up."
Client: Royal Records, 1997.

FIG. 49
For this CD/LP for The
Kent 3, Chantry printed
Day-Glo orange over black—
"a total heresy," he says,
"but it worked really well."
Client: Super Electro Sound
Recordings, 1998.

FIG. 50
CD cover for The Presidents of
The United States of America.
"The band insisted on the
extended version of its name
at all times," Chantry says.
Photographer: Conrad Uno.
Client: Popllama, 1995.

FIG. 51
Limited European-release LP
featuring undoctored photo of
The Presidents of The United
States of America, 1996.

FIG. 52
This King of Hawaii CD
is designed around
a childhood photo
of guitarist/singer
Mark Klebeck's mother.
Client: Mark Klebeck, 1997.

FIG. 53
CD for Forgotten Rebels,
an aptly titled early punk
band from Canada.
Client: Dionysis Records, 1997.

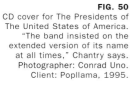

FIG. 54–56
Front and back covers and inside spread
from promotion for Utopia/Appleton
Papers. The portrait on the back cover
is of Bruce Pavitt wearing a T-shirt that
Chantry designed, 1997.
Back cover photograph: Arthur S. Aubry.

as money entered the picture," he says, garage rock "has maintained a very active involvement with women conceptually, financially, all the way down the line. A lot of the bands are all-women bands. There's one called The Trashwomen that used to wear kitty cat bikini outfits, and one of the members weighed three hundred pounds. I've seen The 5-6-7-8's do a striptease down to their panties. They're the ones who instigate the sexist imagery."

After moving out of SCUD, Chantry settled into an apartment in a Mediterranean-style turn-of-the-century building on Queen Anne Hill with a view of Puget Sound and filled it with vintage treasures plucked from used furniture stores and garage sales. In 1994, he left the studio he shared with Hank Trotter in the old Compton Lumber Building on Western Avenue and found space at the School of Visual Concepts, which Jamie Sheehan also occupied. A parade of clients, friends, freelance artists, students, and neighbors dropped in, mixing work and social life—realms that Chantry has never seen much use in segregating.

Never shy about printing on any medium that takes ink, Chantry in the mid- to late nineties grew even more experimental with materials. He silk-screened a 1994 wedding invitation onto the glass holder of a votive candle (Fig. 31). He designed 1995 concert posters with wallpaper cut from an old sample book (Figs. 27, 28), and silk-screened another onto a twelve-inch vinyl LP with silver ink; only one nail—driven through the hole in the middle—was required to hang it (Fig. 30). For a 1997 concert by the Mexican Elvis impersonator El Vez, he used a backdrop of black velveteen paper to achieve "that proper East L.A. look" (Fig. 29). A CoCA exhibition called "Nirvana" about art's relationship to the marketplace prompted a Situationist-inspired vacuum-formed plastic sheet shaped like Mickey Mouse's head, which was made up of newspaper advertising that Chantry assembled out of scraps of vintage samples; also pressed into the form are the outlines of a Barbie doll and a Mr. Peanut served on a platter (Fig. 10). For a 1997 Pearl Harbor Day concert by Teengenerate, a Japanese punk band, he silk-screened a rising sun on metal sheets; then he and some friends fired bullets through the back of each poster with an AK-47 and a .45 automatic (Fig. 26). The metal came from an aborted Nine Inch Nails poster project designed by Grant Alden and Jeff Kleinsmith. The typeface was borrowed from the NRA (as in Franklin Roosevelt's National Recovery Administration, not the National Rifle Association) logo. "Nobody can tell the difference," Chantry says, "but it makes a great joke."

Frequently invited to present his work, Chantry has lectured at schools and design conferences throughout the United States. His posters have traveled on their own as well, entering the collections of the Smithsonian Institution in Washington, D.C., the

FIG. 57
Cover design for book about Seattle's surprisingly
rich jazz heritage. Client: Sasquatch Press, 1996.

FIG. 58
Book cover design for a collection of short stories
by metal maven/horror fanboy Jeff Gilbert.
Client: Hairball Press, 1995.

Logo for performance artists,
Sykes Group, 1996.

Annex Theater logo, 1994.

Annex Theater logo, 1994.

Seattle park celebration logo, 1992.

Logo for jazz society, 1992.

Proposed letterhead for self-help author, 1992.

FIGS. 59–62
By the 1990s, type began to do all the work in Chantry's theater posters, especially a series for New City Theater. His
1993 poster for a Sam Shepard double bill features old, cracked, press type (Fig. 59). Fig. 60's text was rubber-stamped,
Fig. 61's was lifted directly from the client's fax, and Fig. 62's is indebted to a manual typewriter.

FIG. 60

WORKING
SPACE./
New DAnce at New City
August 10-21 Wed-SuN 8 PM
Tickets $3 Call 323-6800

New Work From:
PAT GRANEY
LONG NGUYEN
GEORGIA RAGSDALE
MICHAEL CAVALLI
TASHA COOK
KARN JUNKINS
AIDAN THOMPSON
ANNIE MERCER

WORKING SPACE is for dancers & choreographers who want to exhibit short, new works & works-in-progress. The environment is stripped down to the minimum space to move, resilient floor, lights, & an essential audience surrounding the dance space.
New City Theater, 1634 11th Ave., Capitol Hill, Seattle, USA

FOSTER BY ART CHANTRY

FIG. 61

BiLLY
SOLO
THEATER FESTIVAL
AT THE
New City SEPT. - OCT.
CAPITOL HILL · SEATTLE · 323-6800

dear seattle,
i think you should come
to this festival. artists
from other parts of the
country are coming. los
angeles san fransisco
austin texas. plus really
good people from here.
really good people. from
right here in your own
home town. very smart.
very beautiful funny some
of them. strange. the
pieces are interesting work
all made by their own hands.
fourteen of them. people, not
hands - fourteen ARTISTS.
four weeks. in September and
October and tickets are
only eight dollars. and
sometimes you get to see
four whole pieces in one
evening. it'll be great. it'll
be really great if you're there.
call 323-6800 for a
reservation. bring a friend. see
you
Love, BiLLY ps. it's at new
city
theater

FIG. 62

PLay-
wrig-
hts
Fest-
ival.
nov -
dec.
NEW
CITy
323
6800.

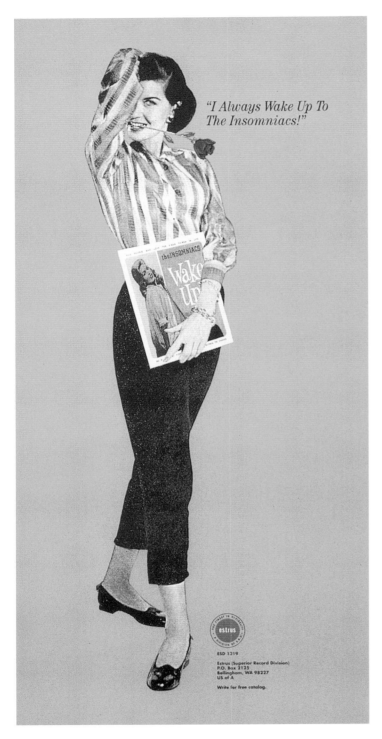

FIG. 63
Insomniacs promo poster. Client: Estrus Records, 1995.

FIG. 64
Valentine mystery date event.
Client: The Swedish Housewife, 1997.

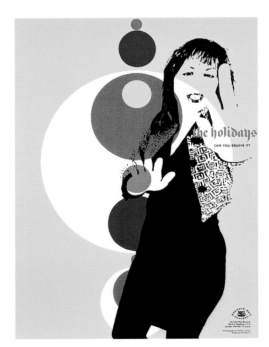

FIG. 65
Promo poster for The Holidays.
Client: Chuckie-Boy Records, 1992.

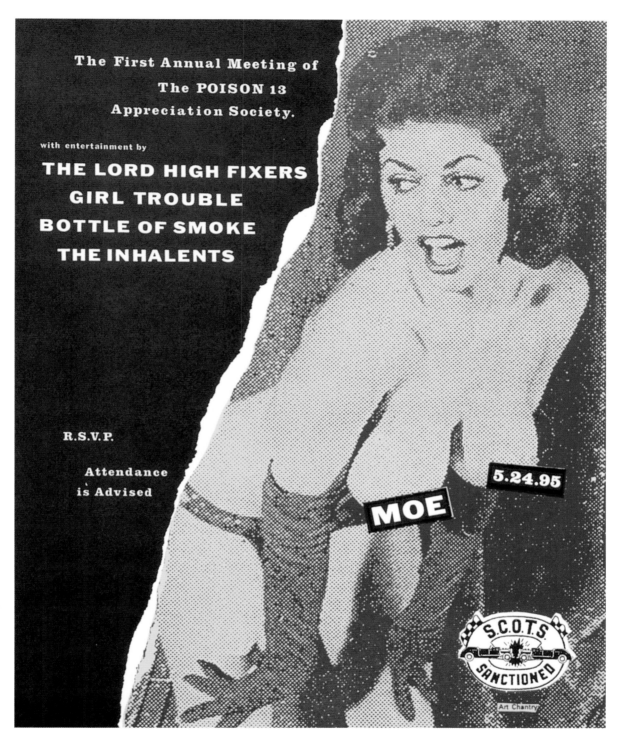

FIG. 66
Concert poster for Moe, 1995.

"Seamless Enterprise—Wide Synergy,"
T-shirt design for rock group Sunny Day Real Estate. Client: Sub Pop, 1995.

Record company logo, 1996.

Logo for Trash City Records, 1994.

Record company logo, 1992.

Record company logo, 1995.

Music event design, 1996.

Arts/music event design, 2000.

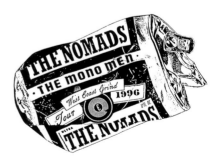

Tour T-shirt design, 1996.

Music event logo (unpublished), 1997.

Record company logo, 1995.

Record company logo, 1992.

Record company logo, 1994.

Record company logo, 1994.

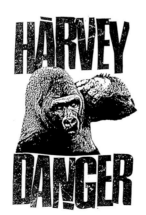

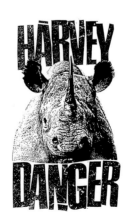

Tour T-shirt designs for rock group, 1998.

0129

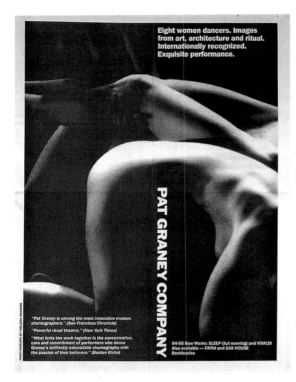

FIG. 67

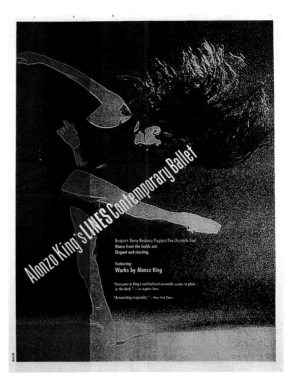

FIG. 68

FIG. 69

FIG. 70

FIGS. 67–71
Pages from a brochure for Nemzoff/Roth Touring Artists, a company promoting performing artists, 1994–1997.
Chantry designed the images also to work as eighteen-by-twenty-four-inch posters to advertise the booked events.
Photographers: Helena Rogers (Fig. 67), Marty Sohl (Figs. 68, 71), Marit Brook-Kothlow (Fig. 69), Kim Zumwalt, (Fig. 70).

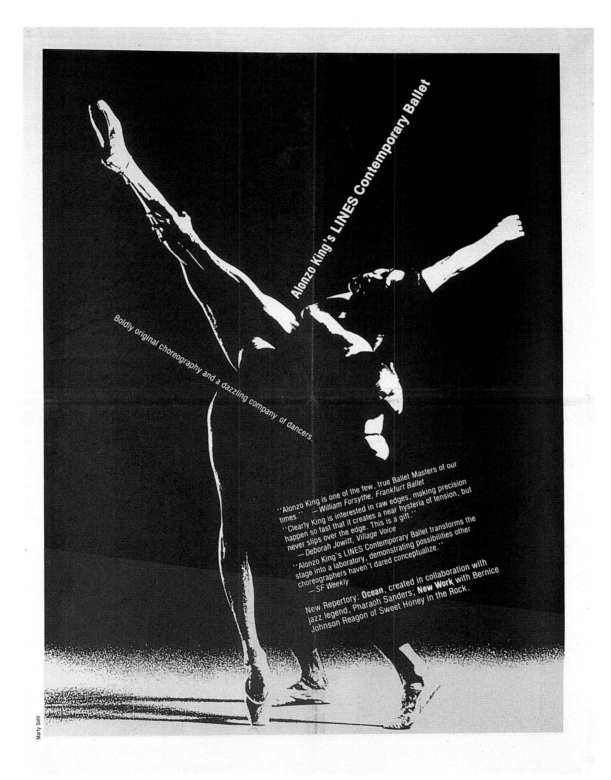

FIG. 71

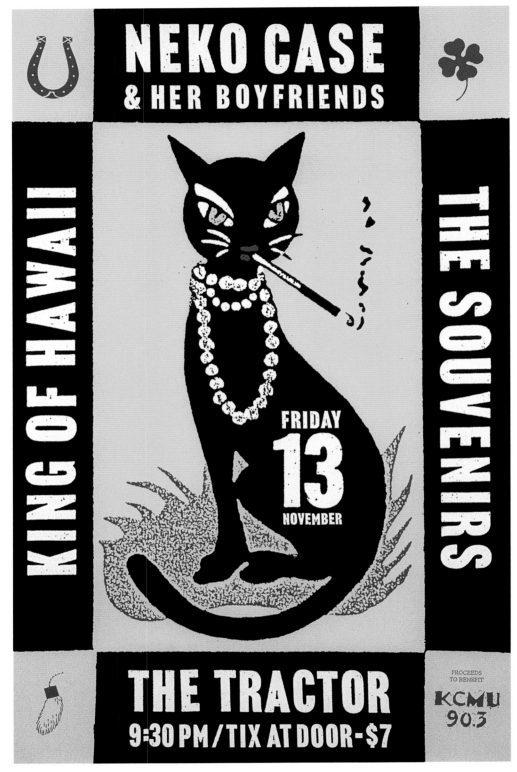

FIG. 72
Concert poster for Neko Case and Her Boyfriends. Client: Mark Klebeck and King of Hawaii, 1998.

Record store logo, 1998.

Snow surfing equipment logo, 1999.

Theater company logo, 1993.

Logo for interior designer, 1994.

Refrigerator magnets logo, 1996.

Record cover typography, 1998.

Blacksmith logo, 1996.

Tavern club logo, 1995.

Catalog cover logo, 1996.

Museum of Modern Art in New York, and the Rock and Roll Hall of Fame in Cleveland, among many others. They are anthologized in scores of books devoted to everything from low-budget design to the best posters produced in the last half-century. His most popular works sell in galleries for hundreds of dollars. An earnest coterie of youthful Chantry fanatics post interviews with him on the Web that usually begin with a grateful tribute to his accessibility—how he takes their calls, patiently answers their questions, and sends piles of graphics for their sites.

Though a fixture on the Seattle design scene, he remains aloof from its organizations, which to him foster as much one-upsmanship among members feeding from the same small pool of corporate accounts as they do a sense of camaraderie. Closer connections are forged with artists in other cities—Portland, San Francisco, Los Angeles, Minneapolis, Nashville, New York—who have a similar, culturally oriented practice or who share his interest in graphic historicism. One recent foray he has made into the corporate sector was joining an advisory board for Utopia, a division of Appleton Paper. In 1997, he designed a promotional brochure for the company that opens with a beautifully roughened black-and-white portrait of a baby reaching for the word *utopia* and concludes with a photo of Sub Pop founder Bruce Pavitt wearing a T-shirt that Chantry designed. Its message is "I ♥ Payola" (Figs. 54–56).

Recently, in his School of Visual Concepts studio, Chantry pointed to a mesmerizing tattoo snaking up his right arm in an abstract pattern of blue, red, and green. It is, he says, a litmus test of his commissions—if a potential client fakes nonchalance when the tattoo is exposed, Chantry believes the relationship is doomed. One finds it hard to imagine anyone being seriously disturbed by the mark, for like most of Chantry's subcultural expressions, it is a stunning piece of design. And it's not something he acquired haphazardly, but as an ongoing project begun in his forties with an artist who has collaborated with him on other work. However raw the materials or raucous the content, a pristine aesthetic sensibility almost always dominates Chantry's art. Clearly the tattoo is meant to signify his commitment to the fringe—not exactly a world of drunken sailors or rebellious punks, but somewhere beyond a heartland of conventional expectations. Only if others accept his nonconformity or are honest about their discomfort can Chantry himself feel comfortable with them, but the litmus test is not as simple as he thinks: he has his own ambivalence about the margins, which starts with his anxiety about where precisely they lie and whether they exact too high a price for occupancy. "It is my home," he said about Tacoma at the conclusion of one of his hilarious descriptions of the city's horrors, though Tacoma stopped being home many years ago. Chantry draws so much creative energy from outlaw places that it

FIG. 73
Poster for "The Fourth of Jul-Ivar's," a fireworks display sponsored by Ivar's Seafood Restaurants
in Seattle, 1999. Chantry and designer Jamie Sheehan culled through the advertising archives
of the venerable eatery to create this return to camp.

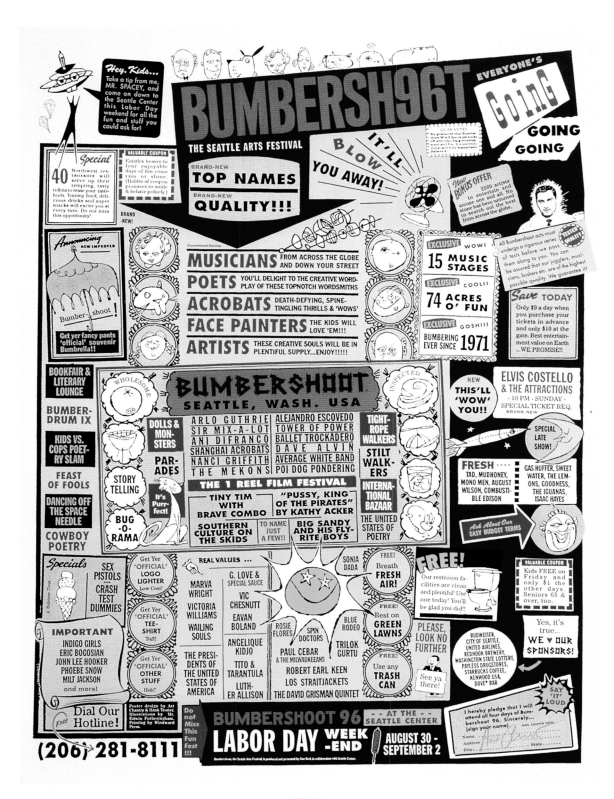

FIG. 74
Poster for Bumbershoot, 1996. Chantry worked with Hank Trotter on the copy and design and Edwin Fotheringham on the illustrations to produce this promotion for the annual arts festival. "Usually a Bumbershoot poster is a big picture with a lot of text around it, because you have to put in so much information, so we treated the text itself as a cheesy piece of advertising," he explains.

FIG. 75
CD cover for a Japanese garage band.
Client: Estrus Records, 1999.

FIG. 76
CD/LP cover for the band Pussy Galore.
Photographer: Michael Lavine. Logo: Nate Kato.
Client: In the Red Records, 1998.

FIG. 77
45 cover for the band Electric Frankenstein.
Client: Estrus Records, 1998.

FIG. 78
45 cover for a Japanese rock band.
Client: Estrus Records, 1998.

FIG. 79
CD/LP cover for a French punk band.
Client: Estrus Records, 1999.

FIG. 80
CD cover for Cookie.
Client: Sabrina Rockarena, 1999.

unnerves him to imagine stepping physically or emotionally into another kind of territory where people lead constrained, clockwork lives and may not always be ready for war. And yet such regions are often difficult to map. More than a litmus test, the tattoo represents a border between conformity and inspiration, safety and danger. And as with all borders—segregating cultures, classes, historical eras, or artistic genres—Chantry's first impulse is to blur the lines.

His sense of the fringe, too, is where he acquired his values. "He is the most moral and ethical designer I have ever met or can imagine," says Hank Trotter, a plainspoken man not given to exaggeration. Chantry works on the reasonable assumption that the marginalized are shunted to the edges mostly out of a simple fear of difference, and his sensitivity toward those classified as outcasts extends to their graphic projections— the images and texts he retrieves from the dustbin of history. Far from being charitable, however, he values such work for its authenticity and the struggle of producing it. Not least, he is impressed by the power of these often naive forms. "He's the only designer I know who talks about not only the history of art, but also the cultural weight of each piece he incorporates," Trotter adds. "I think very few designers put this kind of thought into their work, and because of it, I'm amazed that he's as prolific as he is. It's wound up with his process of designing by hand. He's not at a computer screen, where

things just happen, but has time to think about the clip art or type he's found and where it comes from and what it means."

Asked to define art, Andy Warhol once quipped that Art is a boy's name. Art Chantry's identity is, in fact, twinned with his work. His days are spent in constant assemblage—by his own estimate, he has designed more than three thousand posters, five hundred record or CD covers, and five thousand logos, not to mention *Rocket* layouts, magazines, books, brochures, advertising, and stationery. And though the visual dominates, sound is their natural medium. In his studio, with its view of the Space Needle, he labors serenely through the chatter of guests, incessant phone ringing, music grinding out of an antiquated turntable, a humming fax and photocopy machine, and the squawk of Sheehan's pet parrot. Demonstrating the overlooked fact that the best graphic designers have a sharp ear as well as eye, he enlivens his designs with the snap of a copy line, buzz of color, fugue of overlapping images, and their attenuated echoes out of the past.

From these sensory jumbles, he fashions whole, resolved creations that have an extraordinary effect on viewers. One recent visitor to his studio recalls how she first met Chantry in the early nineties. She had collected his posters for years, tacking them to the walls of her Manhattan apartment. Learning that he would be speaking at a

FIG. 81
T-shirt design for Happy Dead Guy, 1986.

design conference in Philadelphia, she made a point of showing up just to hear him. He was in his late thirties then, fair skinned, reddish haired, dressed casually in jeans, a button-down shirt, and clogs. He lectured to a rapt audience on the virtues of monster type and displayed part of his collection of more than a hundred science-fiction paperbacks with the word *strange* in the title. During a break, the woman worked up the nerve to talk to him, but he was surrounded by groupies, and she hung back. The opportunity presented itself at midnight, however, when the fire alarm rang in her hotel and she ran into Chantry on the twelfth-floor stairwell, along with other guests fleeing the presumably burning building. She recalls having managed to scurry into jeans by then, but he swears she was wearing pajamas. No matter: out of encounters like that not just friendships but books are born. This book can only hint at the complexities of an underground-lurking, monster-loving, self-described iconoclast who has influenced legions of designers around the world while enlivening Seattle's streets. Art Chantry made it memorable to saunter down all those stairs for nothing (false alarm) and emerge into a rainy night. Long may he set off bells.

USDA CHOICE

ART CHANTRY

314·
773·
9421

Bonus Buy!

188
·
Lb.

In March 2000,
shortly after this book was completed,
Art Chantry moved to St. Louis.
His disenchantment with Seattle's
gentrifying neighborhoods, traffic snarls,
and anemic street life overwhelmed him.
Most of his friends had fled. Subcultures
had almost completely capitulated to
Internet prosperity. Yin had won out.
Or was it yang? He forgot.

With Jamie Sheehan, he bought
a beautifully preserved Victorian house
that has six bedrooms and cost less
than half the price of a handyman
special in their old neighborhood.
Chantry's studio takes up an entire floor.
You can find him there designing in
relative quiet. Except for the music.
And the parrot.

FIG. 1
Front and back LP cover for Pigeonhed. Client: Sub Pop, 1994.

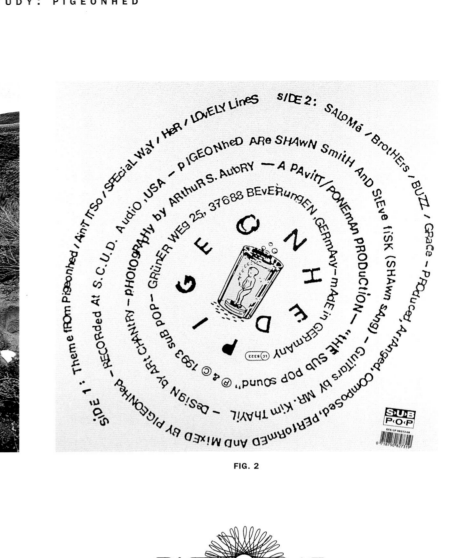

FIG. 2

RATHER THAN PRAISE ADVANCED technology, Chantry took an oppositional approach with his record graphics for the techno-soul duo Pigeonhed. The cover of the band's 1993 *Pigeonhed* release was shot by Arthur S. Aubry at the Hanford Nuclear Reservation in eastern Washington (Fig. 3). "The peak visible on the horizon, Rattlesnake Mountain, actually glows in the dark!" Chantry insists, adding that apparent fallout doesn't deter the locals from using the site as a dumping ground.

To further signify man-made ecological disaster, Chantry designed the lettering to look like "something left under water too long." (He used old press type, photocopied through many generations.) A hole drilled into the center of the CD's front cover, seeming to shatter the TV screen, continues all the way to the back, piercing not just the booklet but also the disk, where it imitates the spindle hole in vinyl. Sharpening the Luddite humor, the disk also offers prim copy praising high fidelity, which Chantry lifted from an old record (Fig. 5). After several efforts "corrected" by the printer, he successfully presented Sub Pop's logo in reverse on the back, the biggest anti-technology joke of all (Fig. 4).

The LP offers a different design. Chantry couldn't find a printer who would agree to drill through the cardboard sleeve. Instead of using a circular type treatment for the front cover, he set the band's name on the horizon (Fig. 1), and for the back cover he substituted a "piddle glass," part of his extensive clip-art collection, in place of the hole (Fig. 2). The posters proved less challenging to puncture. Chantry shot a stack of them with a .357 Magnum. The dropped D in the band's name is a musician's tuning joke.

In designing the twelve-inch single, Chantry enlisted the help of Dale Travous, an artist whose work involves a plasma generator. ("He puts a quarter in it, shoots about twenty million volts of electricity into the plasma, and it creates this explosion. When he digs the quarter out of the rubble, it's the size of a dime," Chantry explains.) The cover photo, by Aubry, shows the generator blowing up (Fig. 6). The disk features badly executed Spirograph art that Chantry found in an old Spirograph kit in a thrift store.

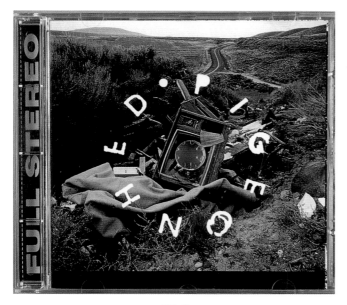

FIG. 3
CD package for Pigeonhed with simulated bullet hole piercing contents.

FIG. 4

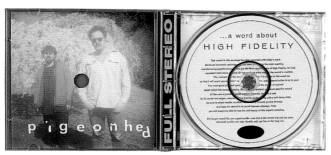

FIG. 5

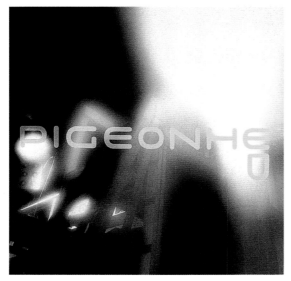

FIG. 6
Twelve-inch single depicting a plasma generator in action.
Client: Sub Pop, 1994.

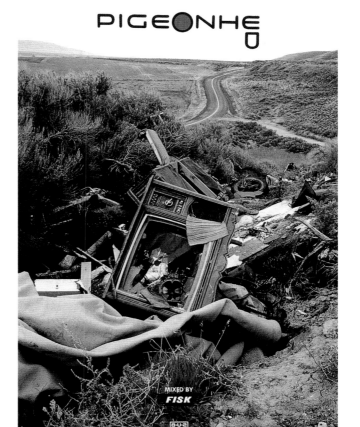

FIG. 7
Promo poster with actual bullet hole.

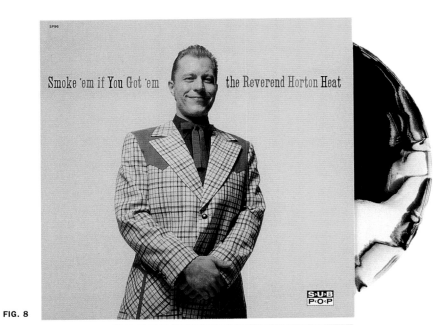

FIG. 8

FIGS. 8–10
Counterclockwise from left: Front and back cover
of *Smoke 'em if You Got 'em*, with pinto-patterned vinyl;
Psychobilly Freakout.

FIGS. 11–16
CD/LP and poster designs for *The Full-Custom Gospel
Sounds of the Reverend Horton Heat*.

FIG. 9

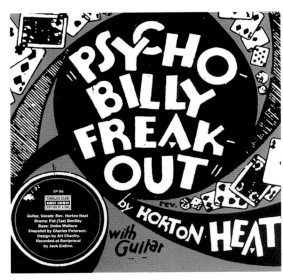

FIG. 10

A CASE STUDY IN THE DEVELOPMENT of an artist's identity within a label, Chantry's graphics for three releases by the rockabilly guitarist and singer Reverend Horton Heat evoke the escapades of a Southern preacher with a weakness for, in the designer's words, "wild women, gamblin', and likker." Heat's *Psychobilly Freakout*, from 1990, for Sub Pop's limited-edition Singles Club, features a sleeve with a two-color swirl of playing cards and novelty Deco-ish lettering (Fig. 10). The artist himself isn't pictured. He makes his first appearance on the cover of the ten-inch single of the same year, *Smoke 'em if You Got 'em*, wearing an Engelbert Humperdinck–meets–Merle Haggard jacket and a smile broadly hinting at illicit desires (Fig. 8). In contrast with the static layout and smug portrait (by photographer Michael Lavine), Chantry designed the back cover to express frantic energy (Fig. 9). The band, shot by Charles Peterson in the sweaty, hair-flopping style of his portraits of grunge musicians, plays under erratically styled paragraphs and radiant lines of type. Chantry, who is rarely satisfied with mere black vinyl, specified a black and white "pinto" pattern for the disk (Fig. 8).

For *The Full-Custom Gospel Sounds of the Reverend Horton Heat*, a CD and LP released in 1993, Chantry went "full bore" in evoking "hallelujah flaming God-love madness" to suggest how very sinful the reverend could be. The cover photo for both formats, by James Bland, required that the band enact a baptism ritual by standing in a river in thirty-degree weather (Figs. 11, 14, 16). The lettering is adapted from the handwriting of the outsider artist Howard Finster. Tattoo flash, which Chantry adapted as a flaming thorn-pierced heart, is emblazoned on Heat's robe as well as on the compact disk, where it's bordered by hot-rod licks of fire (Fig. 13). Another tattoo graphic, featuring a naked woman serving cocktails against a crucifix surrounded by images of death and gambling, appears opposite the disk in the CD package (Figs. 13, 14). Inside the booklet, Bland's photo of Heat in a graffitied nightclub stall contemplating the flame from his lighter places the musician firmly in hell (Fig. 15). He is elevated on the back cover, happily, in a robe of pure white, flanked by band members with angels' wings (Fig. 12).

FIG. 11

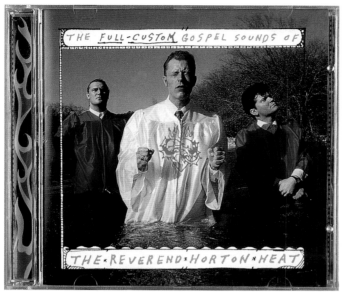

FIG. 12

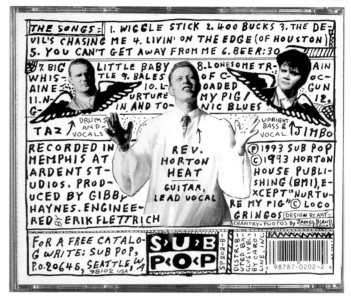

FIG. 13

FIG. 14

FIG. 15

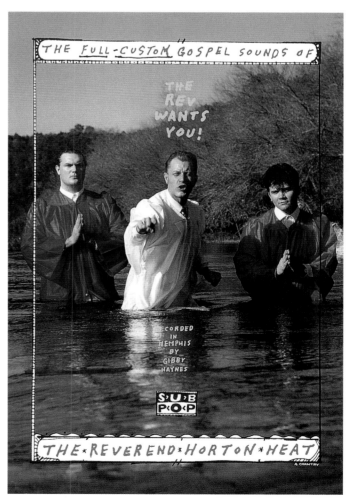

FIG. 16

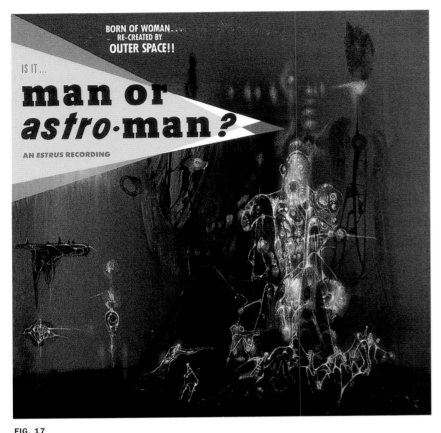

FIG. 17

FIG. 18

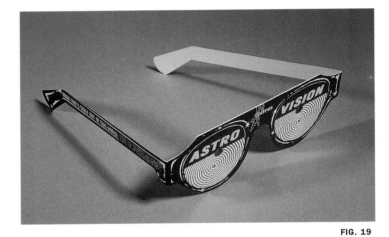

FIG. 19

Clockwise from left: CD/LP cover by Richard Powers, hypnotic disk, and promo glasses for Man...or Astroman's first release.
Client: Estrus Records, 1993.

CHANTRY DESCRIBES THE ATLANTA-BASED Man . . . or Astroman? as "an instrumental surf band from outer space. They are fascinated by spy movies and snack food. They perform with TV sets on their heads." He and the band worked together on the design of several releases exploring different dimensions of the sci-fi motif.

The collaboration began in 1993 with an Estrus-released CD/LP illustrated by Richard M. Powers, a prolific artist whose work appeared on scores of science fiction book covers in the fifties and sixties (Fig. 17). Powers, who died in 1996, was most recognizable for eerie abstract paintings influenced by the likes of Yves Tanguy and Joan Miró. Chantry, long an admirer, found Powers in retirement in Connecticut and approached him for this image, which is creepy, but in a quiet way. One only has to open the CD package to be jolted awake by concentric circles and herringbone patterning in electric blue against a blue glitter tray (Fig. 18).

"Man . . . or Astroman? was terribly confused by the resistance of human earthlings to their superior thought processes, so they considered using robots to help in their conquest," Chantry explains about the design of the next year's Estrus CD/LP *Destroy All Astromen!* (Figs. 20–23). A robot even invades the disk's label, on both the A and B sides (Figs. 21, 22). Also that year, the band released a 45 based on what they insisted was its attempt to recreate the soundtrack from a low-budget 1960s spy film, *Mission into Chaos* (Fig. 24). Having discovered only fragments of the movie, the group offered a large reward to anyone who could supply them with a complete copy. "Of course, they made it all up," Chantry says, "but they got three movies that

were claimed to be the one they were looking for." Their next release, *Return to Chaos*, was packaged as an FBI file purporting to give the (heavily censored) name of the competition's winner (Fig. 25).

The sleeve for *World out of Mind!*, a 45 released by Estrus in 1994 (Figs. 26, 27), evolved out of the band's interest in electricity (two members hold degrees in physics). Chantry introduced them to Dale Travous, his artist friend who built and activated the plasma generator shown exploding on a ten-inch single for Pigeonhed (see page 141). Another of Travous's constructions was a Tesla coil that Chantry estimated to be fifteen to twenty feet tall. "When Dale turned it on he destroyed radio reception for about a five-mile radius and sucked six million volts out of the city's electrical grid. Sparks came out about twenty or thirty feet long. It was just like watching God." After borrowing Travous's apparatus for the *World out of Mind!* back cover photo (shot by Arthur S. Aubry), which shows an alien brain (sculpted by Katharine Wolf) enjoying a surge of electricity, the band went on to build its own Tesla coil for use in performances.

Mixing hi-fi and sci-fi for the 1996 Estrus *Sounds of Tomorrow* 45, Chantry used overlapping metallic inks to promote an "alien test record designed to enslave your stereo." Even the vinyl has a hypnotic swirl (Figs. 28–30).

No Man . . . or Astroman? record features a photo of the band, but the CD/LP covers of *Transmissions from Uranus*, a live recording in 1995 by Homo Habilis, does reveal a colorful blur and some instruments (Fig. 33). "This is what they actually look like," Chantry insists.

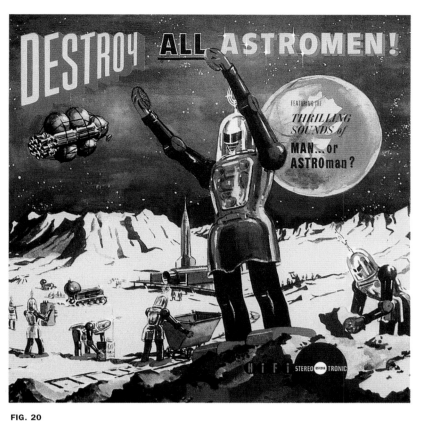

FIG. 20

FIGS. 21 & 22

FIG. 23
Front and back covers of *Destroy All Astromen!* (Figs. 20, 23).
Vinyl with robots (Figs. 21, 22). Client: Estrus Records, 1994.

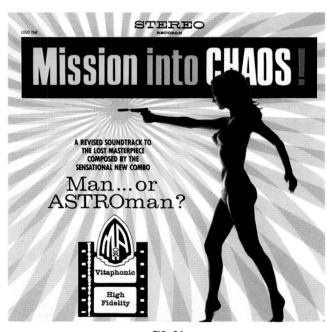

FIG. 24
Cover of *Mission into Chaos,* purported to be based on the
soundtrack from a '60s spy movie. Client: One Louder, 1994.

FIG. 25
Return to Chaos, the band's follow-up to their *Mission into Chaos* prank. Client: Homo Habilis Records, 1995.

 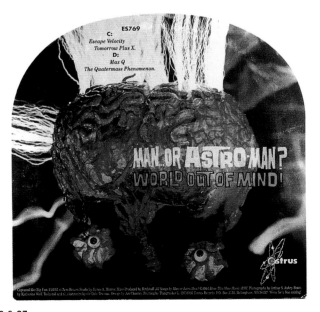

FIGS. 26 & 27
World Out of Mind 45 cover influenced by the Tesla coil of Dale Travous. Client: Estrus Records, 1994.

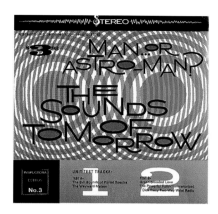

FIGS. 28–30
Chantry designed *The Sounds of Tomorrow* 45 to look like an alien test record. Client: Estrus Records, 1997.

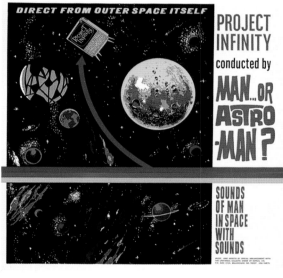

FIG. 31

FIG. 32
LP/CD cover (Fig. 31) and promo poster (Fig. 32) for *Project Infinity*,
"the sounds of man in space with sounds." Client: Estrus Records, 1997.

FIG. 33
CD/LP cover of *Transmissions from Uranus* features the only
band portrait ever published on a Man...or Astroman? record.
Client: Homo Habilis Records, 1995.

FIGS. 34 & 35
Two versions of the Mono Men's *WRECKER!* LP. Photographer: Susan McKeever.
Client: Estrus Records, 1992.

CHANTRY PRODUCED SOME OF HIS MOST SATISFYING designs for the Mono Men, "a rough-'n-ready hard-ass rock band" led by Richard "Dick" Head, *aka* Dave Crider, founder of Estrus. Both Crider and Chantry share a taste for paradoxes like elegant crassness and graceful buffoonery. The label's name, not to mention its graphics, indulges in flagrant sexism with enough self-consciousness to turn the joke back on men. "If Ralph Cramden and Ed Norton had a punk band, they would have been the Mono Men," Chantry insists.

Beginning in 1992, with *WRECKER!*, Chantry worked out a formula for each release involving a nude woman on the front and an exploding hot rod on the back. Typically, he presented this adolescent fare in a front-cover layout inspired by Reid Miles's elegantly minimalist designs for Blue Note (Figs. 34, 35). "Every song on *WRECKER!* was released somewhere, by someone, as a single with a B-side that wasn't from the LP," Chantry explains, but the design style persisted for all versions (Figs. 36–41).

By 1993, the year in which the band's *Shut the Fuck Up!* LP was released (Fig. 43), "many very powerful women were insisting that their nude bodies appear on sleazy Mono Men records," Chantry confides. He designed the work expressly to offend Tipper Gore, then in the thick of her national campaign to clean up music lyrics. And he wasn't happy with the Washington state legislature, either, which had just banned the sale of records with obscene lyrics to children under twenty-one. Crider and Chantry's joke was to place the nude on an all-instrumental recording—no lyrics at all. They also offered a toned-down CD version called *Shut Up!* for which Chantry drew a bra on the model (Fig. 42). The back cover on both versions pays homage to men's magazines from

the fifties, including such Chantry favorites as *Adam, Sir Knight, Mermaid,* and *Tom Cat* (Fig. 44).

The Mono Men's 1994 *Sin & Tonic* CD, Chantry says, "was to bring the cheesy fifties men's culture theme to a head." Its graphics were inspired by "cocktails, strippers, go-carts, cigars, bourbon, and of course, Saul Bass" (Figs. 47–51). The LP, renamed *Skin and Tonic,* features a different Bass-influenced design.

Still, the Mono Men hadn't paid tribute to the greatest male institution of all: the bachelor party. They got around to it in 1995 with a live recording at the Savidge Lane's bowling alley in Illinois, renamed, for the purposes of the record only, T.S.B. (Tom's Strip-n-Bowl). The party involved rock bands, strippers, and even a horn section. Chantry's package for the ten-inch EP includes die-cut bowling pins that open to reveal Sunny, the Mono Men's favorite cover model, doing a strip tease (Fig. 53). Reverse the insert, and Sunny demonstrates proper bowling technique (Fig. 54). The associated single, "Cross Alley Stomp," has a die-cut bowling ball sleeve with a debossed thumb indentation and foil-stamped logo (Fig. 55).

The title of the band's final recording, *Have a Nice Day, Motherfucker,* reflects the Mono Men's evolution by 1998 into an "angry three-man power trio. This was literally a last blast. And then they broke up," Chantry relates (Figs. 58–60). He was able to revisit the girlie theme, however, for *Bent Pages,* a 1997 reissue of early material, produced on Australia's Augogo label (Figs. 63, 64). "This is one of my favorite pieces," Chantry declares. "The dirty-novel approach worked great."

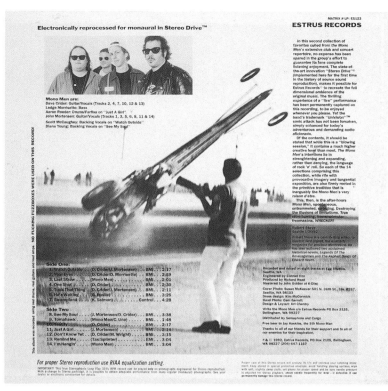

FIG. 36
Estrus Records, USA, 1992.

FIGS. 36–41
Assorted Mono Men records distributed around the world. In each version Chantry presented a nude woman on the front and an exploding hot rod on the back.

FIG. 37
Lucky Records, USA, 1992.

FIG. 38
September Gurls Records, Germany, 1992.

FIG. 39
Augogo Records, Australia, 1992.

FIG. 40
Dig! Records, France, 1992.

FIG. 41
Lance Rock Records, Canada, 1992.

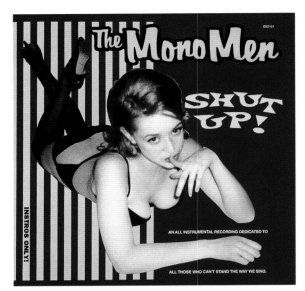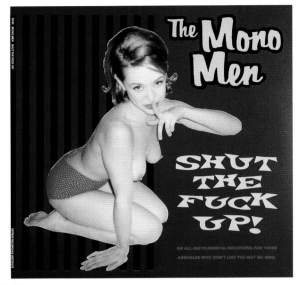

FIGS. 42 & 43
Clean and naughty versions of *Shut the Fuck Up!*, 1993. Photographer: A. Patrick Adams. Client: Estrus Records, 1993.

FIG. 44
Back of both *Shut Up!* and *Shut the Fuck Up!*

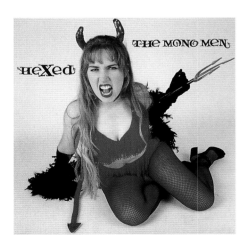

FIGS. 45 & 46
Front and inside covers of *Hexed.* Photographer: Julie Pavlowski. Client: Trash City Records, England, 1995.

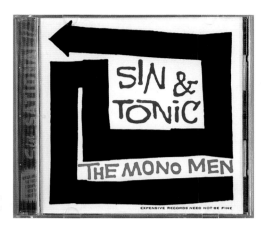

FIGS. 47 & 48
Photographer: Marty Perez

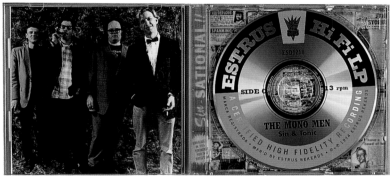

FIG. 49

FIG. 50

FIGS. 47–51
Saul Bass–inspired packaging for *Sin & Tonic*.
Client: Estrus Records, 1994.

FIG. 51

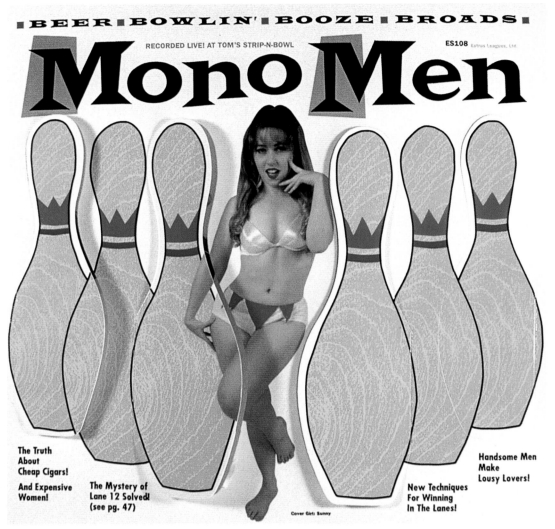

FIG. 52

FIG. 53

FIG. 54

The Mono Men's favorite cover model, Sunny, demonstrates proper stripping and bowling technique on a live recording from Tom's Strip-n-Bowl. Photographer: Julie Pavlowski. Client: Estrus Records, 1995.

FIG. 55

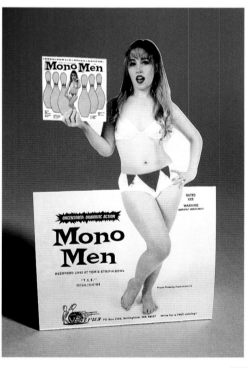

FIG. 56
Photographer:
Julie Pavlowski.

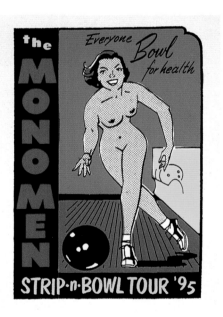

FIG. 57

FIGS. 55–57
Associated single, "Cross Alley Stomp," and collateral promotions. Client: Estrus Records, 1995.

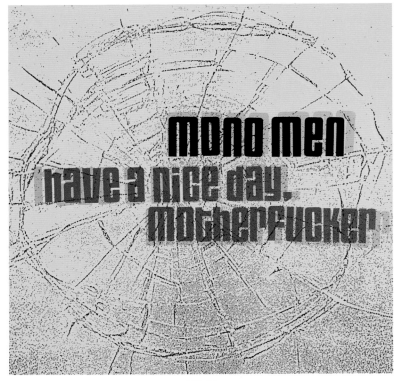

FIG. 58

FIGS. 58–60
LP, CD, and promotional poster
for *Have a Nice Day, Motherfucker,*
the Mono Men's last release.
Client: Estrus Records, 1998.

FIG. 59

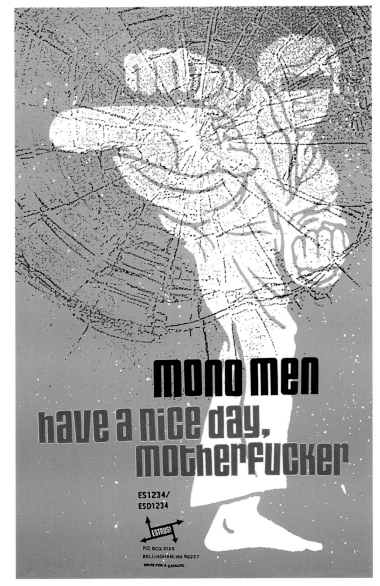

FIG. 60

FIGS. 61 & 62
This Mono Men single parodies the
design of Orange amplifiers, "the
loudest in the business," says Chantry.
The components used icons rather
than words on their controls,
including a fist to signify volume.
Client: Pure Vinyl Records, Austria, 1998.

FIGS. 63 & 64
Chantry adapted a trashy
paperback book for the cover
of *Bent Pages*, a 1997 reissue
of early Mono Men material.
Client: Augogo Records, Australia.

NOTE

All direct quotes in this book that are not noted were culled from interviews conducted by the author between May 1998 and March 2000. The citations here refer to information and quotes from published sources.

CHAPTER 1

1 C. R. Steyck, "Origins of a Sub-Species," in C. R. Steyck, Bolton Colburn et al., *Kustom Kulture: Von Dutch, Ed "Big Daddy" Roth, Robert Williams, and Others.* Catalog for 1993 Laguna Art Museum exhibition. (San Francisco: Last Gasp of San Francisco; Laguna Beach, CA: Laguna Art Musuem, 1993), 16.

2 Regina Hackett, "The Art of Art Chantry," *Seattle Post-Intelligencer,* July 17, 1993.

3 Sarah Thornton, "General Introduction," in Ken Gelder and Sarah Thornton, eds., *The Subcultures Reader* (London and New York: Routledge, 1997), 4–5.

4 Dick Hebdige, "Subculture: The Meaning of Style," in ibid., 135–36.

CHAPTER 2

1 Frederick Foster, "Sir Francis Chantrey," *Derbyshire Life and Countryside* (February 1999): 32–33. This article was brought to our attention by Bill Johnson.

2 Mark D., "The World of Designer Art Chantry," *Pussycat* (1995), 40.

3 Quoted in Steven Heller, "Art Chantry: Ascent into Unslick," unedited ms. Edited version published in *U&lc,* 24, no. 3 (1997), 14.

4 Art Chantry, "I Have Seen the Future and Its Name Is Buds," *Seattle Design Association Newsletter,* (1988), no. 22.

5 Quoted in Heller, "Ascent into Unslick."

6 Walt Crowley, *Rites of Passage: A Memoir of the Sixties in Seattle* (Seattle: University of Washington Press, 1995), 105.

7 Ibid., 135.

8 Ibid., 118.

CHAPTER 3

1 Quoted in Steven Heller, "Art Chantry: Ascent into Unslick," unedited ms. Edited version published in *U&lc,* 24, no. 3 (1997), 14.

2 John Koval, "Adjudication, Rat Fink, and Mass Reproduction: A Conversation with Art Chantry." *Seattle Design Association Newsletter,* no. 18 (March/April 1987), 4.

3 Quoted in Heller, "Ascent into Unslick."

4 Ibid.

5 Art Chantry, *Instant Litter: Concert Posters from Seattle Punk Culture* (Seattle: The Real Comet Press, 1985), 4, 110.

6 Patrick Broderick, "Talking Shop with Art Chantry" (WWW.ROTODESIGN.COM, June 1998).

7 Chantry, *Instant Litter,* p. 99.

8 Dick Hebdige, "Subculture: The Meaning of Style," in Ken Gelder and Sarah Thornton, eds., *The Subcultures Reader* (London and New York: Routledge, 1997), 142.

9 Simon Frith, "Formalism, Realism and Leisure: The Case of Punk," in ibid., p. 167.

10 Quoted in Legs McNeil and Gillian McCain, *Please Kill Me: The Uncensored Oral History of Punk* (New York: Penguin Books, 1997), 256.

11 Chantry, *Instant Litter,* p. 5.

CHAPTER 4

1 "George Tanagi's Work Is All Around," *Seattle Times,* December 20, 1999.

CHAPTER 5

1 "Life After Launch: Four of the World's Premier Publications from the Ground Up," *LIMN,* no. 2 (July 1998), 48–55.

2 Julie Lasky, "A Style to Suit Alaska," *Print* (March/April 1993).

3 Quoted in Clark Humphrey, *Loser: The Real Seattle Music Story* (Portland, OR: Feral House, 1995), 47.

4 John Kiester, "Who's Killing Seattle's Rock and Roll?" *The Rocket* (June 1984), 18.

5 "Rock N Roll Stinko! The *Worst* Rock Films of All Time," *The Rocket* (June 1985), 24.

6 Humphrey, *Loser,* 27.

7 Ibid., 208.

8 Quoted in Steven Heller, "Art Chantry: Ascent into Unslick," unedited ms. Edited version published in *U&lc,* 24, No. 3 (1997), 14.

CHAPTER 6

1 Patterson Sims, "Art Chantry: Posters." Catalog for "Documents Northwest: The PONCHO Series: Art Chantry," July 15–November 21, 1993, Seattle Art Museum.

2 Regina Hackett, "The Art of Art Chantry," *Seattle Post-Intelligencer,* July 17, 1993.

3 Quoted in C.R. Steyck, Bolton Colburn et al., *Kustom Kulture: Von Dutch, Ed "Big Daddy" Roth, Robert Williams, and Others.* Catalog for 1993 Laguna Art Museum exhibition. (San Francisco: Last Gasp of San Francisco; Laguna Beach, CA: Laguna Art Museum, 1993), 7.

4 Ibid., 22.

5 See WWW.IMUSIC.COM/JAMPAC/POSTERBAN.HTML.

6 Alex Steffen, Philip Wohlstetter, Jack Mackie, "Agitating for the Arts," *Seattle Post-Intelligencer,* May 9, 1999.

Ades, Dawn. *The 20th-Century Poster: Design of the Avant-Garde*. Catalog for Walker Art Center exhibition. Minneapolis: Walker Art Center, New York: Abbeville Press, 1984.

Belsito, Peter. *Street Art: The Punk Poster in San Francisco, 1977–1982*. Berkeley: Last Gasp, 1981.

Crowley, Walt. *Rites of Passage: A Memoir of the Sixties in Seattle*. Seattle: University of Washington Press, 1995.

Duncombe, Stephen. *Notes from Underground: Zines and the Politics of Alternative Culture*. London: Verso, 1997.

Foster, Frederick. "Sir Francis Chantrey." *Derbyshire Life and Countryside* (February 1999): 32–33.

Freedberg, David. *The Power of Images: Studies in the History and Theory of Response*. Chicago: University of Chicago Press, 1989.

Gelder, Ken, and Sarah Thornton, eds. *The Subcultures Reader*. London and New York: Routledge, 1997.

"George Tanagi's Work Is All Around." *Seattle Times,* Obituaries, December 20, 1999.

Heller, Steven, and Marie Finamore, eds. *Design Culture: An Anthology of Writing from the AIGA Journal of Graphic Design*. New York: Allworth Press, 1997.

Hughes, Robert. *Nothing If Not Critical: Selected Essays on Art and Artists*. Orig. ed., 1990. New York: Penguin Books, 1992.

Humphrey, Clark. *Loser: The Real Seattle Music Story*. Portland, OR: Feral House, 1995.

Jacobs, Karrie, and Steven Heller. *Angry Graphics: Protest Posters of the Reagan/Bush Era*. Salt Lake City: Peregrine Smith Books, 1992.

Kouwenhoven, John. *Made in America: The Arts in Modern Civilization*. New York: Anchor Books, 1962.

Kuipers, Dean, and Chris Ashworth, eds. *Ray Gun: Out of Control*. New York: Simon & Schuster, 1997.

"Life After Launch: Four of the World's Premier Publications from the Ground Up." *LIMN,* no. 2, (July 1998).

Margolin, Victor, ed. *Design Discourse: History, Theory, Criticism*. Chicago: University of Chicago Press, 1989.

Margolin, Victor, and Richard Buchanan, eds. *The Idea of Design: A* Design Issues *Reader*. Cambridge, MA: MIT Press, 1995.

McNeil, Legs, and Gillian McCain. *Please Kill Me: The Uncensored Oral History of Punk*. New York: Penguin Books, 1997.

Peck, Abe. *Uncovering the Sixties: The Life and Times of the Underground Press*. Orig. ed. 1985. New York: Citadel Press, 1991.

Rubin, William S. *Dada, Surrealism, and Their Heritage*. Exhibition catalog. New York: Museum of Modern Art, 1968.

Seitz, William C. *The Art of Assemblage*. Exhibition catalog. New York: Museum of Modern Art, 1961.

Steyck, C. R., Bolton Colburn et al., *Kustom Kulture: Von Dutch, Ed "Big Daddy" Roth, Robert Williams, and Others*. Catalog for 1993 Laguna Art Museum exhibition. San Francisco: Last Gasp of San Francisco; Laguna Beach, CA: Laguna Art Museum, 1993.

Triggs, Teal, ed., *Communicating Design*: Essays in Visual Communication. London: B.T. Batsford, Ltd., 1995.

Turcotte, Brian Ray, and Christopher T. Miller. *Fucked Up + Photocopied: Instant Art of the Punk Rock Movement*. Corte Madera, CA: Gingko Press, 1999.

BY AND ABOUT ART CHANTRY

Agnew, Nash. "Chantry, Ciccone & Shag: The Look of Surf, Garage and Trash." *The Continental* (Bellingham's Surf-Garage-Exotica-Indie Magazine), no. 3, n.d., n.p.

Albrecht, Donald, Ellen Lupton, and Steven Skov Holt. *Design Culture Now*. Catalog for 2000 National Design Triennial exhibition, Cooper-Hewitt, National Design Museum, Smithsonian Institution, New York City. New York: Princeton Architectural Press, 2000: 128–29.

Arment, Deloris Tarzan. "A Chantry Poster Can Redefine Its Setting." *Seattle Times*, July 15, 1993: E5.

"Art Chantry: A Young Experimental Designer in Seattle." *Idea* (Japan), 1986: 70–75.

Baker, Brian. "Art Chantry's Northwest Passage." *Kulture Deluxe*, 1996: n.p.

Broderick, Patrick. "Talking Shop with Art Chantry." WWW.ROTODESIGN.COM.

Brown, Joan. "The Art of Low-Budget Posters." *Step-by-Step* (March/April 1990): 60–65.

Chantry, Art. "I Have Seen the Future and Its Name Is Buds." *Seattle Design Association Newsletter,* no. 22 (1988).

Chantry, Art. *Instant Litter: Concert Posters from Seattle Punk Culture*. Seattle: The Real Comet Press, 1985.

D., Mark. "The World of Designer Art Chantry." *Pussycat* (1995): 39–51.

Deck, Bob. "Art Chantry." *Micromag,* no. 8 (1998).

Frickman, Linda. "Introduction, Ninth Colorado International Invitational Poster Exhibition," Juror/Laureate: "Art Chantry." Catalog, 1995: 2–6.

Glaser, Milton, Yusaku Kamekura, and Raymond Savignac, executive eds. *The 100 Best Posters from Europe and the United States, 1945–1990*. Tokyo: Toppan Printing Co., 1993, 184–85.

Grushkin, Paul D. *The Art of Rock: Posters from Presley to Punk*. New York: Abbeville Press, 1993.

Hackett, Regina. "The Art of Art Chantry." *Seattle Post-Intelligencer*, July 17, 1993.

Heller, Steven. "Art Chantry: Ascent into Unslick." Unedited ms. Edited version published in *U&lc*, 24, no. 3 (1997): 14.

Heller, Steven. "Art Chantry Design." *I.D.* (January/February) 1995: 52–53.

Heller, Steven. *Designing with Illustration*. New York: Van Nostrand Reinhold, 1990.

Heller, Steven. "Easy Marks: Good Works by Two Designers." *Print* (1992): 32–38.

Heller, Steven. "No Bills Please, We're American." *Affiche,* no. 14 (1995): 56–63.

Heller, Steven, and Karen Pomeroy. *Design Literacy*. New York: Allworth Press, 1997, 233–235.

Hooten, Josh. "Art Chantry." *Punk Planet*, no. 24 (1998): 52–61.

Kleinsmith, Jeff, and Grant Alden. "'Let's Start the Dialogue': Conversation with Art Chantry." *IEM* 2, no. 1, 1993.

Koval, John. "Adjudication, Rat Fink, and Mass Reproduction: A Conversation with Art Chantry." Seattle Design Association Newsletter, no. 18 (March/April 1987).

Lupton, Ellen. *Mixing Messages: Graphic Design in Contemporary Culture*. Exhibition catalog, Cooper-Hewitt, National Design Museum. New York: Princeton Architectural Press, 1996, pp. 28, 42, 43, 93, 95.

Nelson, Sean, "Squashing the Scene." *The Stranger* 6, no. 27 (1997).

Sims, Patterson. "Art Chantry: Posters." Catalog for "Documents Northwest: The PONCHO Series: Art Chantry" July 15–November 21, 1993, Seattle Art Museum.

Sommese, Lanny. "Art Chantry (USA)," *Novum Gebrauchsgraphik* (1987).

Steyer, Stephanie. "Art Chantry." *Communication Arts* (January/February 1988): 50–59.

Urell, Denise. "Contemporary Western-American Counter-Culture." *Affiche,* no. 6 (June 1993): 14–19.